Contemporary British Art in Print

Contemporary

This book is published to accompany an exhibition at
the Scottish National Gallery of Modern Art, Edinburgh
25 February–30 April 1995
and at the Yale Center for British Art, New Haven
2 December 1995–4 February 1996

British Art in Print

The Publications of
Charles Booth-Clibborn
and his imprint
The Paragon Press 1986–95

Scottish National Gallery of Modern Art
The Paragon Press

Published by the Trustees of the National
Galleries of Scotland in association with
The Paragon Press 1995

Hardback edition distributed in the United
Kindom and the rest of the World by:
Internos Books, 12 Percy Street,
London W 1P 9FB, England

Hardback edition distributed in the USA
and Canada by: D.A.P. Distributed Art
Publishers, 636 Broadway 12th Floor,
N.Y. 10012 USA

Hardback edition distributed in France by:
InterArt Paris, 1 Rue de L'Est, 75020 Paris,
France

ISBN 1 873968 63 9

Paperback edition published to accompany
the exhibition 'Contemporary British Art
in Print' at the Scottish National Gallery of
Modern Art, Edinburgh, and the Yale
Center for British Art, New Haven

ISBN 1 873968 68 X

Edited by Patrick Elliott
Designed and typeset by Peter B. Willberg
Printed in Italy by Grafiche Milani
Photography by Antonia Reeve,
Sue Ormerod and Prudence Cuming

The Paragon Press c/o Booth-Clibborn
Editions, 12 Percy Street, London W 1P 9FB,
England. Tel. 0171-637 4255
Fax 0171-637 4251

Contents

Foreword *by Timothy Clifford and Richard Calvocoressi* 7

Introduction *by Patrick Elliott* 9

Projects and Portfolios: Narrative and Structure *by Jeremy Lewison* 11

A Scottish Paragon *by Duncan Macmillan* 21

Catalogue *compiled by Patrick Elliott*

The Scottish Bestiary *John Bellany, Steven Campbell, Peter Howson, Jack Knox, Bruce McLean, June Redfern, Adrian Wiszniewski* 38

London *Dominic Denis, Angus Fairhurst, Damien Hirst, Michael Landy, Langlands and Bell, Nicholas May, Marc Quinn, Marcus Taylor, Gavin Turk, Rachel Whiteread, Craig Wood* 46

Roger Ackling *The First of Ten Two-Day Showings of Two Works Ten Years Apart* 52

John Bellany *Images Inspired by Ernest Hemingway's 'The Old Man and the Sea'* 54

Victor Burgin *Fiction Film* 60

Alan Charlton *10 Grey Squares* 64

Ken Currie *Story from Glasgow* 68

Grenville Davey *Eye* 74

Alan Davie *Magic Reader* 78

Terry Frost *Trewellard Suns* 82

Hamish Fulton *Fourteen Works 1982–89* 86

Trees = Framed Works of Art on Paper [Text-work conceived by the artist for this publication] 92

A Twelve Day Walk and Eighty Four Paces 94

Ten Toes Towards the Rainbow 98

Antony Gormley *Body and Soul* 104

John Hilliard *Seven Monoprints* 110

Shirazeh Houshiary *Round Dance* 116

Peter Howson *A Hero of the People* 120

 The Noble Dosser; The Heroic Dosser; The Bodybuilder 124

Alan Johnston *Loop* 126

Anish Kapoor *[Untitled]* 130

Christopher Le Brun *Seven Lithographs* 134

 Fifty Etchings 138

 Four Riders 144

 Wagner 146

Richard Long *Rock Drawings* 150

Will Maclean *A Night of Islands* 154

Ian McKeever and Thomas A. Clark

 that which appears 160

Ian McKeever *Hartgrove* 166

Lisa Milroy *Rocks, Butterflies and Coins* 170

Thérèse Oulton *Undoings* 174

Adrian Wiszniewski *For Max* 178

 Harlequin Series 184

Bill Woodrow *Greenleaf* 188

 The Periodic Table 192

Appendix I *Other Publications* 198

Appendix II *'The Scottish Bestiary' Poems and Texts* 199

Glossary of Print Terms and Techniques 206

Acknowledgements 208

Foreword

This catalogue is published on the occasion of the first retrospective exhibition of the print projects of The Paragon Press. The Scottish National Gallery of Modern Art began collecting these print publications in 1986, the year in which Paragon was founded by Charles Booth-Clibborn. The Paragon Press was initially based in Edinburgh, where Booth-Clibborn had studied at University, and his publications were naturally of interest to the Gallery since, in his first years as a publisher, he concentrated on the work of Scottish artists. Since then Booth-Clibborn has published work by many of the leading British artists of our time. He has so far published thirty-four separate projects, which together constitute an important and wide-ranging survey of contemporary British art. Over the past ten years we have acquired most of these projects and it is this collection which provided the stimulus to the present exhibition and accompanying catalogue. We are delighted that the exhibition will subsequently be shown in the United States, at the Yale Center for British Art in New Haven.

A full list of our acknowledgements is published on page 208, but we would like to extend our particular thanks to those artists whose work is included in this publication. Almost all of them kindly agreed to talk in depth about their particular projects and assist with the cataloguing of their work. Consequently this publication offers an unusually detailed insight into the making of a work of art.

Timothy Clifford
Director, National Galleries of Scotland

Richard Calvocoressi
Keeper, Scottish National Gallery of Modern Art

Introduction

The Paragon Press was launched in 1986 and since then has published thirty-four projects, all of them by artists either born or resident in Britain. Rather than commission artists to make single prints, The Paragon Press has specialised in publishing limited edition print series in the form of portfolios or books. The artists are selected by Charles Booth-Clibborn, founder of The Paragon Press. Whereas some print publishers have established a particular house style, favouring a certain type of art, Booth-Clibborn's choice has been remarkably eclectic. He has had the confidence to follow his own taste and judgement, regardless of prevailing fashions.

The single restriction Booth-Clibborn places upon an artist when commissioning a project is that the finished work must be portable – a practicable requirement since most of the prints are sold abroad. Otherwise the artists are free to do as they please. Most of the artists Booth-Clibborn has worked with are internationally renowned painters or sculptors, but few of them have made many prints. As the publisher, he will offer advice and guidance as to which medium to choose, which printmaking studio to work in and how best to approach an unfamiliar artform. They are, however, under no pressure to finish the work by a particular date, can experiment for as long as they like, and are given free reign of the best printing studios staffed by expert technicians. This boundless remit allows the artists to pose themselves major, fundamental questions. Should they make printed versions of their work or should they try an entirely new approach more in keeping with the particular qualities of the printed medium? How should they deal with the requirement that the work will be an editioned sequence of images rather than a unique, single image? Using a new medium the artist does in a sense have to reinvent his or her own art, to experiment in new ways. It is this self-generated pressure, this requirement to cope with a new set of problems, that has led to so many extraordinary images.

The fact that Paragon has only published work by artists based in Britain is born of practicable considerations. When an artist is working on a series of prints it is important that he or she have easy access to the printing studios and that the publisher be available at all times to offer advice and encouragement, attend to the material and financial arrangements, and oversee the collaboration with printers, bookbinders, typographers and others who are all important contributors to the project. Each series may evolve over a long period of time and have gone through numerous different stages. It is the project nature of the enterprise which allows for a grander statement to be made than would be possible in a single image. The projects are, in effect, portable exhibitions.

Through The Paragon Press, Charles Booth-Clibborn has done much to promote British art both within Britain and abroad. This catalogue marks almost ten years of print publishing. We look forward to the next decade of publications with much anticipation.

Patrick Elliott

Projects and Portfolios: Narrative and Structure *Jeremy Lewison*

Looking at the history of printmaking in the twentieth century it is striking the extent to which its peaks are defined by portfolios rather than by single prints. Although artists have always made superb individual sheets, particularly in the first half of the century, what stand out above all are the portfolios. Picasso's *Vollard* (fig.1), *347* and posthumously published *156* suites set markers for many of his contemporaries and successors in terms of scale, scope and coherence. The size of these suites seems not to have been predetermined; they were worked on intuitively and in intense bursts of creative activity. The *347 suite*, in particular, is testimony to an artist who, once engaged with the etching medium, consumed it voraciously. This series of 347 etchings was executed from start to finish in just less than seven months, from 16 March to 5 October 1968.

Picasso was not the only artist of the earlier part of this century to create major series of prints. Dix's *War*, Matisse's *Jazz* (published as a book and a portfolio) (fig.2), Lissitzky's *Victory Over the Sun*, Beckmann's *Hell* (fig.3), Kollwitz's *The Peasants' Revolt* and Dubuffet's *Walls* are among the exceptional productions of the first fifty years. Since the Second World War, however, there has been a sharper focus on this publishing format. Many truly remarkable portfolios spring to mind, among them Newman's *18 Cantos*, Rivers's and O'Hara's *Stones*, Johns's *First Etchings*, Marden's *Ten Days*, Motherwell's *A la Pintura* (a book of unbound sheets), Baselitz's *Eagles*, Warhol's *Marilyns* and LeWitt's *Forms Derived from a Cube*. As for the British contribution, Hockney's *A Rake's Progress*, Paolozzi's *As is When*, Hamilton's ongoing *Ulysses* project and Caulfield's *Laforgue* suite measure up to them all.

It is not clear why the portfolio has been such a popular form in the last fifty years. Perhaps it is easier to market a group of works rather than an individual image. Given the unjustifiably low regard in which prints are held – museum print galleries are always separated from painting and sculpture galleries; painting and sculpture are often referred to as the primary media – it would not be surprising if commercial reasons formed part of the justification. There must be, however, more positive, aesthetic reasons for this flourishing. Perhaps it has to do with the publisher's and artist's ambition to make a great work, independent of other works, with an internal coherence and a unity, which provides its own context for display and contemplation and which has built-in momentum. Or maybe the effort to become familiar with a new medium, or to adapt working habits to a medium which requires a different approach, is so great that it hardly seems worthwhile to make a single image.

Historically some of the greatest prints have been published in groups. Goya, Callot and Hogarth are obvious examples of artists who have favoured this format, while other artists have made works which, while published separately, may be perceived as part of an ongoing group. Such is the coherence of Rembrandt's landscape etchings that had he been alive today, they would almost certainly have been released as a package. Closer to our time, the Vorticist woodcuts of Edward Wadsworth are an integrated group, as are his *Dazzleship* linocuts, although they were sold individually. Undoubtedly the fact that Wadsworth worked on these two 'series' during concentrated periods endowed them with a unity of intention and execution. Even more recently, Georg Baselitz's *Neue Typ* prints exemplify the same tendency towards seriality in spite of their status as individually conceived works.

The Nature of Portfolios

Broadly speaking there are four different types of portfolio. The first is a set of prints which is essentially a literary narrative, such as Hockney's *A Rake's Progress* (fig.4), where Hockney describes in images and words the experience of his first trip to New York as a young artist. His original intention had been to execute eight etchings based on Hogarth's tale of the same name, setting them in New York rather than London. He has explained that what attracted him was the possibility of telling a story relying solely on visual means (although the incorporation of words contradicts this somewhat). After speaking to Robin Darwin, then head of the Royal College of Art, he agreed to work towards its publication in book form. He was persuaded to attempt twenty-four plates but he soon discovered that such a large number was technically too demanding and would dilute the story. He finally agreed to make sixteen. The book was never published but, after Hockney finished the plates, the

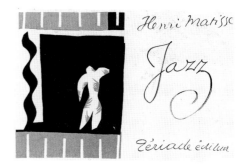

fig.1 Pablo Picasso, *Four Nude Women and Sculpted Head* (plate 82 of *The Vollard Suite*), 1934. Etching and engraving. Collection Scottish National Gallery of Modern Art, Edinburgh.

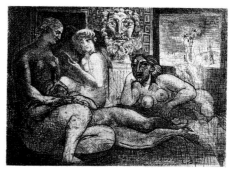

fig.2 Henri Matisse, *Title-page / The Clown* (from *Jazz*), 1947. Pochoir. Collection Scottish National Gallery of Modern Art, Edinburgh.

fig.3 Max Beckmann, *The Way Home* (plate 2 of *Hell*), 1919. Lithograph. Collection Scottish National Gallery of Modern Art, Edinburgh.

project was bought by Editions Alecto and published as a portfolio in an edition of fifty.

The initial idea to publish the prints as a book rather than a portfolio indicates the essentially literary nature of this kind of project. Each image is numbered on the plate, thus determining the narrative sequence. In book form the experience of looking at the prints would have been more intimate and private. Furthermore only two plates at a time could have been viewed. As a portfolio the whole story can be seen at once, although the detail may only be understood print by print.

A second type of portfolio is one which sets up a technical rather than a literary narrative, although in some respects the former is another version of the latter; there is still a sequential format. Newman's *18 Cantos* (fig.5) fall into this category for they are essentially variations on a theme. Newman explained in the preface to this majestic project that his principal concern, as a painter used to saturating the whole field with colour, was how to deal with the margins. 'The struggle to overcome this intrusion', he wrote in the preface to the portfolio,

> to give the imprint its necessary scale so that it could have its fullest expression, (and I feel that the matter of scale in a lithograph has usually not been considered) so that it would not be crushed by the paper margin and still have a margin – that was the challenge for me. That is why each canto has its own personal margins. In some, they are small, in others large, still in others they are larger on one side and the other side is minimal. However, no formal rules apply. Each print and its paper had to be decided by me and in some cases the same print exists with two different sets of margins because each imprint means something different to me.

Although Newman's *18 Cantos* must be interpreted in the context of his paintings, undoubtedly what distinguishes them from paintings is their qualities as printed images on paper, which he was keen to exploit. He refused to crop the margins just as he declined to print on smaller sheets of paper to create a bleed. He experimented with different methods of inking, sometimes reusing the same stone with different colour combinations. As he explained: 'I had no plan to make a portfolio of "prints". I am not a printmaker. Nor did I intend to make a "set" by introducing superficial variety. These cantos

arose from a compelling necessity – the result of grappling with the instrument'.

The third kind of portfolio is characterised by a group of images which are linked thematically but which do not propose a linear narrative. Picasso's *347 suite* does not tell a story, but the group of images collectively depicts the fantasies of an artist in old age who, aware of his own declining sexual potency, casts himself in the role of voyeur. As in Newman's *18 Cantos* there are distinctive clusters of works within the portfolio, almost like discrete short stories, but they are contained within the binding of the central theme.

Finally, some portfolios assemble images by a variety of artists which have a thematic link but often it is of such a superficial nature that the portfolio is really a collection of unrelated works brought together under a group heading. A number of such portfolios were published in the USA during the heyday of Pop Art. While some individual images are engaging, the ensemble is generally disappointing because it lacks coherence. A European example of this is *Hommage à Picasso* which included one of the great prints of the last fifty years, Richard Hamilton's *Picasso's Meninas* (fig.6), printed by Aldo Crommelynck, who had worked with Picasso on the *347* and *156* series. That Hamilton's print appears regularly on the market suggests that many of the portfolios have been broken up, which in turn suggests a lack of internal coherence. Had the portfolio been an integral object the individual prints would not stand so well alone.

In his discussion of Coracle Press, a publisher of artists' books and a gallery in the 1970s and 1980s (see below), Thomas A. Clark (who recently collaborated with Ian McKeever on *that which appears*, pp.160–165) described what he called 'book works' in terms which may readily be applied to the notion of the portfolio: 'The best book works show an understanding of book form as acute as the artist's awareness of gallery space. As in ill-conceived exhibitions, the least interesting artist's books treat the book as a portmanteau for the housing of separately conceived works. Where the form is handled well, the movement within the book and its integrity as an object are as satisfying as felicitous space in a gallery'.* He goes on to equate the artist's 'book work' with an exhibition, distinguishing it from the latter by virtue of its

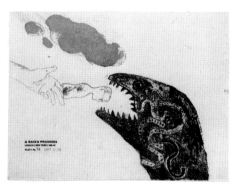
fig.4 David Hockney, *Cast Aside* (plate 7A of *A Rake's Progress*), 1961–63. Etching and aquatint. Collection Tate Gallery, London.

fig.5 Barnett Newman, *Canto III* (from *18 Cantos*), 1963–64. Lithograph. Collection Tate Gallery, London.

fig.6 Richard Hamilton, *Picasso's Meninas* (from the group portfolio *Hommage à Picasso*), 1973. Etching, aquatint and engraving. Collection Tate Gallery, London.

portable nature. An artist's book 'is an exhibition which can be taken away', a permanent form in which the presence and order of exhibits is unalterable. Thus paradoxically, an exhibition of works of art such as paintings, however solidly constructed they may be, is ephemeral, whereas the artist's book, however poorly printed or thin the paper, if cared for, is permanent. The portfolio has some of the same characteristics: the artist may determine the order in which the prints should be seen (although he is at the mercy of the owner of the work if the latter decides not to respect the artist's wishes); the portfolio is essentially a small but complete, portable exhibition. Finally, like the book, the portfolio is not an adjunct to an artist's work but is given as much care and attention as any other part of his activity. There are few artists who when asked about the status of their prints would argue that they are of minor importance. Artists do not distinguish between media. They simply make works of art. Only museums and the art market persist in ghettoising prints and regarding them as poor relations to painting and sculpture.

The Formation of Paragon Press: Booth-Clibborn's Progress

If the portfolio is essentially a literary genre, it is not surprising that Charles Booth-Clibborn's interest in print-publishing developed out of a passion for collecting books. From the age of sixteen he browsed his way through second-hand bookshops and began to collect first editions. He continued to indulge this burgeoning interest while a student of history at Edinburgh University, where he expanded his collection to include illustrated books, that is limited edition publications containing an original print, often published by small independent presses. During this period his interest in British art began to embrace the contemporary. At home he had been surrounded by the paintings of his great aunt, Nina Hamnett, friend of Henri Gaudier-Brzeska, associate of the Omega Workshop and author of a celebrated book, *Laughing Torso*. It was natural, therefore, that Booth-Clibborn should collect publications by Paul Nash and people connected with Roger Fry, but the move into the field of contemporary collecting was perhaps less to be expected. The publications which interested him most,

however, were those put out by Coracle Press, located in Camberwell, London. Booth-Clibborn would visit their exhibitions and buy their artists' books and remembers Hamish Fulton's and Richard Long's as being among the most important. What struck him in particular was the notion of a collaboration between the artist, the printer and the publisher in the making of an object. Coracle also had an outlet at Kettle's Yard Gallery, Cambridge where Booth-Clibborn could indulge his tastes for early modern and contemporary British art simultaneously. It was British art above all that he found exciting.

In some respects Coracle was in a field of its own. Working on a tight budget it found a way of preserving a sense of intimacy between the artist and the public, of creating a private relationship in unobtrusive surroundings. Everything about Coracle was domestic in scale from its shop-front gallery to its home-made, cottage industry publications. While West-End galleries were becoming increasingly imperialistic and grandiose, Coracle showed an alternative way of promoting art which, while not avoiding the need for a certain commercialism in order to survive, nevertheless did not foreground it. Above all Coracle demonstrated the possibility of working with a number of different artists in many different ways. Ultimately, however, its publications proved to be too ephemeral and small-scale for Booth-Clibborn's taste.

A gallery closer to Booth-Clibborn's student patch than Coracle was Graeme Murray's in Edinburgh. Like Coracle, Murray exhibited the work of Ian Hamilton-Finlay from whom Booth-Clibborn commissioned a bookplate in 1984. His choice of a Scottish artist was an indication of the direction in which he was to launch his business on leaving university in 1986.

The previous year, 1985, proved to be a watershed for Booth-Clibborn. Armed with a copy of Sandro Chia's *Bestiary* (fig.7), he trailed around New York introducing himself to curators and dealers on the pretext of trying to sell it, while at the same time picking their brains about publishing limited edition books. There is an amusing resemblance between Booth-Clibborn's adventures and the beginning of those of Hockney's Rake (fig.8).

Booth-Clibborn had seen the Chia book during a stay in Rome over the Christmas period

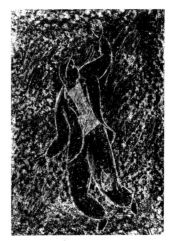

fig.7 Sandro Chia, *The Mole* (plate 1 of *Bestiary*), 1980. Lithograph. Private collection.

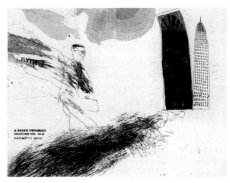

fig.8 David Hockney, *The Arrival* (plate 1 of *A Rake's Progress*), 1961–63. Etching and aquatint. Collection Tate Gallery, London.

of 1983–84. An artist friend, knowing of his interest in books and contemporary art, had taken him to the studio of Romolo Bulla, a printer and typographer who had published small books and portfolios by the young Italian Transavantgarde, with whose works Booth-Clibborn had become familiar through the pages of art magazines such as *Artscribe*. He enjoyed these productions, although he found in them certain shortcomings, and was particularly impressed by the confidence and excitement generated by this Italian school. He purchased Chia's *Bestiary* in 1984 with money given to him for his twenty-first birthday.

The idea of the bestiary had already begun to interest him in the previous year so the Chia struck a chord. In New York he devoted time to researching the topic more thoroughly with a view to publishing a Scottish bestiary. At university he had recognised not only a distinctively Scottish sensibility in the 'local' contemporary art but a resurgence of energy and a certain national excitement equivalent to that generated by the Italian Transavantgarde. The combination of an interest in Scottish art and bestiaries led to his first publication.

From New York where he studied illustrated books and projects in the Museum of Modern Art and the New York Public Library, Booth-Clibborn's odyssey took him to the west coast, still with the Chia book under his arm, where he met with curators and librarians to discuss his publishing ambitions. He also made a brief visit to Crown Point Press and met Patrick Noyen of Arion Press, who showed him Jim Dine's illustrated book, *The Apocalypse*.

A Context for Publishing:
Britain and the USA

Back in Edinburgh Booth-Clibborn selected the *Critical Lines* exhibition at the Talbot Rice Art Gallery in January 1986, which consisted of contemporary graphics of a political nature. In April he and two friends organised the *New Art: New World* auction at Christie's in aid of famine relief in Africa and, in May, Adrian Wiszniewski began work on the first print for *The Scottish Bestiary*, George Mackay Brown having delivered his text for the book the month before. Somehow, in June, Booth-Clibborn found time to sit his final examinations.

The Scottish Bestiary (see pp.38–45), launched in grand style at the Banqueting Hall, Whitehall on 28 October 1986, marked the beginning of Booth-Clibborn's publishing venture. He had been impressed by one or two Scottish publications by William Johnstone but realised there had been little printmaking activity in the area since the war, in spite of the availability of such excellent printing workshops and studios as Peacock Printmakers in Aberdeen. By contrast he was well aware of the revitalisation of English printmaking, which had begun in the late 1950s with Robert Erskine's publishing programme at St George's Gallery, and which really took off in the 1960s and 1970s. Kelpra Studio, under Chris Prater, had encouraged artists such as Hamilton, Paolozzi, Tilson and Kitaj to develop printmaking skills using modern technology, while Editions Alecto and then Petersburg Press, through an exciting publishing programme in all media, exploited this renaissance to the full. For the first time ever it could be said that there were publishing houses and printers capable of rivaling the great French printer-publishers. Galleries also joined the rush into print including Waddington, which confined its publications to its stable of artists – Waddington promoted Pop Art at the time and, through the efforts of Alan Cristea, published many important prints – and Bernard Jacobson who took a wider view of the field. By the time Booth-Clibborn emerged on the scene in the late 1980s, however, activity had died down. Editions Alecto had ceased to publish original prints, Petersburg Press was in liquidation, Jacobson had slowed down his programme and Waddington maintained its policy of publishing only artists whose unique works they sold. There was a diminished amount of serious publishing activity in Britain.

The history of print publishing in the USA had a similar rhythm. Although there had been a flourishing tradition of printmaking among the Regionalist artists as well as among those who had come into contact with the work of S.W. Hayter, who had moved his workshop from Paris to New York during the war, their productions were usually self-financed and published privately. In the late 1950s, however, print publishing began to take off. The founding of Universal Limited Art Editions (1957), Tamarind Workshop (1960), Crown Point

Press (1962) and Gemini GEL (1966) stimulated an increased interest among artists to explore the medium of print. Few artists had been attracted to printmaking among the earlier generation of Abstract Expressionists, partly because in America, as in Europe, printmaking was considered to be a reproductive media. It was extremely common in Europe for the painting of an artist to be copied by a printmaker and marketed as an 'original' print. Furthermore, the spontaneous, gestural quality of Abstract Expressionism made the rather slow, cumulative process of making a print seem unattractive and irrelevant to these artists. There was also, however, a strong European tradition of the *peintre-graveur* and it was the possibility of working directly with artists that interested the founders of these new organisations. The formation of these new printing houses was in some senses European in origin; Tatyana Grossman, the founder of ULAE, was Russian by birth and had spent eight years in Paris in the 1930s; June Wayne, who set up Tamarind Workshop, had trained in Paris; Kathan Brown, who established Crown Point Press, had trained at the Slade in London. Ken Tyler, one of the founders of Gemini, started out at Tamarind.

Robert Rauschenberg, Jasper Johns, Barnett Newman and Larry Rivers were among the first wave of American artists to take up the challenge of making prints while Roy Lichtenstein, Ellsworth Kelly, Claes Oldenburg and Andy Warhol followed on (Kelly, as well as Sam Francis, had previously made prints in Europe). There was an astonishing surge of activity which led to an expansion of the market and an ever increasing number of new publishers. Among the most important of those was Parasol Press, which was responsible in the 1970s for publishing some of the most distinguished portfolios of prints to have come out of the USA. Agnes Martin's *On a Clear Day*, Brice Marden's *Ten Days*, *Five Plates* (fig.9) and *Five Threes*, Robert Ryman's *Six Aquatints* and *Seven Aquatints*, Robert Mangold's *Seven Aquatints* and almost all of Sol LeWitt's etchings until 1980 were among the many key works it financed. Parasol was an early model for Booth-Clibborn's Paragon Press because unlike ULAE, Tamarind and Gemini, it was not a printing house but commissioned work from Crown Point Press, which specialised

in etching. Bob Feldman, director of Parasol, would book time with Kathan Brown and send his artists to work on a project at her workshop in Oakland, California. Although he used Crown Point Press with regularity he was not tied to it. Thus artists, like Richard Estes, who did not want to make etchings, could work elsewhere. More important, perhaps, was the encouragement he gave to his artists to create suites rather than individual works. While ULAE, notwithstanding Grossman's founding intention to publish illustrated books, tended to concentrate upon the single print – Rivers's and O'Hara's *Stones*, Newman's *Cantos*, Johns's *0–9* and Motherwell's *A la Pintura* were among notable early exceptions – Parasol favoured the portfolio. The artists were given an entirely free hand, although Feldman reserved the right not to publish if he felt there was too great a commercial risk. In the event, in spite of their outstanding quality they did not sell well; his largest market was in Europe, especially among museums. Only in recent years have these publications begun to be widely recognised as masterpieces.

Another publisher with a close resemblance to Paragon Press is Peter Blum, again principally a publisher of projects and portfolios and, like Parasol, not tied to any particular press. Blum, who is of European origin, was not known to Booth-Clibborn when the latter launched his business but their interests are reasonably similar. With offices in Zürich and New York Blum works with artists from Europe and the USA. He has published Cucchi, Clemente, Disler and Trockel among Europeans and Kruger (fig.10), Borofsky and Marden among American artists. Most recently he published a portfolio with Louise Bourgeois who, in spite of living in the USA for decades, approaches printmaking in an unmistakably European manner.

Booth-Clibborn first met Blum at the Basel art fair in 1987 and was particularly struck by the Kruger portfolio, a set of nine screenprinted photographic images each bearing a printed word. When read in sequence the words form the sentence 'we will no longer be seen and not heard'. Booth-Clibborn was impressed by the coherence and visual impact of word and image and by the integrity and cohesion of the project. It formed a compelling whole. He had already published *The Scottish Bestiary*, a collection of images by a wide range of Scottish artists, but

fig.9 Brice Marden, *Untitled (d)* (from *Five Plates*), 1973. Etching and aquatint. Collection Tate Gallery, London.

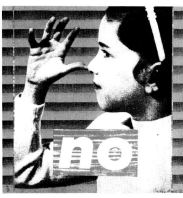

fig.10 Barbara Kruger, *No* (plate 3 from *Untitled*), 1985. Lithograph and screenprint. Collection Tate Gallery, London.

within a short time of the appearance of that publication he had formulated the view that the history of significant prints in the twentieth century was essentially the history of illustrated books and portfolios. From that moment onwards, and possibly encouraged by the example of Blum, Booth-Clibborn began to concentrate on portfolios by single artists. To do this and survive he needed to learn by the example of others. He knew that he had to print in small editions because demand would be low and it was necessary to maintain a high value. He also recognised that it would be a disadvantage to be tied to a print workshop. By declining to take this path he could not only restrict his overheads but choose his printers according to the needs of the artist and the project. The artist would have total freedom of choice of technique and technicians. Furthermore he realised that his job was not so much commissioning a specific work but enabling an artist to work in a chosen medium in the manner which suited him best.

Booth-Clibborn's choice of artist was also strategic. Initially he capitalised on the resurgence of Scottish painting and commisioned works from Scottish artists. He knew the Edinburgh and Glasgow scenes well from his university days and recognised a literary vein in their work which he felt would translate well into print and which, with his own background of book collecting, had an obvious appeal. It was not until he had published a number of projects that he began to commission work from English artists. In addition to his belief in the strength of contemporary British art, he also was aware of the need to establish an identity for his Press and to be near to the print workshop to deal with the production issues. One of the most important aspects of his publishing programme has been his ability to form a close relationship with his artists, so that a real understanding is achieved between them.

From his study of the history of prints of this century he had concluded that most important artists make only one or two significant projects, which tend to occur in mid-career. He regarded Johns's collaboration with Beckett, *Foirades/Fizzles* (fig.11), and Motherwell's *A la Pintura* (fig.12) as prime examples. In his view the ideas and approach of the mature artist are more resolved and confident than those of an artist at the outset of his career and, by the time an artist has reached mid career, he will have more time to devote to a print project, which may be materially unrewarding and lacking in potential for celebrity. Thus Booth-Clibborn generally chooses to work with artists from a generation older than his own. While there is an element of safety in such a choice, the gap in generations permits him to take a more detached and critical view of their work.

A print project for Booth-Clibborn is something of an academic activity involving research, exploration and reappraisal and is not something to be rushed. Whereas Parasol Press would book a finite and limited amount of time on the presses of Crown Point Press – Marden's *Ten Days* takes its title from the period he spent in Oakland on his first visit – Booth-Clibborn imposes no time restrictions but allows his artists to establish the rhythm and pace according to their needs. He generally chooses to work with artists who have little or no post art school experience of printmaking because they arrive with fewer preconceptions. For such an artist the first period of a project is spent in acquainting himself with the medium and there is no pressure to publish the results. Antony Gormley, for example, completed four sets of prints before he finally arrived at a suite which he felt able to release.

Paragon Portfolios

Christopher Le Brun was given similar latitude. Prior to working with Booth-Clibborn, Le Brun had made two etchings at the Slade and one funded by a Gulbenkian award. His exposure to printmaking was therefore minimal. He had also made monotypes with Garner Tullis in Santa Monica. In the case of the Gulbenkian print, Le Brun felt restricted by the time limit imposed by financial constraints; when working with Tullis he felt pressured by Tullis to work fast.

When Booth-Clibborn approached Le Brun he suggested that lithography might be suited to him and, knowing that he was unfamiliar with the medium, he placed him under no time constraint whatsoever. Booth-Clibborn made it clear that if any publication were to emerge it would have to be a unified project rather than a single print but that there was no need to embark with a particular project in mind. Thus Le Brun set out merely with the intention of

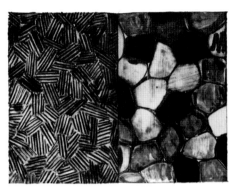

fig.11 Jasper Johns, *Untitled* (from *Foirades/Fizzles*), 1976. Etching and aquatint. Private Collection.

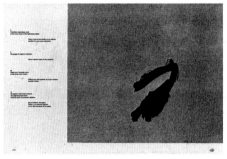

fig.12 Robert Motherwell, *Red 8–11* (from *A la Pintura*), 1968–72. Aquatint and letterpress. Private Collection.

learning about lithography in an unpressured situation. As far as Booth-Clibborn was concerned he simply hoped that something good would result. It was a gamble but with fairly short odds.

In the event a set of lithographs was published. Le Brun drew the images, destroyed and reworked them in the manner in which he was accustomed when painting. However, whereas in a painting he could rely on a depth of paint to indicate the history of the work and to obscure the preceding image, in lithography it was harder to retain the sense of history. As a planographic process lithography is less suited to layering than is etching and Le Brun came to realise this fairly quickly. His next project was to be in intaglio. Le Brun rarely makes drawings and tends to paint directly. His paintings of the 1980s were made by applying one image on top of another, drawing the image in and out of the paint, thereby systematically covering and destroying the previous image until he arrived at a final 'state' which satisfied him. In this respect his approach to painting was that of a printmaker. Towards the end of the decade he was becoming increasingly disatisfied with and nervous of relying on the burial of images to achieve the desired end. Indeed the images he destroyed were in themselves perfectly valid subjects for painting and he wanted to find a way to retain them. Etching was the ideal medium because it is essentially a medium which permits the artist to work in transparent layers.

Le Brun had not predicted that his project would be so extensive when he started out at the Hope Sufferance studios which, having made a number of studio visits with Booth-Clibborn, he had chosen in preference to others. Indeed, as with the lithographic project, Booth-Clibborn simply provided the time and the means to become acquainted with the medium. Le Brun tried out various plate sizes but found he was most comfortable with a small one. Working on the plates in groups, he began to draw the images which had not survived in his paintings. The etching series enabled him to show these images, to test them without the need to question whether they had sufficient authority to carry a painting. The concept of a series came naturally for every image was capable of being worked in a different way. The series, therefore, was determined by an inner logic and necessity. Booth-Clibborn's role was

to provide encouragement, a little gentle direction and some discreet editing but in essence the artist was allowed to determine the boundaries and extent of the project.

Fifty Etchings (see pp.138–143), as the series became known, is a sequential narrative of images which relates the story of their making and highlights the process by which an etching is made. The etchings are concerned with the notion of veiling and unveiling, revealing and layering, image-making and mark-making and the tensions between them all. There is a clear structure to the sequence in which they were made and published. The prints are not a random series of experiments. It was not surprising, therefore, that Le Brun should have wanted to reproduce them in a book, for he realised that the only way to understand the full implications of his achievement was to study them close up. Indeed, two bound volumes of the prints themselves were made up so that he could replicate this experience with the actual works. By restricting the number of images that he could view at any one time, Le Brun was able to concentrate on the individual differences between each print and regain the intimacy he had experienced while working on the plate. The series thus became an album, an object to study rather than an image to be displayed, a sequence of pages to 'read'.

As a result of exploring a range of images through etching Le Brun felt a greater freedom of expression in his paintings, in particular a freedom to make an image and retain it. He has found that painting and etching are complementary activities, of equal status, which may feed off each other. He has demonstrated this most clearly in his recent series of *Wagner* prints (see pp.146–149) which he used as a means to resolve problems in his paintings of the same theme. Encountering difficulties with the paintings he had them photographed and transferred to plates by means of photogravure. After proofing the images he saw they were too flat and realised that the problem lay with the paintings. He amended them and had them rephotographed and re-etched. Then he developed the prints and explored different possible solutions. As etchings the images are in reverse but for Le Brun this posed no problems. In order to satsify himself that a painting is resolved he often views it in a mirror. The mirror image allows him to see it afresh and has a dis-

tancing effect. The etchings do not replicate the paintings but employ them as spring-boards.

The overlap between painting and prints in Le Brun's work is commonly found in the work of many artists. Jasper Johns is perhaps the best known contemporary artist to explore similar images in graphics and painting, but it was Samuel Palmer (fig.13), whose work Le Brun studied intensively at the outset of the *Fifty Etchings* project, who showed him that an artist's prints could be of a quality and impact equal to, if not greater than, his paintings. Reading about Palmer's struggle to produce arguably some of the greatest printed images of the nineteenth century was not only a humbling experience but revelatory. Some years earlier Le Brun had visited the studio of the master-printer Ken Tyler in Bedford Village, New York and had been uncomfortable with what he perceived to be Tyler's emphasis on technology and colour printing. His study of Palmer demonstrated that the greatest prints could be produced by the most economical means. There is a certain Britishness in this high regard for understatement, but it is precisely this quality which Booth-Clibborn appears to recognise in his policy of promoting exclusively British art (perhaps more accurately English and Scottish). Economy of means but intensity of expression underlie his most successful publications. These are characteristics not only of Le Brun's etchings but of Bill Woodrow's linocuts in his recently released *The Periodic Table* (see pp.192–197).

Linocut is one of the most direct and simple methods of making prints. Once it is carved the block may be altered only with difficulty and there is no alchemical process in the plate-making and printing. What you print is what you see on the block. When Bill Woodrow approached Booth-Clibborn and proposed a project based on Primo Levi's autobiographical novel *The Periodic Table*, he realised that etching would be too time-consuming if he were to make one print for every chapter of the book. He opted for linocut because his memory of making one or two at art school led him to believe it would be easy. He also considered that he could achieve greater clarity with this medium and thus mirror the clarity he found in the book. It was only after he had cut the first block that he realised the physical effort required.

The structure of the book determined the structure and sequence of the portfolio. The book is not a straight-forward narrative but does evoke a sense of the passage of time. It is composed more or less as a series of discrete episodes linked by the presence of the author and the common theme of the elements of the periodic table, which form the background for each chapter. Woodrow adopted the episodic form and selected from each chapter an incident or moment which stood out. He did not depict the incident or moment overtly but created a series of symbols and signs to evoke and comment upon them. Although there is no obvious sequential link between the images, they each include the abbreviation of one of the elements. There is also a growing momentum, for cumulatively from first to last they suggest a sense of increasing Fascist oppression, culminating in the print with the symbol for 'Carbon' which depicts a point, a devastating and simple image of finality. The momentum is brought to an abrupt and poignant halt in this final print.

The blocks were carved in the order in which they were published. Each image was mapped out roughly on paper first and then drawn on to the block. There was a certain similarity of concept for Woodrow between making linocuts, in which the image emerges out of the block, and his earlier sculptures, which were cut out of discarded machines. In both cases Woodrow drew on the material before revealing or unravelling an image by cutting. There was a strong notion of sequentiality in both activities and also a sense of unanticipated discovery, of not quite knowing where he was going. Woodrow set out with the intention of making a series of flat sheets but by the time he had executed ten or eleven of them he wondered whether they could also be published in book form. As a book the images would be inseparable, would be seen in the sequence in which they were made and could be looked at privately. The experience would be different from viewing the portfolio which is more declarative. Booth-Clibborn agreed to making a book version but without reprinting Levi's text alongside, which would have been prohibitively expensive. Thus Woodrow's project, which was inspired by a book, ended as a book, indicating once again the essentially literary nature of portfolios.

Woodrow's *The Periodic Table* and Le Brun's *Fifty Etchings* are clearly narrative works.

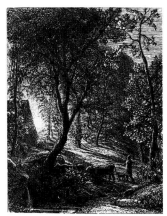

fig.13 Samuel Palmer, *The Herdsman's Cottage*, 1850. Etching. Collection National Gallery of Scotland, Edinburgh.

Fulton's *Fourteen Works* (see pp.86–91) and *Ten Toes Towards the Rainbow* (see pp.98–103) are series of images thematically linked but which do not recount a story or suggest the passage of time. Fulton has a history of publishing artist's books consisting of photographic images and word pieces or a combination of both. In these books the texts frequently replicate wall paintings while the photographic pages, usually combined with words, reproduce photo-text works. The publications, which are designed by Fulton, serve as mnemonics but they do not replicate the experience of an exhibition. Exhibited works are large scale, books are intimate; a book is read in private, an exhibition is viewed in public; in a book the reader may see only two pages at once; in an exhibition he can see a whole body of work together. Finally, in a book the size of the work is determined by the size of the page; works on the wall can vary in size.

One of the distinctive features of Fulton's publications with Paragon Press is the variety of paper sizes he employs within any one project. This is a clear indication that Fulton has made a project for display. Furthermore, although the portfolios have a unity derived from a common theme – the artist within nature – there is no narrative link between the prints. It is, rather, an exhibition in a box of individual items, portable and durable, unlike his wall works which are ephemeral and are destroyed at the end of each show. Each print is like a self-contained short story rather than a chapter. There is no obligation to show a portfolio in its entirety. Furthermore, a number of the texts he has printed, particularly in *Fourteen Works*, have previously appeared in books or as wall works. To pursue the literary analogy a little further, this portfolio is more of a lexicon or an index of Fulton's work than a novel.

Print is an ideal medium for Fulton who excludes autographic marks from his work and who dislikes the notion of uniqueness. Reproduction, mechanism and neutrality are at the heart of his work in which he recreates his experiences in nature. His large scale pieces are derived from notes taken while walking, which are rarely altered when transferred to the wall. He used a similar method in making *Fourteen Works*. There is, therefore, essentially little difference between this portfolio and the large text-pieces other than scale and support and the fact that the texts are printed and framed rather than painted directly onto the wall. In contrast to his books, however, the quality of the printing is such that the works have a greater physicality and presence.

Although Fulton's means of production is relatively neutral the end result is far from impersonal. Indeed his work may be situated within the British Romantic tradition stretching back to the eighteenth century. And although each image may stand alone there is a unity of intention and approach within each portfolio. The same cannot be said with quite such conviction of the *London* portfolio (see pp. 46–51) in which Booth-Clibborn brought together eleven London-based artists, all of whom had recently emerged, but who had only superficial similarities. Booth-Clibborn suggested that each artist should work with screenprint and many of them used photography as a starting point, which is central to their work in other media. To that extent the portfolio is unified through a particular medium which provides a veneer of community. If it has a less coherent 'literary' structure, it is nevertheless a barometer of a particular moment. The motivation for the portfolio was Booth-Clibborn's desire to work with artists of his own generation.

London amounts to a portable group show which permits the discovery of individual talents but somehow does not quite add up to a whole. With the exception of *The Scottish Bestiary*, it is the only group portfolio that Booth-Clibborn has published and it was to some extent driven by a need to seize a moment. In general, Booth-Clibborn has concentrated on one-artist projects because he considers the rapport he builds with the artist and the relationship forged between artist and printer over a period of time to be essential to the success of the work. Working with a number of different artists simultaneously inevitably requires different management skills and a different kind of involvement and level of intensity.

Booth-Clibborn has created a strong identity for his publishing house by concentrating on British artists. Those artists, by and large, have had little previous experience of printmaking. In his autobiography, *Souvenirs d'un marchand de tableaux*, Ambroise Vollard, publisher of Picasso's *Vollard Suite*, wrote: ' "Painter engraver" is a term that has been much abused, applied to professional engravers who were anything but painters. My idea was to order engravings from artists who were not professional engravers'.[**] With few exceptions, such as Victor Burgin, John Hilliard and Grenville Davey, Booth-Clibborn's artists have eschewed new technology and to that extent it could be argued that he has facilitated and encouraged the revival of the hand-made print. While his selection of middle generation artists may be unfashionable, his achievement is to have reinvigorated British printmaking in a serious and lasting way by selecting artists for whom, first and foremost, printmaking is about creating works of art with a strong visual impact.

* Thomas A Clark, 'The Gallery and the Book' in *The Coracle: Coracle Press Gallery 1975–1987*, exh. cat., London 1989, p.70.

** Ambroise Vollard, *Souvenirs d'un marchand de tableaux*, Paris 1937, p.305.

A Scottish Paragon *Duncan Macmillan*

Words and music as a couple seem natural. We take it for granted that they go together and they have given us our most universal art form, the song. Words and pictures suggest a less simple relationship. Both can convey information of a factual kind. Instinctively therefore, we feel that there is some overlap between them, perhaps some redundancy when they are brought together. Certainly they do not have the same natural complementarity. Rather we suppose one or the other must be the dominant partner. A picture has a title in words, but it is the picture that matters. A book has illustrations, but in that case it is the text of the book that is dominant. In print form, too, pictures in a series can do the same job as words in a book, so the artist's print was from the start a direct rival to the book. Pictures had always been able to present a theme, a story, or an idea without dependence on words, but because of the nature of the print they could, in addition, compete in what is regarded as the special competence of the printed book, its portability and its ability to circulate in large numbers.

The idea of the serial print is as old as print-making. Some of the very earliest and greatest prints, Dürer's *Apocalypse* (fig.1) for instance, were in this form. From Dürer onwards too, the print was the chosen vehicle of some of the greatest artists, Rembrandt, Hogarth, Blake and Goya (fig.2) for example. For the three latter artists, too, the serial printed image when it was allied with words was especially important because it promised to carry a particular kind of message from the artist out into the world and with the same extraordinary power of penetration as the printed book. Hogarth was uniquely successful in achieving this, but as he did so he made his images part of the common culture of all Europe. He was also unusual, however, in that his principal vehicle was the reproductive print, not the expressive, artist's print. Blake also believed passionately in the communicative power of the print and he sought to unite words and image indissolubly in a single form. He saw the etcher's acid as the imagination itself burning its meaning into the blank metal and he etched the words of his poetry and the images that illuminated it together on a single plate.

From Hogarth onwards, either with or without words for accompaniment, the series of prints was important in Britain, and at an early

date in Scotland too. The idea of the serial reproductive print was taken up by Gavin Hamilton first of all in the prints that he published of his paintings illustrating Homer, and Hamilton was followed among others by Flaxman whose engraved outline illustrations to Homer, Dante, Aeschylus and Hesiod were widely influential. In them the text was limited to the captions of the plates. A contemporary project, Josiah Boydell's *Shakespeare Gallery* was a huge, collaborative enterprise that also used reproductive engraving. It was undertaken by a publisher and involved a large number of artists. It was therefore the ultimate ancestor of Charles Booth-Clibborn's first project, *The Scottish Bestiary*.

Ironically, Blake's intention was to create, like Hogarth, a form that would be widely available, but instead he created something of exquisite beauty and rarity for the connoisseur. Since that time, this has tended to be the dominant characteristic of the artist's folio of prints – the 'livre d'artiste' – defined for the present purpose as a sequence of prints united by a common idea, or in illustration of a single text, or collection of texts, published like a book, but conceived as a work of art. Blake's *Book of Job* is one of the greatest of all serial print cycles, but in Scotland, David Allan's edition in 1788 of Allan Ramsay's *The Gentle Shepherd* (fig.3), following Piranesi's great folio publications of the preceding decades, was particularly close in spirit to the present projects. In his twelve, full-page, etched illustrations, Allan pioneered the use of aquatint of which the secret had been given to him by Paul Sandby who claimed, rightly or wrongly, to have invented the process. There is an equal balance between Allan's illustrations and Ramsay's text and the book was printed in large format by the Foulis Press which was notable for the quality of its production. This book is therefore an important early example of the collaboration of artist and publisher in the creation of something that combines the skills of artist, printer, binder, and even of the paper maker, in a cooperative, artistic production of the highest material quality.

Other early Scottish examples are the illustrated edition of the *Waverley Novels* that Cadell published as part of the effort to reconstruct Scott's fortunes and, following the example of Boydell's *Shakespeare Gallery*, it was among the first great illustrative projects

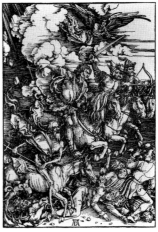

fig.1 Albrecht Dürer, *The Four Horsemen of the Apocalypse* (from *The Apocalypse*) 1498/1511. Wood engraving. Collection National Gallery of Scotland, Edinburgh.

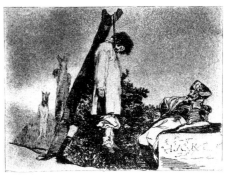

fig.2 Francisco José de Goya y Lucientes, *Tampoco* (plate 36 from *The Disasters of War*), 1873. Etching. Collection National Gallery of Scotland, Edinburgh.

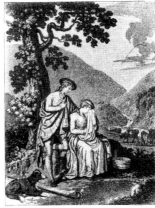

fig.3 David Allan, *Patie: 'My Peggy Why in Tears?'...* (from *The Gentle Shepherd*), 1788. Aquatint. Collection National Gallery of Scotland, Edinburgh.

to unite a large body of artists, but this, like Turner's extensive use of engraving in the printed book, opened the way for the immense success of the illustrated book in the nineteenth century. This is a rather different thing, however, from the true 'livre d'artiste'. It was relatively uncommon in Britain in the nineteenth century, though illustrated books did sometimes come close to it as in the Moxon *Tennyson* of 1855, for example. This was a high quality publication that united a number of the artists in the Pre-Raphaelite circle in a project to illustrate Tennyson's collected poetry. Later in the century, too, some of Aubrey Beardsley and Walter Crane's productions are also really more than conventional illustrated books. In Scotland, an important early example of the 'livre d'artiste', and following the pattern set by David Allan with the artist himself as executor, was the undertaking by David Scott of the illustration in 1837 of Coleridge's *Ancient Mariner* (fig.4) in a de luxe, folio-sized edition using etching and engraving with text limited to the captions in the manner of Flaxman's outlines. Such is the continuity of art, the result is in turn remarkably close to John Bellany's *Images Inspired by Ernest Hemingway's 'The Old Man and the Sea'* (see pp.54–59).

Not all these earlier books were simply artistic however. Some of the large folio scientific publications of the eighteenth century are remarkable as works of art and Edinburgh was a centre for their production. It was for that reason that Audubon came first to Edinburgh to have the plates of his *The Birds of America* (fig.5) engraved. The first (and best) plates were produced in Edinburgh by William Lizars but in the end he could not fulfil his contract for the surprisingly modern reason of a strike among his colourists. His book was a major inspiration to Booth-Clibborn as he planned his own first publication.

The true 'livre d'artiste', though it is published like a book, is really a multiple work of art, often of considerable complexity. In fact it is a kind of small, portable exhibition. The rituals of signing and numbering are all designed to establish its status as a work of art and if not its uniqueness, then at least its exclusivity. As its name implies, it really survived most strongly in France and in the twentieth century most of the great modernists have produced books of this kind.

Words are not a *sine qua non* of this kind of publication though a 'text' in the broader sense of that word is an essential, that is to say a stated theme which unites the images and, so united, gives them a meaning which depends on the way that they relate to it and to each other. Actual words are absent from a good many of the present folios, but this idea of the unity of a formal structure, or shared theme however loose, whether or not they use a written text, is common to them all. Like a book they have a title, and like a book too, the binding is an important part of the presentation. Indeed the material appearance is a definitive characteristic of the folios that are presented here and they could as well be described in terms of their making as of their content. They are all the product of teamwork, masterminded by the publisher and often of extraordinary complexity. The complete edition of Ken Currie's *Story from Glasgow* (see pp.68–73) for instance involved printing by hand 10,000 separate linocuts. The prints in the folio edition all had to be signed and numbered too! With such a production therefore, the idea of the limited edition is not a convenient commercial fiction to enhance value, but a real reflection of the practical constraints of such a complex project, and in recent times, the dominant – though by no means the only – interest of the artist's print folio has been the way in which it combines so many skills into a complex product of the highest refinement.

Through the Paragon Press, Booth-Clibborn has published altogether thirty-five print folios of this kind. They include work by a wide range of artists, but there are several reasons for looking separately at the Scottish projects among them. To start with the whole thing began in Scotland. Booth-Clibborn tells how his interest in the production – and crucially the publication – of such folios of prints and text was stimulated when he was a student at Edinburgh University by the two series of lithographs that William Johnstone produced – when he was himself in his seventies – to poems by Hugh MacDiarmid in 1977 and Edwin Muir in 1981 (fig.6). Booth-Clibborn studied these in the National Library of Scotland. They are remarkable, for what Johnstone did was not to produce conventional illustration, but to make a series of abstract ink drawings of dramatic simplicity that complement the texts in an

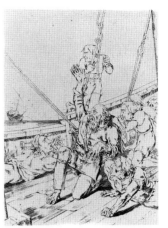

fig.4 David Scott, *The Spectre-Ship Approaches* (from *The Rime of The Ancient Mariner*), 1837. Engraving. Collection National Gallery of Scotland, Edinburgh.

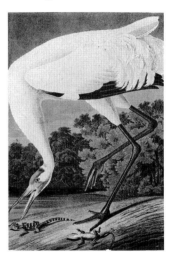

fig.5 John James Audubon, *Hooping Crane* (from *The Birds of America*), 1827–38. Hand-coloured etching. Formerly University of Edinburgh collection.

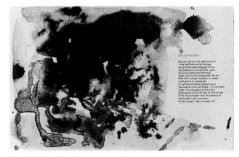

fig.6 *The Confirmation* (from *Lithographs by William Johnstone with Poems by Edwin Muir*), 1981. Collection Scottish National Gallery of Modern Art, Edinburgh.

entirely autonomous way. Ian McKeever's woodcuts to Tom Clark's poems in *that which appears* (see pp.160–165) are the closest to this in the present collection. Johnstone's projects were followed in 1983–85 by three similar, though smaller projects in which John Bellany collaborated with Alan Bold in suites of etchings to poetry by Bold (fig.7). Bold himself has also made something of a speciality of illuminating his own poetry.

Johnstone's two and Bellany's three series were printed at the Edinburgh Printmakers' Workshop. This is another Scottish dimension to the present projects, for these cooperative workshops meant that high levels of printmaking skill were readily available in Scotland and it was to them that Booth-Clibborn turned with his first project, *The Scottish Bestiary*. Edinburgh Printmakers' Workshop, founded in 1973, was the first of the Scottish workshops to be established, though it was followed shortly afterwards by the Printmakers' Studio in Glasgow and Peacock Printmakers in Aberdeen. Johnstone's series were among the Edinburgh Printmakers' most ambitious early projects.

Another Scottish example that was important to Booth-Clibborn was Ian Hamilton Finlay who had been producing high quality publications from the Wild Hawthorn Press for a good many years by the time Booth-Clibborn commissioned a bookplate from him in 1984. Finlay's standards of typography and production were of the very highest, nevertheless he always eschewed the variability and uncertainty which goes with the expressive strength of most artists' print media. It was in this area of artistic adventure that Booth-Clibborn himself wanted to work, however, and it was first of all his interest in the artist's print that inspired him to embark on *The Scottish Bestiary*. This was even before he had graduated from Edinburgh University and it is still among the most ambitious projects that he has undertaken.

The idea of the *Bestiary* was for a series of prints with a text and the text was the first thing to be commissioned. After considering several contemporary poets for this, Booth-Clibborn chose George Mackay Brown. The resulting collection of poems presents a distinctly Orcadian set of beasts and to those already chosen, Mackay Brown added two specifically Orcadian mythic creatures, the nuckelavee and the stoor-worm. From the range of artists

whom Booth-Clibborn considered, he ended up commissioning seven to produce between them twenty plates. The whole edition eventually involved two and a half thousand large-scale prints variously in etching, woodcut, screenprint and lithography. It was pretty ambitious for an undergraduate and as it involved a huge outlay, it involved a big risk which with his characteristic enthusiasm and persuasiveness Booth-Clibborn persuaded some of the others involved to share. His philosophy was that if he wanted to make anything of his ambition as a print publisher, he had to start at the top and not at the bottom in the vain hope that he would eventually work his way up. Life is too short to hang around, he reckoned. In the end it was such an imaginative project carried through so well that it paid for itself very quickly.

One of the most important factors in the genesis of this project was the rising fashion for figurative painting in the early eighties. Booth-Clibborn had acquired a bestiary by the Italian, Sandro Chia, in 1984 and Chia was one of the fashionable lions of this movement. In Glasgow, Steven Campbell was responding to Chia among others in the dramatic, figurative work that he produced when he was still a student in 1980–81. Campbell's success was a major stimulus for his contemporaries in Glasgow School of Art, especially Ken Currie, Peter Howson and Adrian Wiszniewski, all three of whom have since carried out projects for Booth-Clibborn. Behind this activity among the younger painters, however, there stood an older generation that was equally committed. Sandy Moffat teaching at Glasgow was the main transmitter of the ideals by which he had been inspired along with John Bellany and a few others in the early sixties. Together they had championed a more vigorous belief in the importance of the great tradition of figurative painting as the vehicle, not for academic picture making, but for the expression of human concern.

This kind of figurative art need not be simply narrative in the sense that it tells a story, or that it stands in the world of images for something that is recognisably its equivalent in the perceived world of experience. It does, however, open the way for art to carry something that it is possible to relate imaginatively to the kind of meaning – better perhaps the quality of meaning – that is familiar and acceptable in poetry.

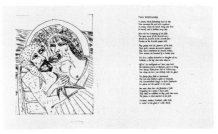

fig.7 John Bellany and Alan Bold, *Two Scotlands* (from *Homage to MacDiarmid*), 1985. Etching and letterpress. Collection Scottish National Gallery of Modern Art, Edinburgh.

It is here that the genesis of Booth-Clibborn's first project can be seen to belong very much in this particular time and place – Scotland in the early eighties. Indeed, the main unifying factor of Booth-Clibborn's Scottish projects since then has been his loyalty to this group of artists and their particular approach to imagery. It often ranges a long way from any conventional idea of narrative, but it does work with recognisable symbols and images. In this way, Will Maclean, though he is not a figurative artist in a simple sense, belongs naturally in this group. He also parallels Bellany in a number of other ways, particularly in the importance in his work of the imagery of fishing and the sea. Even Alan Davie, though he is not a figurative painter, belongs as a kind of friendly uncle for he was an important inspiration to Bellany at the start and in the last two decades his art has incorporated a wide range of symbolic images.

In *The Scottish Bestiary*, Booth-Clibborn eventually employed Bellany, Campbell, Howson and Wiszniewski from this group. In addition to these four, he wanted to extend the team to include other artists from both Edinburgh and Glasgow and so June Redfern was brought in. Her approach to figurative painting was directly influenced by the German painter Baselitz who was a similar figure in a way to Bellany. Jack Knox was older, but as head of painting in Glasgow School of Art he was close to the younger painters. Bruce McLean was an outsider in a way, but the results proved him an appropriate choice.

The bestiary itself is a medieval form, though there had been a number of twentieth-century examples before this one, all of which Booth-Clibborn had studied. The attraction of the bestiary is that although it was always nominally factual, in its origins it stems from a time when the modern distinction between what is imaginative and what is fact did not hold. In a society dominated by its belief in the supremacy of fact, we too easily forget that information at the imaginative, emblematic level can be just as potent and 'useful' as information of a more prosaic kind. If we should indeed have lost sight of that fact, George Mackay Brown restates it for us explicitly in his poem the *Stoor-worm*. In the poem, this fearsome beast is eventually conquered by a boy using only his imagination.

The great strength of this kind of collaborative production is that it can move into the realm where we are not bound either to word or to image, but that the imagination is free to move in a space between them. Indeed, in the *Bestiary*, the relationship between text and image is pretty semi-detached, but this creates a free moving dialogue with the kind of perspective that comes from two points of view, from binocular vision. For example, Bellany's *Eagle* reflects the human aspiration striving to rise above the drudgery of agricultural toil, the implicit message of Mackay Brown's poem. McLean's *Salmon* reveals the sexual imperative that impels the salmon to leap the waterfall also drawing on elements that are present in the poem, but which are not explicit.

Booth-Clibborn felt it was important that there was no surviving Scottish bestiary from the medieval period, though it is inconceivable that one never existed. The animal imagery of the Picts is one of the glories of European art and it depended on a stock of images that must once have been transmitted in this form, not only throughout Pictland but beyond and which in turn exchanged inspiration with the animal imagery of the Vikings and the Celts. George Mackay Brown's poetry is largely set in the time when such things existed. By this imaginative transposition, the poet gives us back the inventive freedom that gave life to the images of the Picts or the Vikings. Indeed, his dragon is the dragon of the Viking ships and specifically invokes the dragon scratched on the wall of Maes Howe amongst the extraordinary Viking graffiti there, while his lion is an imaginary original of that familiar heraldic beast, the rampant lion of Scotland. The artists have responded to this special imaginative quality of the texts in different ways. Indeed, their responses cover most of the approaches to the text-picture relationship seen in the rest of these Scottish folios.

Steven Campbell opens the *Bestiary* with an image that puts the Scot himself into the book. It is a figure doing a sword dance over flaming swords, rendered in stark, dramatic woodcut. The series closes with an equally vivid evocation of the *Lobster* by Campbell in the same medium. There is of course no text at all for Campbell's image of the dancing Scotsman, but when it comes to illustrating the actual poems, though Campbell's *Lobster* is only

loosely inspired, if at all, by Mackay Brown's text, some of the artists, like Peter Howson in the *Fieldmouse* (fig.8) and the *Moth* for instance, have been pretty faithful to them. In the *Stag*, though, Howson himself has also been more oblique. He contrasts its freedom on the hillside and the freedom of the natural world that is its habitat, as Mackay Brown evoked them, to its eventual fate. It is doomed at the hand of the hunter and ends as a trophy adorning a squalid, city pub. Jack Knox too has interpreted the poet's imagery with a straight-forward equivalent in his strong and simple drawings of the hunted *Whale* – Orc the namesake beast of Orkney – Columba's *Dove*, and even the grotesque and terrifying, mythic *Nuckelavee*.

Bruce McLean and June Redfern have chosen apparently simple forms which never-theless open out the imagery of the poems that they illustrate. Thus in Redfern's *Wolf*, the flow of her wash invokes both the shape of the wolf's head and its 'great smoking tongue… the kiss of peace' which is such an important part of the image in the poem and is its con-clusion as the wolf evolves into the dog and becomes the friend of men. The gold of Redfern's *Lion* merges with the landscape of the African desert shore where in Mackay Brown's poem, the sailor, Fergus, is wrecked and from which he brings the royal beast back to Scotland. In the *Seal*, the ambiguity of the image allows Redfern to present the seal in the process of metamorphosis into the silkie, the legendary seal-woman.

George Mackay Brown writes of the salmon leaping: 'This prince of the waters hurls him-self against the challenging trumpets of a water-fall.' Bruce McLean takes this text, but, as we have seen, he uses the female form in a reduced black and white linear image to personify the waterfall that the salmon leaps, suggesting a Naiad, a water nymph perhaps, but also the sexual drive of the salmon. The same female form placed alongside a wriggling worm sug-gests the primeval, phallic imagery of the *Stoor-worm*. For the *Spider*, McLean suggests the psychological force of the tale of his namesake Bruce and the spider by making an analogy between the *Spider's* form and the frown of the king's perplexity. The stark simplicity of these images matches the emblematic quality of the poems.

Adrian Wiszniewski likewise responds to the ancient, sexual imagery in the mythic beast, the *Unicorn*, turning it into a beautiful, naked boy, young enough, but erotically self-aware. The *Dragon* (fig.9) in his hands seems sexual, too.It is almost a pet as he describes it, but it nevertheless suggests the dark link between destructive violence and sexuality that seems always to be ready to awaken in the male, even in boyhood innocence. Wiszniewski's *Raven* on the other hand is more simply poetic. It sug-gests the enduring potency of the raven as an image by making a link to Edgar Allan Poe's bird of ill omen from Mackay Brown's raven that leads the Vikings to land from the wilder-ness of the deep.

The most complex images in the book are John Bellany's *Wildcat*, *Eagle*, and *Capercaillie*. The image of the *Wildcat* is perhaps inspired initially by one of the lines in Mackay Brown's prose-poem where the Scottish wildcat, in whose voice it is written, dismisses the domes-tic cat as effete: 'I expect the Romans took them here, in ships, to keep their ladies from being bored,' he remarks scornfully. Bellany has com-bined the suggestion of a lady in a boat with other elements of the imagery in the poem with real imagination to create a sinister and sexually ambivalent figure, standing in a boat which is called appropriately the *Wildcat*. 'Poet and moon and cat are all kin,' writes the poet and the moon hangs in the sky behind, exploiting Mackay Brown's conjunction to open the iden-tity of the image towards the poet, or even the bisexual seer, Tiresias.

The *Grouse* was to have been one of Bellany's images, but he chose instead to portray its larg-er, woodland cousin, the *Capercallie*. This was partly because he thinks that the capercaillie is a far more impressive bird, but there was also a personal reason. He had painted a picture called the *Capercaillie Sings his Love Song* in which the bird is a kind of emblematic self-portrait, but then in 1985 both his father and his second wife, Juliet, had died. In this plate the image is a reflection on these sad losses. The bird can no longer sing its love song and the plate is inscribed instead 'the Capercaillie sings his lament'. The bird calls sadly over a pros-trate, lifeless creature at its feet.

The *Capercaillie* is an appropriate reminder of the autonomy of the image in such a work and of the way that it is enriched by this imagi-

fig.8 Peter Howson working on the screenprint *Fieldmouse* for *The Scottish Bestiary*, June 1986.

fig.9 Adrian Wiszniewski working on the lithograph *Dragon* for *The Scottish Bestiary*, May 1986.

native freedom. In his *Eagle* on the other hand, Bellany once again enlarges directly on the imagery in the poem. There, an infant boy, like Ganymede stolen by an eagle, is rescued by his mother, but when he is safely returned, his grandfather wonders if it had not been better for him to enjoy the freedom of 'rock and cloud / A guest / In the house of the king of birds' than to suffer the human fate: 'Ten thousand brutish days / Yoked with clay and sea-slime.' Bellany in a metamorphic image of boy/eagle personifies the nobility of this aspiration.

Given the success of Bellany's contribution to the *Bestiary*, it was appropriate that Booth-Clibborn's next Scottish project, and one of the finest of them all, should have been with him. Bellany had already thought of Hemingway's short novel of almost mythic character, *The Old Man and the Sea*, as a source of inspiration twenty years before when he was using direct, almost narrative imagery of the lives of the fishermen of his own community. Like Hemingway, too, through this imagery he tried to make some kind of universal statement. Whether or not it does so consciously, Hemingway's novel does not simply tell a story. It also sets out in allegorical form the existentialist world view. This is pessimistic because it is circular, for if we are only defined by our actions, no matter how heroic, then the world that we create for ourselves is ultimately pointless for our actions can have no impact beyond this self-definition. In spite of all his heroic endurance, all that the old man brought home with him was the useless skeleton of his great fish. This is similar to the predicament that Camus described so luminously in *L'Etranger* and at the time he made these prints, Bellany himself also felt it very acutely in terms of his own life.

In the folio, the novel is taken as read. Its full title is *Images inspired by Ernest Hemingway's 'The Old Man and the Sea'*. No text is included, nor are the plates illustrations in the sense that they follow the narrative or are arranged in a particular order. In them, nevertheless, it is clear that the artist has reflected closely on the novel and identified directly with its theme. He remarked that the old man could almost have been his own father, but the existentialist theme also echoed his own life. This deeply felt series of images was made over a relatively

short period of time when he was mortally ill. His life was saved soon after by a liver transplant. It is easy to see how Hemingway's story could have had a special poignancy for him as he confronted his own mortality so directly.

Part of the story concerns the ultimate futility of a man's quest for the greatest prize, futile though utterly heroic and the last great effort and ambition of his life, but Hemingway redeems the futility of the existentialist circle – the pointlessness of the actions that give us point – through the character of the boy. The boy who is devoted to the old man represents the power of love to break that circle and in turn, as the old man's pupil, he lends purpose to his experience by allowing him to pass it on. It is this also that gives point to Bellany's series for by turning it into art, he too can pass on his experience, just as Blake does in his *Book of Job*. In the twentieth plate (fig.10), Job who is also Blake, just as Bellany is also the old man, turns the lessons of his experience into art and passes it on to his children. Bellany, who represents the boy as a young man, modelled him on a compound of two of his own children.

Although the series has no narrative sequence, an etched portrait of the old man, set in a frame behind a low wall or shelf in the manner of Van Eyck or Bellini, was originally intended as a kind of frontispiece. As in such quattrocento models, too, there is an inscription beneath the portrait. This is the title of the novel. Seen as a frontispiece, this image does establish the feeling of the whole series for it too is really a kind of portrait. It was clearly the old man's character and his endurance that interested Bellany most. Four times Bellany returns to the portrait of the old man, conveying his suffering and his loneliness. Three of these portraits are in the vivid colours of silkscreen. In one, the old man is depicted against the sea, head in hands, the useless skeleton of a fish in front of him, suggesting symmetry with the end of the story when he returns to harbour, his great catch no more than a skeleton picked clean by the predators of the sea. This plate is labelled 'The Trough of Despond' and a likeness to the artist in the old man's face makes clear that here it is the artist himself who speaks to us. Indeed, Hemingway uses no such phrase. On the contrary, the old man remarks at one point 'a man can be destroyed, but not defeated.' Bellany through drink had almost destroyed

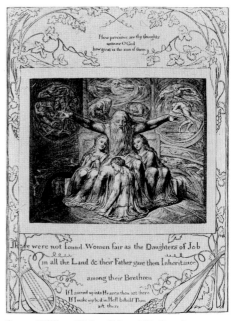

fig.10 William Blake, *Job and his Daughters* (plate 20 of *The Book of Job*) 1825. Engraving. Collection National Gallery of Scotland, Edinburgh.

himself. In another of these portraits, the man is shown against the intense blue of the sea, his eyes burnt white by the sustained ferocity of days of tropical sun in an open boat. The fisherman-artist has a bird sitting on his hat. In the novel an exhausted land-bird settles on the taut fishing line as the great fish pulls the boat, but by perching the bird on the man's head, Bellany suggests how he has become as much a passive part of the environment that he shares with the birds as an old sea-worn post.

Of the fourteen plates, only these three and one other are screenprints, the remainder are in the black line of etching which Bellany handles with great mastery. In several of them instead of the etching needle, however, he uses a crayon line which achieves the intense black of aquatint, but with the controlled line of drawing. After the four portraits, these images are all narrative in the way that they relate to the text, though they do not follow its structure. Only one belongs to the beginning of the story. It establishes the old man's relationship with the boy as he eats the food the boy has brought him. Another shows his memory of the epic bout of arm-wrestling that won him the title of El Campion. Five more show the man at sea. In one he is baiting a line to catch a fish to eat and then in another he is holding a fish in his hand as he eats it with the line round him. In another he is shown with his hands raised in prayer – though he never actually prays, he proposes to. An image that stands out among these, however, is the fourth screenprint. Brilliant in colour, it is well judged in its impact for it shows the climactic moment when the fish leaps for the first time, revealing its enormous size as it soars above the boat – two feet longer than his skiff the old man reckoned.

Bellany has taken the colours of this image from the text when the old man sees the fish for the first time: 'He came out unendingly and water poured from his sides. He was bright in the sun and his head and back were dark purple and in the sun his sides showed wide and a light lavender.' In this plate as the fish looms over the boat, sea and sky are permeated by the purples and lavenders of his colouring.

The last image of the man at sea shows him near the end of his epic voyage. His great fish is lashed to his boat. It is so long that it overlaps it at either end. But it is now only a skeleton, picked clean by the sharks, a stark silhouette

against a blank sea. It is an image that the artist says was especially close to his own state of mind and it leads into three powerful plates all drawn from a few lines at the end of the story. The man comes up from his boat carrying his mast and sail, he falls under their weight exhausted, like Christ carrying the cross, and finally he falls asleep, face down on his bed: 'He unstepped the mast and furled the sail and tied it. Then he shouldered the mast and started to climb. It was then he knew the depth of his tiredness. He stopped for a moment and looked back and saw in the reflection from the street light the great tail of the fish standing well above the skiff's stern. He saw the white naked line of his backbone and the dark mass of the head with the projecting bill and all the nakedness between. He started to climb again and at the top he fell and lay for some time with the mast across his shoulder. He tried to get up. But it was too difficult and he sat there and looked at the road… He picked the mast up and put it on his shoulder… He had to sit down five times before he reached his shack… He slept face down on the newspaper with his arms out straight and the palms of his hands up.'

As he made his plates, the artist himself was as weak and exhausted as this and as the old man was cared for and sustained by the love of the boy, he was sustained by his family and helped to achieve this great series of prints by the devotion of his collaborators

In several plates, he suggests a link with Coleridge's equally mythic, dream tale, *The Rime of The Ancient Mariner* (fig.11). This link is reinforced by the similarity of Bellany's etchings to David Scott's illustrations to that poem, illustrations in which there was also a degree of self-identification, for Scott felt himself to be a man with a message with at best a reluctant audience. Like Scott too, there is nothing bland or academic about any of Bellany's images and the wiry line that he uses stresses the particularity of his images. Nor is there anything melodramatic about them and the seven additional plates that he made, but did not use in the folio, largely for reasons of space, support this. One of the most memorable of all the plates made for this series is one of these, a dark portrait in crayon etching of the fisherman alone against the sea.

In contrast to Bellany's inspired pictorial gloss on Hemingway's text, Booth-Clibborn's

fig.11 David Scott, *The Wicked Whisper* (from *The Rime of The Ancient Mariner*), 1837. Engraving. Collection National Gallery of Scotland, Edinburgh.

next Scottish project, Peter Howson's *A Hero of the People* (see pp.120–123), is illustration in a much more literal sense. Once again as in the *Bestiary*, text and illustration were both commissioned by the publisher, but this time the product is a conventional bound book. It is large in format and luxurious in production, but the balance is in favour of the text which is a prose narrative written by Crispin Jackson. The fourteen black and white linocuts intersperse the text and relate to it directly. The subject was attractive because it was an unusual one for an artist's book. It was also a monument to a great, but short-lived triumph of British boxing when in 1951, Randolph Turpin beat the reigning American champion, Sugar Ray Robinson, only to be defeated in the return match. It was a heroic defeat perhaps, and this was part of Booth-Clibborn's motivation in commissioning the production. It was a kind of commemoration, not just of the ill-fated Turpin, but of the whole story of British boxing. As a subject, it both matched Howson's usual iconography and suited his style. He gives to his illustrations a coarse, almost comic book simplicity, which is closely in tune with the brutality of the sport that they celebrate.

Ken Currie's *Story from Glasgow* (see pp.68–73) might be compared to Howson's *A Hero of the People*, but it is not really simple illustration any more than Bellany's great series is, for Currie's story has no text and only exists in the prints that tell it, though both are moral tales. Currie's story began in an encounter that he had with a poor down-and-out who told a tale of decline from the security of family, work and union into destitution, through bereavement and accident. It is a story that reflects the end of a society built on the solidarity of the workforce of heavy industry. It also demonstrates that even for those of us who do enjoy security, in the society that we have created it is fragile. In the manner of Hogarth (fig.12) therefore, Currie's series is a moral tale aimed, as Hogarth's were, not at the weaknesses of the individual, but at the society whose materialism has caused the tragedy that the artist relates.

Chronologically, in his use of linocut for a story without words, Currie was anticipated, not only by Howson, but also by Adrian Wiszniewski whose book, *For Max* (see pp. 178–183), discussed later, was made at the same time as Howson's, in the winter of 1987–88, just before Currie embarked on his series which was completed in the summer of 1988. Though there may have been a degree of unspoken rivalry between the artists, the three sets of prints are very different. Currie and Howson's themes might at first sight seem to be parallel and both have a certain affinity with the graphic simplification of the comic book, but there the resemblance ends. In contrast to both of theirs, Wiszniewski's *For Max*, its title a simple dedication to his infant son, was modelled on a child's story without words, or on an elementary text-book.

Currie's real model was in the novels without words of Frans Masereel (fig.13), a Flemish artist of the inter-war years who created stark, moral tales from the dramatic simplicity of black and white prints. Masereel's style exploits the pictorial simplifications and energetic diagonals made possible by the pictorial innovations of cubism. Currie echoes this in the technically almost domestic medium of linocut. Lino is cut by hand without great exertion if it is warmed to make it soft. The line tends to be broad and the technique does not lend itself to intricacy. This certainly suited Currie's purpose for he wanted to make images that were simple, bold and immediate, carrying the line of the story without pause for qualification or apology and this was how he worked, not in his studio, but sitting at home in the evenings, producing one or even two plates a night.

The story begins in the ordinary domesticity that it is easy to take for granted. The man gets out of bed at sunrise, cleans his teeth while his wife makes the breakfast, goes to work in a television factory and during the course of the day, in solidarity with his workmates, he challenges the boss's complacency. Later he goes to a union meeting and for a drink with his friends, but returning home in good spirits, he finds his wife is ill. Her subsequent death devastates him and in an image of bleak despair and overwhelming blackness, relieved only by a few splinters of moonlight, he stands in the dark by her bed. After her funeral, his loneliness is described in a series of telling images of him alone in the pub, or sleepless in his bed, or walking to work apart from his workmates.

In his state of mind, it is not surprising that he has an accident at work, graphically presented as the blinding flash of an explosion. Injured,

fig.12 William Hogarth, *Prosperity* (plate 2 of *A Rake's Progress*), 1735. Engraving. Collection National Gallery of Scotland, Edinburgh.

fig.13 Frans Masereel, *Spleen*, 1924. Woodcut. Private collection.

he loses his job and joins the unemployed in the reading room and the pub. The poor comfort offered by drink is evoked by striking images of him vomiting and lying in the street. After a night in the cells, he returns in the morning light to find his furniture being repossessed. He is homeless. Thus far the story follows quite closely the true story that the artist heard, though he has substituted a television factory for the man's actual place of work.

Homeless and hopeless, he tramps the streets looking for work and in these images, the artist vividly conveys the sense of exclusion, of being an outsider and not belonging that is such an important part of the cruelty of unemployment; the townscape that was home has become hostile, the walls are blank. He witnesses a union protest against the poll-tax, but as a spectator. A railway station suggests the anonymous transience that has replaced his former security and a meaningless tangle of flyovers leads him to a lift in a lorry to London, its driver characterised as a brutal chauvinist, both sexual and political. The landscape en route offers little comfort and when the man reaches the city, it is Metropolis, a grim and joyless fortress of towers. In an image whose near symmetry emphasises its inhumanity, the truck plunges into what looks like the gate of Hell. A whole series of images follows which demonstrates how this is a society entirely dominated by cash values, personified in the capitalist with his cigar, just as he was seen by the left-wing satirists in Germany in the twenties. A view of his fat backside squeezing into a limousine goes even further back however, for it is an unconscious echo of Hogarth, a fitting acknowledgement of pedigree. Such values as these figures represent lead to unqualified greed and its corollary, violence and naked, selfish ambition. This is enshrined in financial institutions without windows and leads to lunatic extremism, personified in a bearded nationalist. In this world, there is food, but nothing to eat and sex, but no love. Now the man is utterly alone without either physical or psychological sustenance.

From now on, Death stalks him as he witnesses the ultimate logic of a society that has forgotten that it is human, the hate marches of the National Front. For him there is only the cardboard box, the hostel and the companionship of other destitutes, dazed by what alcohol they can find. Ending up on a hospital bed, the print is as white and etiolated, as bled of humanity, as at the beginning his despair was black. Finally, he hitches back to Scotland and the story closes with the road leading into his home town, no longer organised as dwelling and workplace, but a vision of chaos, a society in which he can no longer find his way.

In this series, Ken Currie has used the stylistic language and the iconography of the socialist and anti-Nazi art of Germany in the 1920s and thirties. It is legitimate for him to do so, for though the politics may have changed, the basic issues have not as Currie makes clear in the tragic tale so vividly told that the series provides. It is perhaps ironic that the vehicle for the story should be an art form that is by definition expensive, exclusive and strictly limited in the number produced. On the other hand, the dramatic simplicity of his images, close in style to the comic book form which requires minimal literacy in its readers does make his series universally accessible at one level.

If Currie's *Story from Glasgow* is a clear moral fable, dramatically and lucidly told, Alan Davie's *Magic Reader* (see pp.78–81) is quite deliberately exactly the opposite. It consists of eighteen lithographs of line drawings. Currie chose a medium and adapted his style to suit the particular purpose that he had. His series is in the most literal sense narrative art. Davie on the other hand has taken the forms and imagery of his drawing and painting to take the 'reader' through a sequence which is deliberately pitched below the level of the conscious mind. In the fifties and sixties, Davie made an international reputation. His work was free and improvised. His paintings coalesced into form and then dissolved again before one could capture the outline of a fixed idea. It was his declared purpose to paint in a way that was purely intuitive. In the late sixties, he began to use more definite forms, symbolic elements derived from a variety of sources, but always of a kind that could be associated with the idea of spirituality, whether from the archaic religions of extinct, primitive peoples like the Caribs of the West Indies, or of surviving modern cultures like the Jain art of India. In this shift, Davie's purpose had not changed, only his method. He still combined these images intuitively so that they set up their own internal drama, and in his paintings this is enhanced by his brilliant use of colour. This is present here

only in the brilliant red cover, but it is used to dramatic effect to claim the imaginative status of the book at the outset, with black writing on white and brown, all set within the reflecting gold of the lining of the blue outer case.

Davie's position is self-consciously that of a shaman offering to Western culture a route back into the freedom of the imagination that since the eighteenth century has been seen as the gateway to the metaphysical. In a way therefore his series is not only the opposite of Currie's. It is also the complement, a demonstration of what is lacking in a society that can allow such tragedy, as Currie relates, to be normal and unremarkable in its midst. At another level, Davie's book works like a bestiary in that the images are not intended to delimit their subject as a zoological textbook would do, but to do the opposite, to use the subject as an opening to the poetic imagination. The animal and human forms in Davie's series work in just this way.

Davie establishes this in the first plate where an artist's hand appears with a brush alongside an eye. The brush is drawing an animal of some kind, while further up, an imp-like creature points with a forked stick – an ambiguous pointer – at a column of hieroglyphics. Throughout Davie uses western writing very much as though it too was hieroglyphic. Many of the words and phrases that he uses are Spanish, taken from a book on the rock art of the Caribs. Elsewhere he uses French and English words. Generally he attaches no specific or accessible meaning to these, but from time to time they clarify into legible form as in the second plate where the words 'blind reader' appear among a variety of animate and inanimate symbols. The blind reader, like the blind seer and the blind poet of antiquity, is here one whose imagination is not limited to the visible superficies of the text before him, but is illuminated by his inward eye. A few plates later we see just such a 'blind' reader, hands raised in wonder before a room full of symbols as a snake crosses the barrier between the two levels of representation. After a series of symbolic images including a grand, many-handed, many-eyed divinity, the same little figure looks up at an even more complex wall of signs. This time at the top of the page the words 'artiste magicien' appear. Elsewhere in the page are the words 'metamorph' and 'animiste', words

which together invoke the idea of the artist as intermediary in an exchange with the created world of a kind that is available to societies that have not lost touch with their own spirituality, an idea of interchange that in the West was preserved in the *Metamorphoses* of Ovid, poetry that contained within it the memory of a world inhabited by wonder and the divine, poetry that was also a primary imaginative resource for western artists for centuries.

On the second last plate, Davie himself makes an ironic juxtaposition which could stand for just this. He puts the words 'El Secreto' next to the words 'cultural readings'. The 'secret' is of course what no anthropological (cultural) reading can ever capture, yet it is precisely the point of the image. The artist, bypassing the constraints of the formal intellectual disciplines of the west – specifically invoked at the bottom of the page in the part-title of a Spanish learned journal, *Boletin de la Sociedad* – can reopen the secret to us. In the final plate, the artist's hand appears again, and again, though this time much more clearly, it is drawing the inhabitant of an imaginary bestiary, a Pictish beast, or the Nuckelavee perhaps, though it looks more friendly. The words in French alongside are appropriate – 'creation du monde des animaux.'

Wiszniewski's book, *For Max*, stands midway between Currie's strongly structured narrative and Davie's deliberately elusive *Magic Reader*. Wiszniewski's book tells a story, but it is one that is improvised. It does not guide our interpretation, but is open-ended, leaving it up to us to decide on the meaning. Since he completed the series though, Wiszniewski has made a concession to clarification by adding short titles to the twenty-five plates. A further indication of structure is provided by the grouping of the plates into sets of seven brightly coloured images, punctuated by three plates in black, the seventh, the fourteenth and the twenty-first. These relate to the principal episodes in the story: the mysterious, surrealist object that turns out to be both a plant and a lampshade; the trip to Paris where he encounters modern art and a souvenir in the form of a lady art lover's hat blown away by the wind and rescued; a fishing trip with his friend where he ends up, not with a fish, but with a tin can; and the final denouement where he combines all three objects, the lessons of his experience, to provide himself with a lamp to read by.

Wiszniewski's plates are simple and summary. They are quite without the drama, or emphatic narrative drive of Currie's. Instead they are gentle and reflective and mostly in bright colours in keeping with the character of a children's book. The tale they tell is more emblematic than moral, too. It invites us to approach the world of objects with childlike wonder, putting us very much in the position of Max who was only one year old when the series was made. That this is part of the business of art is suggested by the tenth plate where the young man standing beside the lady art lover in her elegant hat in the Pompidou Centre – is this also his first encounter with love? – contemplates Jasper Johns's beer cans. He learns from this for when he catches a tin can fishing, it becomes a treasured object. When he gets home, he sets it on a plinth like the beer cans in the gallery and then incorporates it into his lamp. This which combines all his trophies is much more than just a souvenir, but a source of illumination. It replaces the candle by which he is seen reading in the fourteenth plate. The message for Max which is somehow encapsulated in the almost naïve style of drawing and the bright colours is 'let your imagination flourish'. It is the same message as Davie's *Magic Reader* though it is delivered so unpretentiously. Imagination, too, identified by Adam Smith as the prerequisite of sympathy and so the foundation of society, is what is lacking in the world invoked by Currie, and so there is a complementarity here too.

Wiszniewski's other project is his *Harlequin Series* of etchings made in 1991 (see pp. 184–187). Like *For Max*, the ultimate subject of these ten etchings without text, is art, but it is at a much more sophisticated level of reference, though it is also deliberately elusive. The series was conceived as a homage to Picasso and in particular to the painting that more than any other launched the history of modernism, his *Demoiselles d'Avignon*. Part of the potency of this picture is that it is unfinished as a painting and unresolved as a narrative. Wiszniewski says of it: 'The *Demoiselles d'Avignon* draws open the curtain on the twentieth century. Picasso could not foretell what would unfold – he described the painting as unfinished. As the century draws to a close the *Harlequin Series* is an attempt through ten etchings to complete the picture on Picasso's behalf.'

It is a grand ambition, but though he speaks of completing something, Wiszniewski too has left the question still open. He has not chosen a simple narrative, though he touches directly on the iconography of the *Demoiselles* and makes reference to the implied narrative within it. He also relates his series art-historically to Picasso's own development, implicit in his choice of title, for Harlequin figures appear among the characters in some of Picasso's greatest, early paintings. It is an appropriate homage. This particular period of Picasso's art has had an important influence on Wiszniewski. The quality of his drawing and the use of a kind of neoclassical simplicity of expression are things that he may have learnt from Picasso, though perhaps it is Picasso's reversion to a similar style in his prints of the thirties that has influenced Wiszniewski most closely.

The first two plates which the artist labels 'Portrait' and 'Rake's Progress' appear to establish a hero for the series. The artist himself suggests that it is the sailor who appears in the *Demoiselles*, a customer in the brothel which is the picture's implied setting, but he is perhaps also the twentieth century artist tempted by the posturing sirens of modernism. The third plate suggests that the world that this individual inhabits is a neoclassical wasteland on the edge of a primeval swamp that could be the source of creation, or its end. Wiszniewski then sets up Picasso's painting itself as theatre, but with an all female cast. The sailor is absent. He then recomposes the image with a male cast, making an implied reference to Picasso's inspiration in Cézanne's Bathers which exist as compositions of both male and female nudes. In the next plate Wiszniewski intercuts the two previous images, establishing the connection by the use of the same coloured ink in both and bringing in one of the men as a voyeur, the title of the plate, or as the sailor. This opens the dialogue for it is a detail that suggests the intrusion of Actaeon on Diana and her nymphs, the subject of Titian's great painting in Edinburgh and the ultimate source of Picasso's iconography in a long pedigree that reaches back through Cézanne. It is a small reference that places Picasso's painting, not only in the context of the twentieth century, but in the much longer history of figurative painting which has been modified, but not abandoned by the greatest modern painters.

With deliberate elusiveness, Wiszniewski then takes the next image away from the style of Picasso's radical modernism to the neoclassical drawing and apparent narrative simplicity that he favoured in the earlier period of his career. As he does this in an image that he labels *Pietà*, Wiszniewski also moves out of the theatrical setting that Picasso has chosen in the *Demoiselles*, a setting which suggests that modernism itself was a theatrical idea – a performance on the stage of art history – into what is for a moment the real, modern, urban world. This should after all be the presumed context for modernism and in a further invocation of this real world and its inevitable intrusion into the rarefied world of art, Wiszniewski suggests that the subject of this *Pietà*, the dead body of a young man carried home, is a reference to the death of Picasso's own close friend, Casagemas, an event to which Picasso himself responded with a Pietà-like composition called *Evocation*.

Wiszniewski follows this with an expressly dramatic return to the imagery of the *Demoiselles*, with three of the figures on a stage, lit by a spotlight. It is an image which by its theatrical setting implies the existence of the 'real' world of the audience, but in the next image, we see that the reality of the modern world is itself penetrated by theatricality. Here Wiszniewski invokes the pool-side world of the Pop star, drawn in an eloquent neoclassical line, its colour hinting at Picasso's use of rose and its subject touched with the same enigmatic stillness as Picasso was wont to create in his Harlequin paintings. Wiszniewski finally closes the series with an image that reverts to the technique of softground etching that he had used in the first plates and so makes the connection between beginning and end. In this final plate, the sailor-artist figure wanders through the landscape of art suggested by a male and a female nude. He himself is clothed. He is the artist as a traveller, much as he was seen by Courbet in his famous painting *Bonjour, M. Courbet*, but he is also an actor on the stage of an unending drama where there is no clear line between the audience and the players and where the script is constantly improvised.

Wiszniewski's *Harlequin* series is elegant and consciously enigmatic. It has the most difficult 'text' of any among these series, but it nevertheless has a close bearing on the genesis of many of them for he sets out in emblematic form some of the concerns that he shared with some of his contemporaries among the figurative painters in Glasgow, concerns about how to develop the figurative tradition and keep it alive and relevant without being swamped by the sheer magnitude of the inheritance that it represents.

Will Maclean's series *A Night of Islands* (see pp.154–159) was also published in 1991 and it too is concerned with tradition and its survival and meaning in the present, but its concern is with the tradition of Gaelic culture and its interpretation and transmission into the late twentieth century as visual art (fig.14). Maclean's series is one of the most technically ambitious of all the folios that Booth-Clibborn has produced. The platemaking and proofing was done by Beth Fisher and Jo Gantor at Peacock Printmakers. It consists of ten large-format coloured etchings of great complexity involving three or four etching plates for each one. The accompanying texts are printed in Gaelic and English. Each of the plates has a wide border printed in softground etching on a separate plate and the artist has in places added texture to these by taking a direct impression from materials suggested by the poem such as fishnet, snake skin, or seaweed. The borders contain the central image and these were published as a separate set of black and white etchings in 1992. The texts include both traditional Gaelic poetry and work by living Gaelic poets and were all either chosen or commissioned by the artist.

Construction is Maclean's most familiar art form and his constructions work by the association of images. His approach in these etchings is similar for in them he uses a kind of compound imagery which works by allusion and the association of ideas, but he also exploits the capacity of multi-plate etching to superimpose one image on another often moving towards a deliberately expressive effect of density and darkness that reflects the sombreness of mood in many of the poems.

The title of the folio comes from Angus Martin's poem *Dancers* which records the poet's response to the end of the tradition of ring-net fishing. Maclean himself had worked on a massive project documenting the lives of the ring-net fishermen, their boats and their equipment, a project which was the subject of his first major exhibition. Angus Martin had

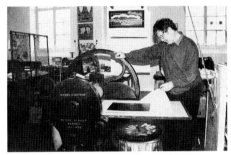

fig.14 Will Maclean at Peacock Printmakers, Aberdeen, during the making of *A Night of Islands*, 1990.

helped him with the project and so this poem and its subject had a special significance for him. He chose to illustrate it with a variation of an image of a fisherman enveloped in oilskins that was also the subject of a major collage created in memory of an uncle, *In Memoriam Skye Fisherman*. It is a timeless, enigmatic figure, looming above the sea. The border is printed with the direct impression of a fishnet.

A frequent theme of the poetry is the tragic exploitation and depopulation of the Highlands. *Strathnavar* for instance records one of the most notorious of the Clearances. The poem was written by Derick Thomson. It opens with the lines: 'In that blue black sky / as high above us as eternity, / a star was winking at us, answering the leaping flames of fire / in the rafter's of my father's house.' These provide the artist with his dominant image. Bare, smouldering rafters reach like hands in despairing supplication towards the black, starlit sky. The smoke extends to fill the whole border of the plate. Between the rafters there is a fishing creel filled with the horns of sheep. Many of the people driven off the land to make way for sheep were compelled to make their living on the sea.

The grim face of the inhuman cruelty of these deeds is personified by Maclean in his plate to John Maccodrum's poem, *Elegy to Captain Ferguson*. Ferguson was a notorious freebooter who took advantage of the suppression of the Highlands after the failure of the Forty-Five to pursue a career of pillage and cruelty. He was an object of cordial hatred among the Highland people and the poet wishes him drowned by telling of his supposed death. Maclean has created a grim, cadaverous face, but its mouth is an upturned schooner and its nostrils are a pair of whales. It is the face of a grim ghost suspended in the darkness of the sea, the ghost of cruelty haunting the Highlands from a watery grave.

Meg Bateman's short poem *The Loss of Gaelic* laments both the loss of the language by individuals and families and its consequent death throughout most of the Highlands, the old Highland culture dying with it. The poem ends with the terse line: 'The heartbreak of the matter.' The bleakness of that heartbreak and the darkness that would follow the death of a language are captured by Maclean in an image which is almost completely black. A small light

area opens to an occluded fragment of a desolate landscape of sea and mountains. In the foreground in the shadows there is a collection of masks, masks which are however also faceless, the ghosts of the memory which lives in the language and will die with it. The border of the plate is dense black, the black of mourning.

For Will Maclean, one of his greatest sources of inspiration has been the Gaelic poet, Sorley Maclean, a poet who has defied the threatened loss of Gaelic by adding his own wonderful achievement to the corpus of Gaelic poetry. Sorley Maclean's contribution to this collection, *A Highland Woman*, is a fierce, dark poem about a life of oppression and unremitting labour. The poet challenges directly the hypocrisy of the Christian dispensation that tolerates such things offering the illusion of an afterlife in compensation for the suffering of the present. The poet introduces the woman labouring under a creel of seaweed and the border of the plate is printed with seaweed. The main image is suggested by the lines in the poem: 'and the unremitting toil has lowered / her body to a black peace in a grave.' The grave is a dark mound in the foreground. Beyond it lies a bleak and inhospitable landscape.

All the foregoing plates and the poetry that inspired them deal with the dark side of Highland history. The series also includes a number of poems of a more diverse character, however. Valerie Gillies's *Trio*, for instance, takes the ancient theme of tripleness, the three-fold goddess reflected in the three phases of the moon, seen in the sky of Maclean's print and the triple hill of the landscape. Most of the other poems are traditional. *Fraoch* and *The King's Fish* are folk tales, one records a fight with a dragon, the other a fight over a fish. The imagery in the respective plates reflects this with the refinement that the plate of *The King's Fish* is split in two as though by the two sides of the quarrel and the two competing fishing lines pull at the fish from either side.

The Author of this is (it is known by its opening words), on the other hand, is an ancient, but surreal poem that takes the theme of the ship of fools, but turns it into a ship of grotesque women. This was the subject of an important construction by Maclean, *Bard MacIntyre's Box* (collection Scottish National Gallery of Modern Art) and in the print he has reused the main lines of its composition. The final poem,

Adam's Clan, by George Campbell Hay, also uses the image of a ship, this time the ship of the whole human race sailing over an uncharted ocean to an unknown destiny. Maclean's image is adapted from a nineteenth century engraving of a view through the masts and rigging of a full-rigged ship leaning against the wind.

This great series of prints is of especial importance for in it the artist has sought successfully to find a form of visual art that is explicitly equivalent to the achievement of Gaelic poetry. Although this has been the driving ambition of his art for a long time, nowhere else has he been able to make both the analogy and the relationship so clear. He has been able to do this because of the nature of the imaginative opportunity offered by this kind of print-text cycle which makes it possible to create a close, parallel relationship between the work of the poets and visual images that are as rich and complex as any that he has made.

Together this group of folios by Scottish artists constitute a remarkable achievement They are diverse, but they all work through the imaginative exchange between text and image and even when the text is unspoken, the images themselves carry it and so still work in this way.

In addition to these Paragon Press publications by Scottish artists, a number have been published with a certain Scottish relevance. Hamish Fulton's *Ten Toes Towards the Rainbow* (see pp.98–103) has been inspired by the landscape of the Cairngorms. They record walks that he has made in the Cairngorms (fig.15), measuring himself against eternity as he tracks his progress through the empty land. It is one of the ironies of history that the same social and economic changes which led to the destruction of so much of the Highland way of life also produced the romantic attitudes which especially value the empty landscape that has been left. This is part of the paradox of the Highlands and even as Will Maclean reminds us that much of its beauty is founded on tragedy, some of it has always been wilderness and is now a great natural and spiritual resource.

Like Hamish Fulton, Thomas A. Clark and Ian McKeever reflect the inspiration of this wilderness in the illustrated book on which they have collaborated, *that which appears* (see pp.160–165). Clark is a Scot and his minimal poems reflect on the mountain landscape, the details that animate it and the processes that

have formed it and that continue to do so. The spare quality of the poems is similar in many ways to Japanese Haiku and McKeever's woodcuts match this with an elemental simplicity that suggests the same Zen inspiration that moved William Johnstone.

The approach to the marriage of print and text adopted by Johnstone and seen in the work of Clark and McKeever is very different from the one that has been the subject of most of this essay, however. If the works that reflect a narrative tradition create a dialogue, this approach is more like polyphony in a medieval church: music where voices singing different parts combine in the echoing space of the architecture to make a harmony which is purely abstract though it is composed of human sounds.

One of the most recent projects undertaken by Paragon combines this approach with something that takes us back to the point where we began, *Loop* by Alan Johnston (see pp.126–129). Included in the portfolio are six pairs of etchings and a poem written in response to them 'Tractatus Cosmo-Poeticus' by Kenneth White. The prints are minimal in form. Superficially they echo Mondrian's division of the surface of the image into a set of interrelated rectangles. There is no colour however, only black and grey. The prints are etched and the lines out of which they are composed are created by drawing freehand with the etching needle. Thus they appear formal and geometric, but as you look more closely you realise that what appears to be solid and architectural is actually a close mesh of freely drawn lines. The eye can penetrate this and so we realise that even such formal structures, like all communications are both intuitively made and intuitively understood. It is a minimalism which is closer to Japanese art in a way than to the traditions of the west and it is in keeping with this that the spaces between the lines are as important as the lines themselves.

This is a process of mutual definition, therefore and this idea is extended by the way in which the prints are paired into mirror images. One mirrors the other, but as it does so it shifts it and alters it tonally. There is no narrative relationship between these images and Kenneth White's text, but the text nevertheless locates the images in a precise area of philosophic dialogue. It is one which by a very different route takes us back to the point where we began of the

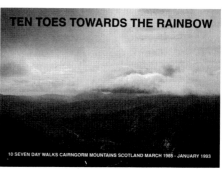

fig.15 Hamish Fulton, *Announcement card for 'Ten Toes Towards the Rainbow'*, 1993. Off-set lithograph. Collection Scottish National Gallery of Modern Art, Edinburgh.

relationship of words to representations. It is the argument about the status of words themselves, of language and thought itself as representation, a point where the difference between language and image breaks down. Within this discourse about language, the idea of the mirror has played an important role for it stands for the apparently discredited idea that language is a lucid and transparent medium through which the mind can reflect the world as though it was a mirror.

The argument about language that has played such an important role in modern intellectual history involves the recognition of the fact that language itself is not a neutral medium of discourse, a mirror of the mind, but a construct. Like all human constructs it is shaped by structures of power, but in this case, through language they have become so intimately part of our thinking that they can control and distort it without our even being aware of it. George Davie fights back on behalf of the Scottish empiricists with whom this simplistic view is associated and argues that the mirror idea is valid because it is a psychological one. It entails self-knowledge through our membership of society. Seen thus the mirror provides a partial answer to Burns's prayer. 'O wad some poor the giftie gie us / To see ourselves as others see us.' The subtlety of the human touch with which Alan Johnston has created his images, working closely with the printer Alfons Bytautas, is a demonstration of just this truth, that the structures by which we live must be human and humane if they are to be valid at all. We gain nothing by the deconstruction of language if we allow it to extinguish the transcendental values inherent in it and on which society itself depends as was made clear by David Hume and Adam Smith long ago in 'the sharp lines of sceptical Scotland'.

Catalogue

The Scottish Bestiary

DESCRIPTION: Loose-leaf book with 19 poems and prose texts by George Mackay Brown and 20 prints by 7 artists in cover and slip-case bound in green buckram; portfolio edition with 20 prints, title-page and colophon bound in green buckram.

EDITION: 60 unbound books numbered 1 to 60 plus 15 proof copies numbered I to XV; 50 portfolio sets numbered 1 to 50, numbers 31 to 50 being reserved for the artists, plus 3 proof copies.

INSCRIPTIONS: Book edition signed by the author and the artists on colophon page; each print in portfolio edition signed and numbered by the artists.

SIZE: 56 × 38cm (page size of book version); 56.5 × 76cm (paper size of portfolio version).

PAPER: 300gsm Somerset TP Textured.

TECHNIQUE: Screenprint, etching, woodcut and lithography.

PRINTER: Peacock Printmakers, Aberdeen. Etchings printed by Beth Fisher and Lennox Dunbar, lithographs by Stewart Cordiner, woodcuts by Bob Bain, and screenprints by Arthur Watson. The printers were assisted by Brian MacBeath, Phyllis McGibbon, Ruth Maxwell and Joan Wilson. Printing co-ordinated by Arthur Watson. Texts, title-page and colophon printed by Simon King, Cumbria, on an Albion Press.

BINDING: Designed and initially made by Sangorski and Sutcliffe; main production by R.G. Scales Ltd., London.

TYPOGRAPHY: Texts, title-page and colophon designed by Phil Baines in 18-point Monotype Baskerville.

This, the first publication of Charles Booth-Clibborn's Paragon Press, was published while Booth-Clibborn was still in his final year at Edinburgh University. Having conducted research on print publishing in Britain and the USA, he decided to set out by publishing a work of national and international significance. Through his reading at the National Library of Scotland, he had become aware that although the medieval and Renaissance scribes of most European countries had produced lavishly illustrated bestiaries, there appeared to be no surviving example of a Scottish bestiary. Inspired by the twentieth-century bestiaries of Dufy, Calder, Picasso, Sandro Chia and others, Booth-Clibborn decided to make a contemporary Scottish Bestiary, with a text commissioned from a Scottish author and prints made by a range of Scottish artists.

Booth-Clibborn began by asking Scottish writers, including Alasdair Gray, Edwin Morgan, and George Mackay Brown, if they would be prepared to write a text for the *Bestiary*. A native of Orkney, Mackay Brown, who was born in 1921, readily accepted and from an initial list of twenty-four beasts suggested by the publisher edited the number down to nineteen, having added two of his own choice, the mythical nuckelavee and stoor-worm. The final choice settled upon was the following: Raven, Fieldmouse, Dove, Wolf, Spider, Salmon, Lion, Nuckelavee, Dragon, Stoor-worm, Eagle, Seal, Whale, Unicorn, Moth, Grouse, Stag, Wildcat and Lobster. The title-page of the *Bestiary* gives the beasts in this order though the sequence is not crucial.

Booth-Clibborn had also begun inviting artists to contribute images to the *Bestiary*, choosing a range of both young and established artists from Glasgow and Edinburgh: some of them were very experienced printmakers (Bellany and McLean), while others had not previously made any prints. Alan Davie and Graham Durward were among the artists initially approached to work on the project but Davie declined and Durward was unable to participate, owing to commitments in New York. The final list of artists who agreed to take part was John Bellany, Steven Campbell, Peter Howson, Jack Knox, Bruce McLean, June Redfern and Adrian Wiszniewski. Of these, Campbell, Howson and Wiszniewski had recently emerged as three of the most exciting young artists working in Scotland. They had each shown in the exhibition *New Image Glasgow* (Third Eye Centre, Glasgow, 1985) and had begun to establish international reputations. Bellany and McLean were already well established artists working in London, Knox was Head of Painting at Glasgow School of Art, and Redfern had recently been appointed Artist in Residence at the National Gallery in London.

Having approached a number of printmaking studios in Scotland, Booth-Clibborn elected to have all the prints made at the renowned Peacock Printmakers in Aberdeen. There would be seventy-five book and fifty portfolio versions of *The Scottish Bestiary*, each containing twenty original prints: thus there was a total of 2500 individual prints to be editioned, making it probably the most ambitious fine print project made in Scotland this century. Arthur Watson, founder and Director of Peacock Printmakers, agreed to accept payment two months after all the prints had been produced, enabling the publisher to sell copies of the *Bestiary* before having to pay the bill. Booth-Clibborn readily acknowledges that, but for Watson's faith, the project would have been difficult to realize. Each of the artists agreed to make the prints on condition that they received a copy of the book and copies of their own prints, and that all their expenses would be paid.

By April 1986 Mackay Brown had finished the texts. John Bellany and Adrian Wiszniewski were keen to draw particular animals, and selected them from the list, while the other artists were asked to make prints of specific beasts. All the artists made three images each except Steven Campbell who did two. The first prints were made in mid-May 1986, Wiszniewski being the first to begin. Each of the artists was free to choose their print medium, though it was intended that there would be a range of different techniques throughout the portfolio. Some artists chose to follow the narrative of Mackay Brown's text while others were much freer in their approach. For personal reasons (see below) Bellany even changed one of his beasts from a grouse (the title of the poem) to a capercaillie.

Unable to find a letterpress of sufficient quality in Scotland, Booth-Clibborn had the texts printed by Simon King in Cumbria. In most cases the images were printed first, on the right hand side of the double page, and the texts were printed afterwards on the left side of the sheet. The two woodcuts by Steven Campbell arrived late and were the only ones to be printed on pages already bearing the texts.

The project was launched on 28th October 1986 at the Banqueting Hall in London, and was first shown in Scotland at Artspace in Aberdeen in November.

Note: The texts and poems for *The Scottish Bestiary* are reproduced in Appendix II, pp.199–205.

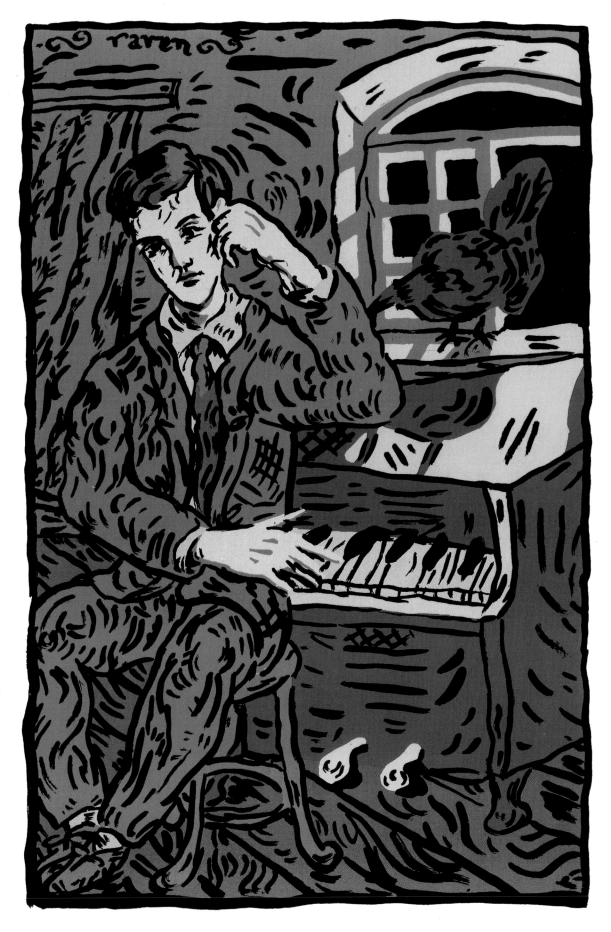

2 Wiszniewski *Raven*

John Bellany

BIOGRAPHY: Born Port Seton, near Edinburgh, 1942. For full details see p.54

Eagle (hardground etching on steel, 45.2 × 30cm).
Grouse / Capercaillie (hardground etching on steel, 45 × 30cm).
Wildcat (hardground etching on steel, 45.6 × 29.6cm).

Rather than illustrate the poems, Bellany used them as a point of departure. In addition to depicting the three beasts he also included motifs and symbols relating to his own life: these three images are intimately concerned with the recent deaths, in 1985, of his wife Juliet and his father. The figure of the *Wildcat* – half cat, half woman – may be seen as Juliet. The motifs around her can be given a symbolic interpretation: the hour-glass is a traditional pictorial symbol of the passing of time; the owl is an image of death; and the balloon is a symbol of transience. Although Bellany chose Mackay Brown's poem of the grouse as the starting point for one of his images, he decided instead to draw the capercaillie, a large relative of the grouse. He had recently made a painting and related etching entitled *The Capercaillie Sings his Love*, referring to his love for Juliet; this image, entitled *The Capercaillie Sings his Lament*, was made in response to her death. The artist prefers not to discuss the symbolism in his work but the *Eagle* may be seen as a self-portrait or possibly even a portrait of his father, clutching a fragment of fish-head (his father was a fisherman). The three plates were drawn by Bellany in Edinburgh and printed in Aberdeen. They were drawn directly onto the steel etching plates: no preparatory drawings exist.

Steven Campbell

BIOGRAPHY: Born Glasgow 1953. Studied at Glasgow School of Art 1978–82. Lived in New York 1983–86. Solo exhibitions include Riverside Studios, London, 1984; Third Eye Centre, Glasgow, 1990; and Marlborough Fine Art in London and New York. Lives in Stirlingshire.

Untitled (Frontispiece) (woodcut, 56.5 × 38.9cm).
Lobster (woodcut, 56.5 × 38.9cm).

Campbell's only prints prior to *The Scottish Bestiary* were three very large woodcuts made in New York in 1983: *Gesturing Hiker*, *The Tragic Hiker* and *The Hiker Said 'Death you shall not Take the Child'*. For *The Scottish Bestiary* he made a woodcut of a sword-dancer for the frontispiece and a woodcut of the *Lobster*. Both woodcuts were made on the backs of woodblocks which Campbell had cut and rejected (one is of the head of a bearded man, the other is a figure). He decided to use the woodcut medium because it could be done at home and did not involve complex technical apparatus: these prints were cut with a simple chisel. They were the last of the *Bestiary* prints to be finished.

Peter Howson

BIOGRAPHY: Born London 1958. For full details see p.120.

Fieldmouse (screenprint, 55 × 36.8cm).
Moth (screenprint, 54.5 × 36.7cm).
Stag (screenprint, 55 × 36.7cm).

Howson had made very few prints prior to *The Scottish Bestiary*. He drew between fifteen to twenty sketches for each of the three prints, beginning with the *Fieldmouse*. Mackay Brown's poem refers to the poet Robert Burns who, in his own poem *To a Mouse* (which begins with the celebrated line 'Wee, sleekit, cowrin' tim'rous beastie') meditates on the mouse's plight. The print of the *Moth* relates to a section of Mackay Brown's poem in which the moth passes by the windows of houses, observing men drinking in one and a couple counting money at another. The artist has remarked that the image 'brings together greed and drunkenness with the beauty of the moth and the serene Scottish sky.' Howson was unsure how to represent the stag but unexpectedly resolved his quandary when he visited a pub in Aberdeen and saw a stag's head hanging from the wall. The image brings together two hackneyed symbols of Scotland, the stag and whisky. Howson subsequently incorporated the three images into a large painting, *The Scottish Trilogy* (1986–87; private collection USA): this was to be the first in a long series of triptychs. Each of these screenprints was composed from approximately twelve separations, each colour being painted onto a separate sheet of acetate film in order to generate the screens from which the prints were made (see fig.8 on p.25).

Jack Knox

BIOGRAPHY: Born Kirkintilloch 1936. Studied at Glasgow School of Art 1953–57 and in Paris 1958. Head of painting at Glasgow School of Art 1981–92. Solo exhibitions at Serpentine Gallery, London, 1971; Third Eye Centre, Glasgow, 1983; and Glasgow Museum and Art Galleries 1990. Lives in Glasgow.

Dove (lithograph and screenprint, 53.5 × 35.5cm).
Nuckelavee (lithograph and screenprint, 53.5 × 35.5cm).
Whale (lithograph and screenprint, 53.5 × 35.5cm).

Knox made a number of lithographs in the early 1960s but otherwise had little experience of printmaking. By coincidence, he had done a series of drawings relating to poems by George Mackay Brown several years before being asked to work on *The Scottish Bestiary*. Asked to make images of the *Dove*, *Nuckelavee* and *Whale*, he made a few small sketches prior to going to Peacock Printmakers in Aberdeen: there he worked in lithography, using the sketches only as approximate guides and drawing directly onto the stone. In producing these images, the black lithographic line was printed first, then a translucent white rectangle was screenprinted over the top. The nuckelavee is a malevolent, ugly beast of Scottish legend, half horse and half man.

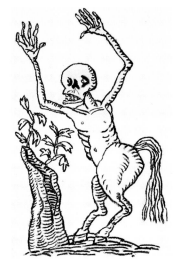

1 Campbell *Frontispiece*

4 Knox *Dove*

13 Redfern *Seal*

15 Wiszniewski *Unicorn*

5 Redfern *Wolf*

7 McLean *Salmon*

3 Howson *Fieldmouse*

8 Redfern *Lion*

9 Knox *Nuckelavee*

SPIDER

NEVER AGAIN. It was broken. The kingdom lay in ruins about him.

This was the end. This the nadir, coldness and dark of exile, utterly. The grave, this.

He stood on the last stones. Here Scotland ended.

Lamentation of sea against rocks.

The swineherd has a hut. The fisherman a bothy. For this king, a cave, without food or fire or couch.

Ah, but some creature was busy building itself a house! The spider hung here and there its delicate scaffolding.

The master mason with his chart and compass, the craftsman dressing a granite block, the labourer going here and there about the site with his barrow-load of cement: what slow clumsy creatures they were compared with this little aerial architect, as he climbed and swung and dropped down on his gossamer thread.

A freshet of sea wind blew into the cave. Down it fell in ruins, the web. The work had been for nothing.

Kirk and castle and palace, ship and chariot: all these, once, not so long ago, lovely artefacts, he had thought to gather into the fair bound of his kingdom.

Six times he had tried. Six times it had ended in ruins.

The creature was having another go. Once more the delicate dance of construction got under way. The half-made web shimmered with sea light. A bumble bee rolled heavily out of a clump of seapinks and blundered into the web, and broke it.

The king was sorry for the spider.

The spider knew nothing about rage, or self-pity, or despair.

Once again, out of his own body, he began upon a new edifice of air and light. The work didn't get so far this time. A heavy water drop from the roof of the cave, like a crystal, fell through it.

The king became more and more interested in this creature of endless resource and purpose and energy.

A strand of the fourth web would not adhere to the slimy wall of the cave. It ended in tatters.

A water rat, scurrying along a stone ledge, shattered the spider's next house.

Immediately the work began again. The spider swung down and across and up. The delicate structure was all but finished, when the king put out his finger to touch, appreciatively, the work, as (in the old days) he might prove a granite lintel. Silently the spider's castle collapsed, a broken silver thread about the man's finger.

'This grieves me,' cried the king.

Human grief and sympathy were all one to the spider.

Its seventh web spanned an inner coign of the cave: a shimmering perfection.

'Well done,' sang the king.

A month or two later the king returned to his broken kingdom. He began once more to spin the web of policy and statecraft, planning and negotiation, sympathy and summoning and subtleness and sternness, that had its consummation a few years later on a battlefield under Stirling Castle.

6 McLean *Spider*

Bruce McLean

BIOGRAPHY: Born Glasgow 1944. Studied at Glasgow School of Art 1961–63, and at St Martin's School of Art, London, 1963–66. Worked in performance art from late 1960s, as well as in painting and printmaking. Solo exhibitions include Galerie Konrad Fischer, Düsseldorf, 1969; Stedelijk Van Abbemuseum, Eindhoven, 1982; Whitechapel Art Gallery, London, 1983; and Anthony d'Offay Gallery, London, from 1981. Lives in London.

Spider (two-colour screenprint, 36.8 × 36cm).
Salmon (two-colour screenprint, 33 × 32.3cm).
Stoor-Worm (two-colour screenprint, 37 × 36.8cm).

McLean initially made the three images as colour screenprints but eventually decided to abandon these and use black and white screenprint instead. The prints were made with two separate screens, the drawn black image being printed over a white square. Normally screenprints are made by painting with photo-opaque onto a transparent acetate sheet, but for these prints McLean painted squares of particularly thick photo-opaque onto the acetate and then scratched the lines away. He made them in London though they were printed in Aberdeen. The *Spider* relates to Mackay Brown's poem of Robert the Bruce who, hiding in a cave, observes a spider constructing its web. The text on the salmon tells of the fish's perilous quest across sea and up river to spawn: McLean's image succinctly identifies the riverbank with female fertility. The stoor-worm, a giant monster of Scottish legend, fed on a diet of girls.

June Redfern

BIOGRAPHY: Born St Andrews 1951. Studied at Edinburgh College of Art 1968–72. Artist in Residence at The National Gallery, London, 1986, followed by solo exhibition there. Lives in London.

Wolf (two-colour lithograph on stone, 56 × 38cm).
Lion (two-colour lithograph on stone and zinc, 56 × 38cm).
Seal (lithograph on stone and screenprint, 57 × 38cm).

Although Redfern had made many etchings and a few screenprints prior to this project, she had never tried lithography; she chose the medium precisely because of this, also feeling that the fluid lithographic line would suit her way of working. She saw the seal as a very feminine animal, and responding to the poem in which Mackay Brown tells of the slaughter of seal-pups, drew it with blood spouting from its mouth. By contrast she saw the wolf as a masculine beast and chose to depict it in a submissive position, lying on its back. All the key drawing in black was done on lithographic stones, but the colour in each was produced by different means. The red colour in *Seal* was done in screenprint since it proved difficult to achieve the rich, opaque colour over the black line with lithography. Mackay Brown's tale of the lion tells the mythical story of the first lion to be brought across the seas to Scotland for the King, hence Redfern's decision to depict the beast hovering above the sea. The orange in *Lion* was made on a separate zinc plate, using an effect called *peau de crapaud* (toad-skin) in which water and ink are mixed to give a marbled effect. Redfern wanted to have a sense of continuity between her three prints, and gave them each a circular movement, which relates to her strong interest in Celtic imagery.

Adrian Wiszniewski

BIOGRAPHY: Born Glasgow 1958. For full details see p.178.

Raven (eight-colour screenprint, 53.5 × 35.5cm).
Dragon (lithograph, 53.2 × 34.2cm).
Unicorn (hardground etching on steel, 51.5 × 33.7cm).

Wiszniewski was one of the first artists to be shown the list of beasts and initially chose the *Dragon*, the *Salmon* and the *Unicorn*. Apart from two etchings these were the first prints he had ever made. Having completed small sketches for each, his initial idea had been to make three lithographs. He began with the *Dragon*, drawing onto newsprint laid on top of the lithographic stone (see fig.9 on p.25). Using the same process he made lithographs of the *Unicorn* and the *Salmon*. The lithographic stone used for *Unicorn* broke after only about twelve prints had been pulled. At the time Wiszniewski was living in Liverpool, where he was Artist in Residence at the Walker Art Gallery. He asked for an etching plate to be sent to him and drew a new image of the unicorn using a sewing needle taped to a pencil. Having thus used two different techniques for two prints he decided not to submit the lithograph of the *Salmon* and chose instead to employ a third technique, screenprint, for a new image of the *Raven*. He began by making a drawing in gouache at Peacock Printmakers in Aberdeen. Finding the raven difficult to draw, he decided to borrow a stuffed one from the university museum. Arthur Watson used the gouache to generate the colour separations for the screenprint. After it was proofed Wiszniewski introduced a black screen to pull the image together. Wiszniewski has often drawn and painted poets and young, sexually ambiguous men, so he felt particularly attracted to the unicorn who, in legend, arouses female passions and is unable to eat, gaining sustenance instead by smelling flowers and drinking dew.

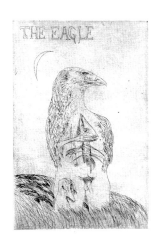

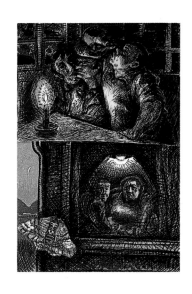

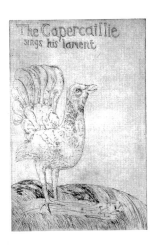

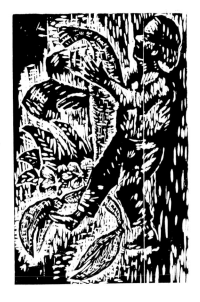

10 Wiszniewski *Dragon*

11 McLean *Stoor-Worm*

12 Bellany *Eagle*

14 Knox *Whale*

16 Howson *Moth*

17 Bellany *Grouse/Capercaillie*

18 Howson *Stag*

19 Bellany *Wildcat*

20 Campbell *Lobster*

London *Group Portfolio*

1992

DESCRIPTION: 11 prints, title-page and colophon, in portfolio case bound in black buckram.

EDITION: 65 sets numbered 1 to 65, of which 40 numbered 1 to 40 are portfolio sets and 41 to 65 are the artists' copies. Additional 15 sets numbered I to XV for artists and collaborators. Between 8 and 20 proof copies made of each print.

INSCRIPTIONS: Each print signed on verso apart from the prints by Nicholas May, Rachel Whiteread and Dominic Denis, which are signed on the front.

PAPER: 300gsm Somerset Satin, except: Dominic Denis on 300gsm Velin Arches; Langlands and Bell on 300gsm Somerset White Textured; Michael Landy on 350gsm card before being laminated in plastic; and Craig Wood on 500gsm card.

TECHNIQUE: Screenprint except the print by Langlands and Bell which is embossed. The print by Landy also has writing in black marker-pen.

PRINTER: Screenprints, including title-page and colophon, at Coriander (London) Ltd. Embossed image by Langlands and Bell printed by Ian Mortimer.

BINDING: Made by Ryders, Bletchley.

TYPOGRAPHY: Title-page and colophon designed by Phil Baines in his own typeface Toulon (1st version).

Following *The Scottish Bestiary* (see pp.38–45) this was the second group portfolio to be published by The Paragon Press. All eleven participating artists were, at the time of publication, based in London, and most were under the age of thirty. Booth-Clibborn had collected work by a number of the artists invited to participate. There is no thematic link between the prints: instead the aim was to present the work of a range of young artists working in diverse ways, to create, as it were, a portable group show. Fifteen artists were invited to participate in the project. Ian Davenport and Fiona Rae were unable to accept owing to gallery contracts, and Angela Bulloch and Gary Hume declined the invitation.

Just as several of the artists represented in *The Scottish Bestiary* had recently come to prominence when that portfolio was published in 1986, so the artists featured in the *London* portfolio were, by 1992, beginning to gain national and international recognition. Denis, Fairhurst, Hirst, Landy and Wood had all studied at Goldsmiths' College, London, in the late 1980s; Hirst had been one of the organisers of a group of exhibitions (*Freeze*, *Gambler* and *Modern Medicine*) held in disused factories in London between 1988 and 1990, which included work by himself, Fairhurst, Denis and Wood; Quinn, Turk, Hirst and Taylor had all featured in exhibitions organised by Jay Jopling (who later opened the White Cube gallery in London); and Landy, Fairhurst and Whiteread had all shown at the Karsten Schubert Gallery in London. Work by Hirst, Whiteread and Langlands and Bell had also attracted much interest when shown at the Saatchi Gallery, London, in 1992. Craig Wood had shown with the Laure Genillard Gallery in London and Langlands and Bell had shown with Maureen Paley/Glenn Scott-Wright, also in London. Thus as well as representing the work of young London artists, the portfolio also showcased the young London art-dealers.

Few of the artists had done any printmaking before embarking upon this project. The only restrictions imposed upon them were that the printed image should be two-dimensional and that it should be no larger than 30 × 35 inches (76 × 89cm). With the exception of Langlands and Bell, whose image is embossed, all the artists chose to work in screenprint (at Coriander studios in Acton, London). This choice parallels a tendency among young artists to move away from the graphic, drawn or painted image in favour of making art from pre-existing objects or generating images through photography. In the case of Michael Landy and Craig Wood, the screenprinting process served solely to establish the ground colour of the print: Landy wrote over the laminated screenprint with a black marker-pen while Wood had elements of the coloured card stamped out.

All the prints were made between February and May 1992.

Dominic Denis

BIOGRAPHY: Born London 1963. Studied at Chelsea School of Art 1984–86 and Goldsmiths' College of Art, London, 1986–89. Solo exhibition at Galerie Harry Zellweger, Basel, 1991; has participated in group exhibitions in London, Basel and Brussels. Lives in London.

Untitled (eight colour screenprint, 76 × 82.5cm; image size 75 × 47cm).

This was the first print Denis had made since leaving art college. It relates to a projected series of paintings (15 were envisaged but only two were completed), to be executed in a very simple, deadpan style. The two finished works, painted in household eggshell paint, depict an interior and an exterior: this print relates to the latter. The composition of the print, which differs slightly from the painting, was established in a small pen drawing; the colours were selected at Coriander studios where the screenprint was made.

Angus Fairhurst

BIOGRAPHY: Born Kent 1966. Studied at Canterbury College of Art 1985–86 and Goldsmiths' College, London, 1986–89. Solo exhibitions at Karsten Schubert Ltd., London, 1990–94. Lives in London.

When I Woke up in the Morning, the Feeling was Still There (three-colour screenprint with varnish, 86.5 × 65.8cm).

This print relates to a series of four large photographic panels Fairhurst had recently made of a man sitting in a chair holding primary coloured canvases (*Man with Dream Colours*). Each panel is pierced with hundreds of the coloured plastic tags used by high-street stores. Like other works by Fairhurst, *When I woke up...* is in the form of a blown-up postcard with a caption at the bottom. The caption refers to that 'just-come-to-after-the-night-before' feeling. It alludes, perhaps, to a hangover or a night of drugs or love, but is not specific about the object or nature of the 'feeling'. The yellow form is hard-edged and precise (recalling paintings by Malevich and Yves Klein) but does not quite fit into the space left for it. Fairhurst comments that 'I wanted to play on the misalignment of the hard form and the notion of feeling, both physical and emotional, which is something you cannot be so sure about.' The photograph was taken in the artist's studio.

When I woke up in the morning, the feeling was still there.

2 Fairhurst

Damien Hirst

BIOGRAPHY: Born Bristol 1965.
Studied at Goldsmiths' College,
London 1986–89. Solo exhibitions
include ICA, London, 1991; Mattress
Factory, Pittsburg, 1994; DAAD
Gallery, Berlin, 1994; and Dallas
Museum, Texas, 1994. Lives in
London and Berlin.

Untitled (eight-colour screenprint
with matt varnish, 86 × 62.4cm).

Hirst bought all these stones on the King's
Road in London and laid them on a sheet of
pink paper in a form which reminded him of an
illustration from a school geography text book.
The grid layout is also found in Hirst's *Spot
Paintings* and *Cabinet* constructions. It was his
first print.

Michael Landy

BIOGRAPHY: Born London 1963.
Studied at Goldsmiths' College,
London, 1985–88. Solo exhibitions
include Gray Art Gallery, New York,
1989; Studio Marconi, Milan, 1990;
and Karsten Schubert Ltd., London,
1989–93. Lives in London.

COR! WHAT A BARGAIN!
(one-colour screenprint, laminated in
plastic, with black marker-pen,
68.5 × 85.7cm).

This is the artist's first print though he does
not see it as a print in the traditional sense of
the term. The only reproductive element is the
screenprinted Day-Glo colour (Landy made
versions in green, pink, orange and yellow). The
sheet was then laminated in plastic and drawn
on with a black marker-pen. Landy wanted the
print to have a hand-made, street-market quali-
ty: it is designed to be pinned or stuck onto a
wall, rather than framed. The work relates to a
series the artist made for an installation at the
Karsten Schubert gallery, London (*Closing
Down Sale*, April–May 1992). The exhibition,
consisting of a room filled with shopping bas-
kets and trolleys and hundreds of signs
announcing a closing down sale, was conceived
as a comment on the recession.

Langlands and Bell

BIOGRAPHIES: Ben Langlands born
London 1955. Nikki Bell born
London 1959. They studied at
Middlesex Polytechnic, London,
1977–80, and have worked together
since then. Exhibitions in London,
Frankfurt, Rome, Paris and elsewhere
since 1986. Live in London.

UNO City
(blind embossed print, 71 × 74cm).

Since 1978 Langlands and Bell have made
sculpture which refers to the ground-plans of
buildings. These buildings invariably have a
utopian agenda and/or a strategic brief, and
include prisons, churches, art galleries and UN
offices. UNO City is in Vienna, UNO standing
for United Nations Organisation. The section
featured in the print is the conference centre
which is split into two assembly rooms, each
having a semi-circular seating arrangement.
Beyond the main seating area in each segment
are press and translation booths and other
offices and lift-shafts. The three T-shaped
forms protruding from the circular structure
are lift-shafts and staircases. Although parallels
exist between the work of Langlands and Bell
and the theoretical writings of Michel Foucault
(amongst others) regarding concepts of power
and surveillance, they developed their sculp-
tures in an intuitive rather than a theoretical
way. Apart from two works involving screen-
print on glass, this was the first print Langlands
and Bell had made. They worked directly from
the ground-plan, representing solid and void
structure with blacks and whites on tracing
paper. Their plan was transferred onto a metal
plate which was then used to emboss the paper.

Nicholas May

BIOGRAPHY: Born Limavady, County Londonderry,
1962. Studied at Bath Academy of Art 1981–84 and
Goldsmiths' College, London, 1988–90. Solo exhi-
bitions include John Hansard Gallery, University of
Southampton, 1990; Frith Street Gallery, London,
1991; Victoria Miro, London, 1994; and touring
show at South London Gallery, Cornerhouse Man-
chester and Leeds Metropolitan University, 1994.

Anabatic Print (ten-colour screenprint with high-
gloss varnish, 88.5 × 60cm; image size 75 × 47cm).

The print is derived from a photograph of a
section of one of May's paintings. The artist
regarded the painting, which was nearly
3 metres square and in acrylic and resin, as
unsuccessful (it has never been exhibited), but
liked this particular segment. May has made
a series of works titled *Anabatic Paintings*:
anabatic is a meteorological term defining the
upward movement of air – a movement
suggested in May's work.

Marc Quinn

BIOGRAPHY: Born London 1964.
Studied History and History of Art at
Cambridge University, 1982–85.
Worked as assistant to sculptor Barry
Flanagan 1982–86. Solo exhibitions
include Galerie Jean Bernier, Athens,
1993 and Jay Jopling/Grob Gallery,
London, 1993. Featured in group
show *Young British Artists II*, Saatchi
Gallery, London, 1993. Lives in
London.

Template for my Future Plastic Surgery
(four-colour screenprint with varnish,
86 × 68cm).

This print was generated from a photograph
of the artist with photographs of casts of parts of
other people's bodies collaged on top. The pho-
tography was done by Dan Leppard. Much of
Quinn's work is about the relationship between
the inside and the outside of the human body,
between feeling and appearance, and much of it
is generated from photographs or impressions
of the artist's own body. The collaged items are
an ear which is that of a violinist; the nose of an
impressario; the tongue of a noted chef; the
hand of Quinn's then-girlfriend, lying over his
heart; and the brain is a photograph of a piece
of coral which alludes to the interface between
humans and nature (this is a theme explored in
later sculptures such as *The Origin of the Species*
and *Rubber Soul: the Frozen Frog*, the latter
made for the exhibition *Time Machine* shown at
the British Museum, London, in 1994). The
work deals with the idea of physical appearance
and the elusive way it relates to feelings inside.
Quinn subsequently developed the image into a
large three-dimensional piece, *Template for my
Future Plastic Surgery (Aged 80)*. Constructed
on transparent acrylic, it features life-size pho-
tographs of the naked artist from front and side
views, with plaster-cast elements of his body
laid on top.

1 Denis *Untitled*

4 Landy *Cor! What a Bargain*

6 May *Anabatic Print*

3 Hirst *Untitled*

5 Langlands and Bell *UNO City*

Marcus Taylor

BIOGRAPHY: Born Belfast 1964. Studied at Ulster Polytechnic then Camberwell School of Art, London, 1982–86 and Slade School of Fine Art, London, 1986–88. Solo exhibitions at White Cube Gallery, London, 1993, and in Berlin, Paris, Dublin and elsewhere. Lives in London.

Untitled (six-colour screenprint with varnish, 86 × 70.5cm).

Since 1990 Taylor has made sculptures from sheet perspex. In many of these works the sculpture is a box-like construction, echoing the forms of fridges and freezers, and the perspex is sanded on one side so that it becomes partly opaque. This print was generated from a small carving in acrylic of a plug: this was photographed in black and white and screenprinted with a blue screen. It was the first print he had made.

Gavin Turk

BIOGRAPHY: Born Guildford 1967. Studied at Royal College of Art, London, 1988–91. Solo exhibitions with Jay Jopling/White Cube Gallery, London. Lives in London.

Gavin Turk Right Hand and Forearm (thirteen-colour screenprint with varnish, 86 × 68cm).

This was Turk's first screenprint. He had taken a series of photographs of his own arm, hand, leg, torso and head in flasks of water some time before being asked to participate in the present project, though without having any particular finished artwork in mind. He decided to use one of the images for the screenprint and had his hand and forearm re-photographed by photographer Sue Ormerod. The viewer's initial reaction may be to see the image as a severed hand preserved in a jar, though the arm is not in fact cut and the caption specifies that it is the artist's own limb. Turk's work deals with issues relating to art and other artists, and to institutions such as museums. This work may be read as an ironic comment on the process of artistic creation and the way its products are seen, documented and preserved. Here the hand of the artist is preserved as if for posterity, much as an artist's work might be preserved in a museum.

Rachel Whiteread

BIOGRAPHY: Born London 1963. Studied at Brighton Polytechnic 1982–85 and Slade School of Fine Art, London, 1985–87. Solo exhibitions include Chisenhale Gallery, London, 1990; Stedelijk Van Abbemuseum, Eindhoven, 1993; and touring show beginning at Kunsthalle, Basel, 1994. Lives in London.

Mausoleum under Construction (after a photograph by Camilo José Vergara) (four-colour screenprint with mezzotint screens, 71 × 88cm; image size 55.6 × 79cm).

This was Whiteread's first print. She decided that she wanted to make a simple image via a photographic process rather than use drawing. Her initial idea was to photograph the primitive operating table in the Old Herb Garret, now preserved as a museum within St Thomas's Hospital, London. This project was subsequently shelved and instead she selected a very small photographic illustration of a mausoleum under construction, at Queen of Heaven in Southern California, published in a book on cemeteries called *Silent Cities* (Princeton Architectural Press). Booth-Clibborn obtained the original transparency from the photographer in America. The enlarged photograph was found to contain a coke-can in one of the sections, so this was edited out. Just as Whiteread uses the negative spaces of domestic objects and interiors to evoke feelings of memory and mortality, so these concerns are addressed in this screenprint.

Craig Wood

BIOGRAPHY: Born Leith, Edinburgh, 1960. Studied at Goldsmiths' College, London, 1986–88. Solo exhibitions include Laure Genillard Gallery 1990 and 1992; Städtisches Museum Abteiberg, Mönchengladbach 1992 and Kunsthalle Nürnberg 1993.

Safeway Gel Air Freshener, Alpine Garden (Detail) (one-colour screenprint with mouldcut sections and varnish, 66 × 86cm).

Wood trained as an architectural draughtsman and also made highly detailed drawings of archaeological finds. His current work offers an almost archaeological perspective on consumer society. In 1990 he began a series of 'drawings' of the enigmatic code numbers and logos printed underneath plastic cleansing containers, rendering them in the same computer-generated, dot-matrix typeface. Initially he drew the dots onto paper, but subsequently drilled into acetate sheets and later drilled the codes directly into walls. In 1992 he made a series of cut-out forms which developed out of the drilled drawings: the present 'print' relates to that series. The pattern replicates a section of the floral design found on a Safeway Air Freshener container. The screenprinted green colour denotes the 'Alpine Garden' variety; Wood has done larger pink and lilac versions after other fragrances in the Safeway range. The pattern on the container is an inoffensive, abstract form, symbolizing something fresh and natural, but the product itself is entirely synthetic and chemical: the irony is that it is designed to imitate nothing other than fresh air. Wood's work may be seen as a comment on late twentieth-century consumer culture, but is carried out with the objective rigour of the archaeologist.

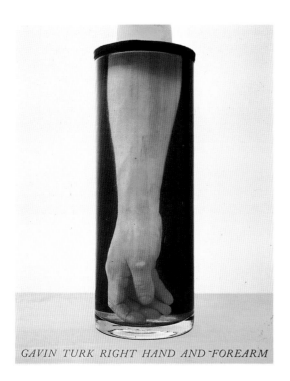

GAVIN TURK RIGHT HAND AND FOREARM

7 Quinn *Template for my future Plastic Surgery*

8 Taylor *Untitled*

9 Turk *Gavin Turk Right Hand and Forearm*

10 Whiteread *Mausoleum under Construction*

11 Wood *Safeway Gel Air Freshener, Alpine Garden (Detail)*

Roger Ackling *The First of Ten Two-Day Showings of Two Works Ten Years Apart*

1991

DESCRIPTION: A card.

EDITION: 250, distributed free.

INSCRIPTIONS: Signed, stamped and numbered by the artist on verso.

SIZE: 10.5 × 14.7 cm.

PAPER: 300gsm Parilux cream card.

TECHNIQUE: Off-set lithography.

PRINTER: Fernedge Printers Ltd., London.

TYPOGRAPHY: Designed by the artist in Gill Sans. Art-work by Phil Baines.

BIOGRAPHY: Born Isleworth, London, 1947. Studied at St Martin's School of Art, London. Solo exhibitions at Lisson Gallery, London, from 1976–84; Annely Juda Fine Art, London, from 1987; Centre d'Art Contemporain, Geneva, 1991. Has exhibited widely on the continent and in Japan. Lives in London and Norfolk.

Ackling's art is concerned with time and location. Since 1974 much of his work has been in the form of driftwood marked by the sun's rays by means of a magnifying glass. The burning marks run horizontally across the wood in precise, regular lines, responding to the particular form or character of the wood.

When Charles Booth-Clibborn invited Ackling to make a series of prints Ackling reluctantly declined, feeling that printing, and many of the ideals associated with printing (for example limited editions and technical sophistication) ran counter to the ideas that informed his art. Instead he suggested they make an exhibition. It was agreed that the exhibition would take place in the front room of Booth-Clibborn's house in Fulham, London, and that for practical reasons it would last just forty-eight hours.

Just as the sun's rays marking a piece of wood involves a time factor, so the time element was brought into the Fulham exhibition by agreeing to repeat it at ten-year intervals until the year 2081. While prints are made in limited editions, Ackling inverted the idea and made the exhibition itself into a limited edition of ten. The exhibition would consist of just two sun-marked wood pieces (the artist describes them as being in 'sunlight on wood'; both are untitled), neither of which would be for sale. It was not important that the same two works be shown at each subsequent exhibition, nor was it relevant that the same location in Fulham be used.

It was decided that a simple card, to be distributed free, would mark and embody the event. The card offered a solution to Booth-Clibborn's invitation to make a print yet did not compromise the artist's reluctance to work in a print medium. The finished card carries no aesthetic merit beyond the pleasing clarity of its typography, and has the appearance of a card one might receive through the post. The fact that it was free was also important.

Another element which appealed to Ackling was the personal one. Just as he enjoys the way his art brings him into contact with people, so the exhibition (and card) would help to sustain his contact and friendship with Booth-Clibborn since they would have to collaborate on an exhibition every ten years; this collaboration would even continue after both were dead. The exhibition will be repeated on 25 March 2001 at precisely 6pm.

THE FIRST OF TEN
TWO-DAY SHOWINGS
OF TWO WORKS
TEN YEARS APART

BY ROGER ACKLING
WITH CHARLES BOOTH-CLIBBORN
AT 92 HARWOOD ROAD, LONDON SW6

FROM 6 PM ON MONDAY 25 MARCH 1991 FOR 48 HOURS AND
THEREAFTER YEARS 2001, 2011, 2021, 2031, 2041, 2051, 2061, 2071, 2081

ウオルター
ロジャー
アックリング

EDITION 79. /250

front

verso

John Bellany *Images Inspired by Ernest Hemigway's 'The Old Man and the Sea'*

1987

DESCRIPTION: 14 prints (10 etchings and 4 screenprints), title-page and colophon, in portfolio bound in blue buckram.

EDITION: 60 sets numbered 1 to 60, issued in portfolio form, plus 15 sets numbered I to XV, which were split up and released separately, and 5 proof sets.

INSCRIPTIONS: Each print signed and numbered by the artist.

SIZE: 75.7×56.8cm or 56.8×75.7cm (paper size).

INDIVIDUAL DETAILS:
1. Crayon etching on steel, plate size 52.8×42.4cm.
2. Hardground etching on copper, plate size 52.8×42.4cm.
3. Hardground etching on zinc, plate size 48×32.1cm.
4. Crayon etching on steel, plate size 42×53cm.
5. Hardground etching on copper, plate size 53×42.4cm.
6. Screenprint, 75.7×56.8cm.
7. Hardground etching on zinc, plate size 48×32cm.
8. Crayon etching on zinc, plate size 32.2×47.6cm.
9. Screenprint, 75.7×56.8cm.
10. Screenprint, 56.8×75.7cm.
11. Hardground etching on zinc, plate size 32.2×47.8cm.
12. Crayon etching on steel, plate size 52.8×42.4cm.
13. Crayon etching on steel, plate size 52.6×42.4cm.
14. Screenprint, 75.7×56.8cm.

PAPER: 300gsm Somerset TP Textured.

TECHNIQUE: Hardground etching on zinc plates; hardground etching on copper plates; crayon etching on steel plates with substantial plate-tone; colour screenprints. Some aquatint on steel and copper plates.

PRINTER: Peacock Printmakers, Aberdeen. Etchings printed by Beth Fisher and Lennox Dunbar, screenprints by Arthur Watson. The printers were assisted by Charles Hynes and David Atherton. Printing co-ordinated by Arthur Watson. Title-page and colophon printed by Simon King, Cumbria, on an Albion Press.

BINDING: R.G. Scales Ltd., London.

TYPOGRAPHY: Title-page and colophon designed by Phil Baines in Monotype Baskerville.

BIOGRAPHY: Born Port Seton, near Edinburgh, 1942. Studied at Edinburgh College of Art 1960–65 and Royal College of Art, London, 1965–68. He has exhibited widely in Europe and the USA and has had major retrospectives at the Scottish National Gallery of Modern Art, Edinburgh, 1986, and National Portrait Gallery, London, 1986. Lives in London, Cambridge and Edinburgh.

Bellany first read Ernest Hemingway's *The Old Man and the Sea* when he was a student and was immediately struck by the closeness of the text to his own experience. The novel tells of an old fisherman who has caught nothing for weeks and then hooks the largest marlin he has ever seen. The fish drags the man's boat day and night until finally it is caught. The man straps the giant fish to the side of his skiff and sets for port, only for the boat to be attacked by sharks which pick the fish clean. The old man's respect for the noble fish and his battle to kill it (or be killed by it), their return to port in tandem, his efforts to defend it from the sharks: these themes may be taken as a parable of man's self-discovery and of his struggle with life and the elements. Bellany's father and both grandfathers were fishermen so for him Hemingway's short novel had a particularly strong resonance: he describes it as having 'hit a nerve inside'. Although he did not produce any work directly relating to the story at the time, Bellany acknowledges that it was flavouring his work over a long period.

Bellany began etching seriously in the early 1970s, when he was teaching at Winchester College of Art, and went on to make numerous single prints and portfolios. He had, however, made only one or two screenprints prior to the present project. It was partly on account of Bellany's portfolios published between 1983–85, *A Celtic Quintet*, *Haven* and *Homage to MacDiarmid*, that Charles Booth-Clibborn was inspired to set up the Paragon Press and embark upon a career in print publishing. Early in 1986 Bellany had contributed three etchings to *The Scottish Bestiary* (see pp.38–45), the first publication of the Paragon Press. In the winter of that year Charles Booth-Clibborn asked him to make a complete publication of his own choosing. At the time Bellany was housebound with a serious illness which led in 1988 to liver transplant surgery. Recognising the parallel between Hemingway's novel and his own predicament, he immediately thought of making a series of prints inspired by it. Just as the old man in the story drives himself to the brink of death, so Bellany had done the same with the heavy drinking which caused his illness.

Bellany worked on the prints from October 1986 to May 1987, ever conscious that the gravity of his illness meant that they might be among his last. Rather than make sketches for the prints he worked directly onto the plates and screens, ensuring that all his energy was channelled into the images. He paints in the same way, making, at most, only a small sketch before embarking upon a large canvas. He had no calculated idea of how many prints the portfolio might contain: when he had completed twenty-one prints he laid them out on the floor and selected fourteen, ten of which were etchings and four screenprints. For the prints he used three different types of etching processes, each of which gives a different quality of line: hardground with plate tone on zinc plates (which gives a robust line); hardground on copper plates (this gives a very fine line); and crayon etching on steel plates (this technique gives a broad line similar to lithography). He also made seven screenprints, four of which feature in the portfolio. The seven etchings which were not eventually incorporated into the portfolio were subsequently printed in editions of ten: some of them are in coloured inks (see Appendix I).

Bellany made most of the etchings and separations for the screenprints (done on acetate sheets) at his home in Clapham Common, though one or two were done in Edinburgh. When he had completed several works, Booth-Clibborn would collect the plates or separations and send them to Aberdeen for proofing by Arthur Watson at Peacock Printmakers. Watson, who had assisted Bellany in Clapham with production of the screenprint separations, would then send the prints to Bellany for checking. None of the etched prints were re-worked though Bellany did make changes to some of the screenprints once they had been proofed. One, the very dark horizontal image of the fish jumping in the air, went through nearly thirty proof stages before Bellany was satisfied with it. Asked about his approach and technical procedure, Bellany responded: 'I just did them. The technique was secondary - the imagery was the important thing. The technique adapted itself to the imagery. It really developed almost like a painting would develop – like a tidal wave. The whole thing evolved from start to finish.'

The publisher grouped the fourteen prints into a sequence which follows the development of Hemingway's narrative, but the artist does not see this order as being critical to the portfolio. He did not want to associate the imagery

too closely with his own life, though an autobio-graphical element does underlie them and the figure of the old man can clearly be identified as a self-portrait. The crayon etching bearing the title of the portfolio was conceived as a title-page or frontispiece but acts as the first print in the sequence. Hemingway's story features a second character, a fisherboy who is devoted to the old man. The arm-wrestler on the right in the sec-ond print is the artist's son Jonathan who may perhaps be identified with the fisherboy. Jonathan reappears in the third print as does Bellany's second wife, Juliet, who had died in 1985: she features in the painting of the crucifixion hanging on the wall. The remaining images correspond quite closely to Hemingway's text, referring as they do to the old man's self-doubt, to his capture of the fish and to his ill-fated return to port. The vertical-format etching of the man holding the boat's mast was sub-sequently developed into a large oil-painting.

Looking back on the project Bellany stated: 'I think I had been ruminating over it from the age of twenty – with all my experiences over a period of twenty-five years added to which I was in a life and death situation myself at the time. The imagery itself just flowed like a tidal wave from start to finish; and the passion in the work was magnified by the fact that I was struggling for my own life at the time. I was making these statements. The spiritual struggle somehow comes through by itself, I hope. Some of the prints were done in the middle of the night: it depended on when the inspiration struck. I was terrified to go to sleep at night in case I died in my sleep. I think that kind of angst – the anguish of the soul – permeates the whole portfolio. The portfolio is really reflecting my own voyage through life in some kind of way. When Hemingway was talking about the feelings of the fisherman when he had taken the life of this part-leviathan - it was a bit like a drowning man looking back over his life. Like the fisherman, I had destroyed my life myself.'

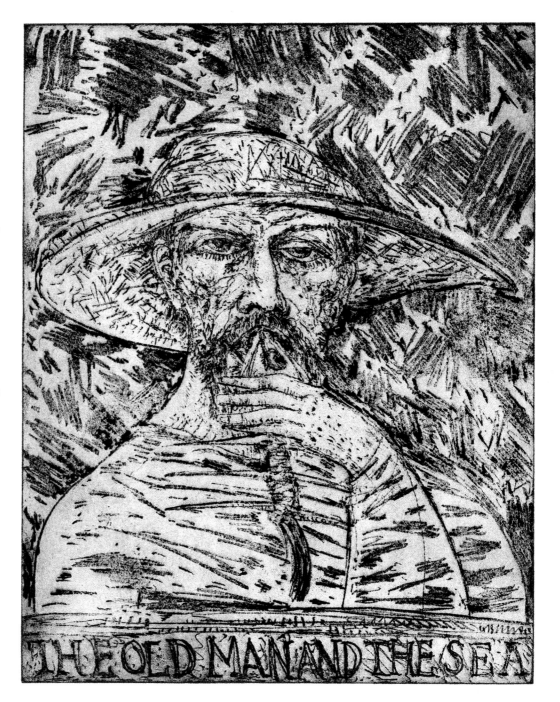

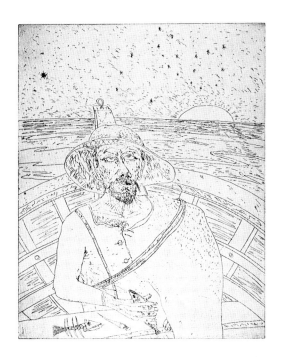

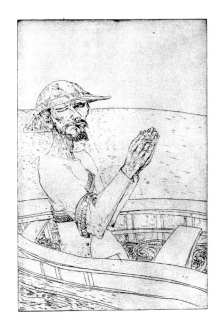

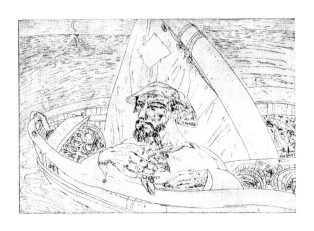

5 6

7 8

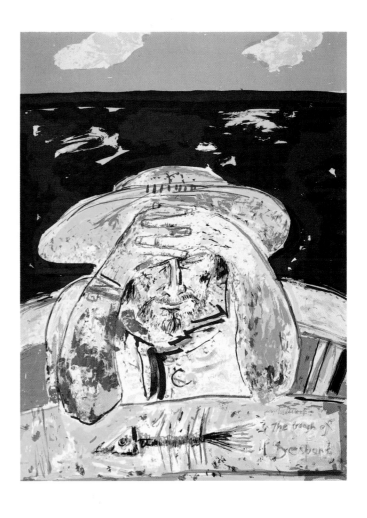

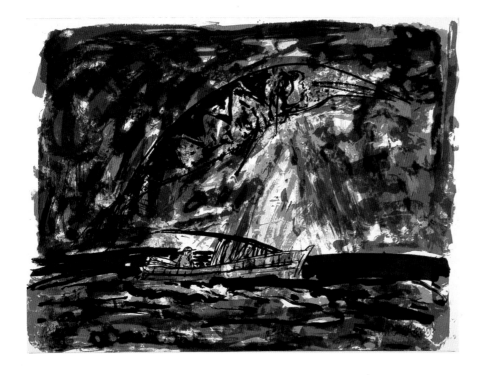

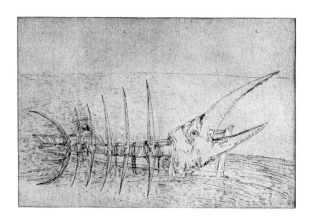

9

10 11

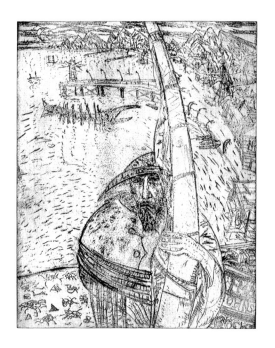

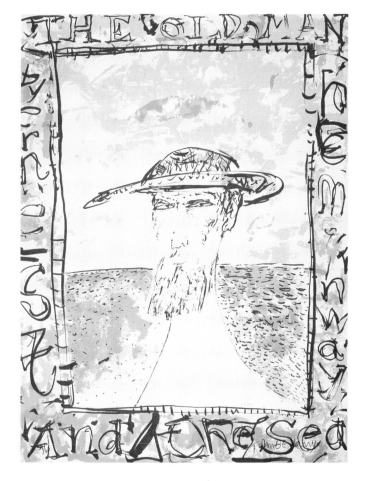

Victor Burgin *Fiction Film*

1991

DESCRIPTION: 9 video/computer originated duo-tone screenprints plus title-page, statement and colophon, in portfolio case bound in black buckram.

EDITION: 35 sets numbered 1 to 35 plus 10 proof sets.

INSCRIPTIONS: Certificate with each portfolio, signed and numbered by the artist.

SIZE: Each 75.5 × 95.2cm.

PAPER: 300gsm Somerset Satin.

TECHNIQUE: Three screens (white printed over whole sheet followed by two duo-tone mezzotint screens), varnish.

PRINTER: Coriander (London) Ltd.

BINDING: Made by Ryders, Bletchley.

TYPOGRAPHY: Title-page, statement and colophon designed by the artist in Times Roman, Helvetica, Helvetica Condensed and Matrix Wide.

BIOGRAPHY: Born Sheffield 1941. Studied at Royal College of Art, London, 1962–65, and Yale University, New Haven, 1965–67. Solo exhibitions include Stedelijk Van Abbemuseum, Eindhoven, 1977; Museum of Modern Art, Oxford, 1978; Institute of Contemporary Arts, London, 1986; Musée d'Art Moderne, Villeneuve d'Ascq, 1991. Has shown regularly at Lisson Gallery, London, from 1974; John Weber Gallery, New York, from 1977; and Galerie Durand-Dessert, Paris, from 1978. Moved from London to Sanda Cruz, California, in 1988; moved to San Francisco in 1991.

The series was conceived and made during 1991 when Burgin was staying in Paris, preparing a retrospective exhibition of his own work for the Musée d'Art Moderne at Villeneuve d'Ascq, near Lille in northern France. When Booth-Clibborn invited him to make a portfolio of prints (his first), Burgin chose to base it on André Breton's book *Nadja*, first published in 1928. Breton (1896–1966), the founder and theorist of the Surrealist movement, has been one of Burgin's abiding interests (the previous year he wrote an essay on Breton's *Nadja*, published in the journal *New Formations*). By coincidence when Burgin arrived in Paris in April 1991 to prepare his retrospective, a major exhibition about Breton's life and work had just opened at the Centre Pompidou.

Nadja, one of Breton's best-known works, tells the true story of his relationship with a mysterious young woman, Nadja, whom he first encountered on a Paris street in October 1926 and with whom he had a brief but passionate affair. Breton was struck by Nadja's disquietingly strange manner and speech, and by the originality of her responses to the everyday world around her. He found in Nadja the spontaneous and unaffected embodiment of those attitudes to the world which the Surrealists were self-consciously cultivating. (It transpired that Nadja suffered from schizophrenia. She was eventually confined in a psychiatric hospital.) Nadja also made bizarre drawings which compare with those the Surrealists themselves were creating.

Breton's book recounts their almost daily meetings in bars, their missed rendezvous and chance encounters, and, above all, their wanderings together through the streets of Paris. Burgin recalls that in the prints, 'I wanted a sense of the repetitious street-walking in all this finding, losing, pursuing and re-finding of Nadja, as she herself aimlessly wanders the streets of Paris.'

Burgin's prints are conceived as if they were out-takes from a lost film of Breton's *Nadja*. In a printed statement included with the portfolio, Burgin writes: 'We may reconstruct the lost film of André Breton's Nadja only in imagination, in the interstices of all that now remains of it: isolated frames from rejected lap dissolves, perhaps gathered by some infatuated assistant editor from the cutting-room floor – and which are themselves fictions.'

Since the late 1960s Burgin has worked principally with photographic and cinematic images. The images used in the *Fiction Film* series derive mainly from a video Burgin shot in Paris specifically for the project. The video was fed into a Macintosh computer which could capture individual frames from videotape and broadcast television. He also introduced images from the 1936 film *Pépé-le-Moko* (for example the kissing couple) and added a single image of a crashed car taken from a French television broadcast. The images were montaged using the computer and were subsequently made into screenprints at Coriander studios in London. The technique may be seen as a contemporary equivalent of the collage techniques developed by the Surrealists. Moreover, for Burgin the computer-collaged image is an analogue for the processes by which we mix and project images from memory, fantasy and daily life onto a mental 'screen'.

Many of the images in *Fiction Film* relate to specific passages in Breton's text. For example, the image of the bridge and river Seine relates to a walk Breton and Nadja took from the Palais de Justice to the Conciergerie, passing the exact point featured in the print. The scene behind the kissing couple is the Gare du Nord railway station where Nadja would have entered Paris from Lille (her home town), and near the place where she and Breton first met. The clock may evoke their various rendezvous in the bars and cafés of Paris. The crashed car relates to a long

footnote near the end of the book in which Breton recounts a car journey with Nadja and her attempt to make him crash.

Burgin's interest in the Surrealist movement is grounded in the fact that for the Surrealists (as for Burgin himself), aesthetic, political and theoretical issues were inseparable. Burgin has shown a consistent interest in codes of representation and sexual politics: much of his work is concerned with examining the conventions by which artists and film-directors portray women. Burgin remarks that Breton 'was the first of the political avant-garde to take sexuality seriously. He raised questions which others preferred to avoid, and which many avoid to this day.' The psycho-sexual dimensions of everyday life – indeterminately Breton's and/or Burgin's – are evident in *Fiction Film*. However, Burgin remarks, that such concerns are worked through in the print series in a less 'programmatic' way than they have been in his larger scale works made expressly for exhibition in galleries and museums.

We may reconstruct the lost film of André Breton's Nadja only in imagination, in the interstices of all that now remains of it: isolated frames from rejected lap dissolves, perhaps gathered by some infatuated assistant editor from the cutting-room floor – and which are themselves fictions.

Victor Burgin

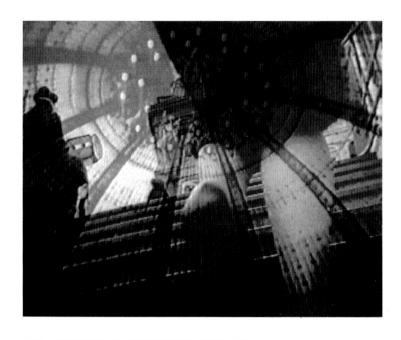

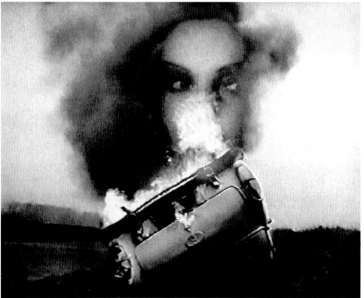

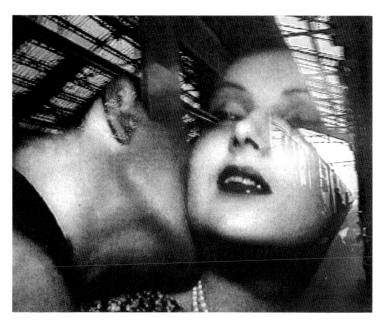

Alan Charlton *10 Grey Squares*

1991

DESCRIPTION: 10 screenprints, title-page and colophon, in portfolio case bound in grey cloth.

EDITION: 35 sets numbered 1 to 35 plus 10 proof sets.

INSCRIPTIONS: Each print initialled, dated and numbered by the artist on verso, and one print in each portfolio fully signed.

SIZE: 58.5 × 58.5cm (paper size).

PAPER: 300gsm Velin Arches.

TECHNIQUE: Each square printed from one silkscreen, some printed twice.

PRINTER: Coriander (London) Ltd. Title-page and colophon printed by Simon King, Cumbria, on an Albion Press.

BINDING: Made by Ryders, Bletchley.

TYPOGRAPHY: Title-page and colophon designed by the artist and Phil Baines in Gill Sans.

BIOGRAPHY: Born Sheffield 1948. Studied at Camberwell School of Art, London, 1966–69, and Royal Academy, London, 1969–72. Solo museum exhibitions include Stedelijk Van Abbemuseum, Eindhoven, 1982 and Museum Haus Esters, Krefeld, 1992. Has shown regularly at Galerie Konrad Fischer, Düsseldorf, from 1972 and Galerie Durand-Dessert, Paris, from 1978. Lives in London.

Prior to this project Charlton had made only three printed works, all of them connected with exhibitions. These were a poster for the Van Gogh centenary in Amsterdam in 1989; a print and poster for Charlton's own exhibition at the Palais des Beaux-Arts in Charleroi, Belgium, in 1989; and a print commissioned by the Schaffhausen museum for his 1991 exhibition. All three prints were in grey, the Van Gogh poster being grey mixed with yellow ochre, to give a relationship to the work of Van Gogh.

Charlton began making uniformly grey paintings in 1969. They are square or rectangular, vary in size from small to large, and are in shades of grey. There is no implied metaphorical or spiritual content in the work beyond their existence as grey paintings of differing size, shade and form. They are paintings which assert their presence as paintings. In a recent interview Charlton remarked: 'I am an artist who makes a grey painting.[...] One of the most important, or perhaps the most important quality that the work has to maintain is about an honesty, and an honesty to the space that it exists in, to the way that it's made, to the intentions of how you look at it.'

A series of Charlton's paintings begun in 1969 featured small square holes near the corners and edges of the canvas, while another series (the *Slot* series, begun in 1971) had narrow channels running down or across the edge or centre of the painting. All were made on canvas supported on 2 × 1 inch wooden stretchers, and it was the size of the stretcher which gave Charlton the unit on which his work is based. Once the stretcher had been planed to accommodate the canvas, it was 1¾ inches deep. Just as the stretcher was precisely 1¾ inches deep, so the pierced squares and channels are precisely 1¾ inches wide and deep and at a distance from the edge of the canvas that is divisible by 1¾ inches. The total size of all these paintings is also divisible by the same unit of measure. In a series of paintings begun in 1975 consisting of two or more grey panels, the gap between each panel was 1¾ inches. In 1978 Charlton adopted the 4.5cm metric equivalent of the stretcher, and that year made a series of what he titled *Detail Paintings*, which were exactly 9cm square and 4.5cm deep.

In 1989 a French publisher invited Charlton to make a limited edition book. The principle behind the series was that each copy would be unique. So, for example, one artist who participated in the series contributed drawings for reproduction and added an original drawing on the final page. Since the early 1970s Charlton has kept small canvas samples of all his grey paintings which constitute a kind of catalogue of his work. For the book project he gave the publisher fifty of these canvas samples, all in varying shades of grey, and these specific shades were exactly copied for the cloth covers of the book making each copy unique. The book itself featured linear drawings of Charlton's paintings.

The Paragon project united aspects of Charlton's approach to painting and the principle adopted in the book. The ten squares are all based on the 4.5cm unit, the smallest square being 9cm, and the size of the other squares increasing by 4.5cm, so that they measure 13.5cm, 18cm, 22.5cm, 27cm, 31.5cm, 36cm, 40.5cm, 45cm and 49.5cm. The paper itself is 58.5cm square, 9cm larger than the largest grey square. All the grey tones are precise duplicates of the tones used by Charlton since the early 1970s (Charlton gave the publisher colour samples of ten canvases) so that they are, effectively, reduced, printed versions of a range of his own paintings. The works can be hung in any order, though the intention is that the order be random: in the portfolio they are not stacked according to size or tone. While he was finishing the ten grey prints he began a series of ten grey paintings of exactly the same size but with a different tonal range.

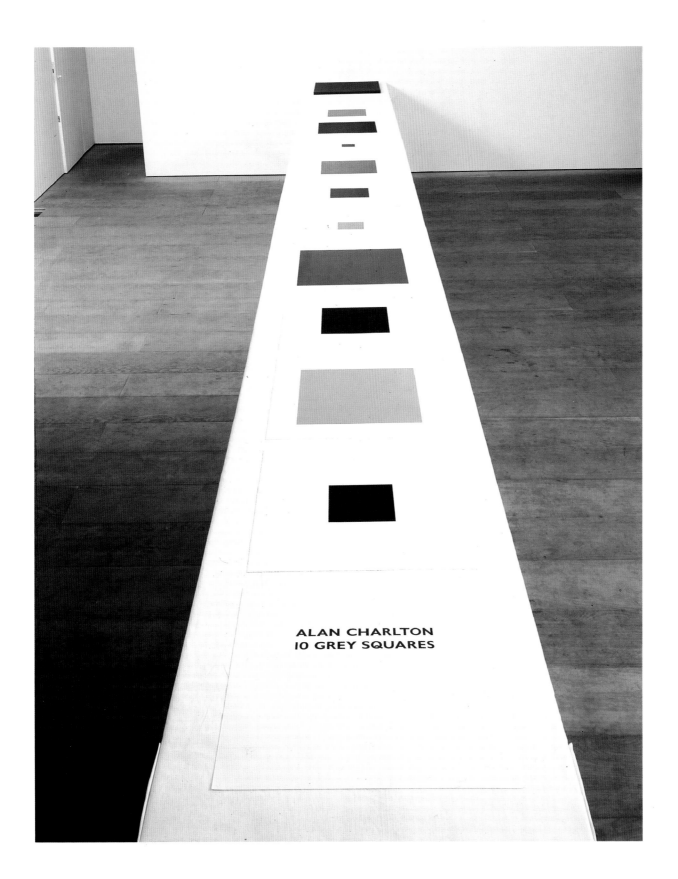

Portfolio launched at the Victoria Miro Gallery, London, September 1991.

Ken Currie *Story from Glasgow*

1989

DESCRIPTION: 97 black-and-white linocuts, linocut frontispiece and colophon page, all cut by the artist. Book version in slip-case bound in black buckram; portfolio version in solander box bound in black buckram.

EDITION: Book in edition of 50, numbered 1 to 50, plus 5 proof copies; portfolio in edition of 45, numbered 1 to 45, plus 5 proof copies.

INSCRIPTIONS: Book signed and numbered by the artist on colophon page; each print in portfolio signed and numbered by the artist on recto.

SIZE: 43×32.2cm (paper size). All images 29 × 25cm except frontispiece 40.5×30.3cm.

PAPER: 225gsm Zerkall.

TECHNIQUE: Linocuts cut by the artist. All printed in black.

PRINTER: Simon King, Cumbria, on an Albion Press.

BINDING: Book in paper wrappers hand-sewn by Simon King. Slip-case and solander box made by Perstella Ltd., Dorset. Two special bindings made for the book, one by Charles Gledhill, another commissioned by the Contemporary Art Society from Romilly Saumarez-Smith.

BIOGRAPHY: Born North Shields, England, 1960, to Scottish parents; the family moved to Glasgow shortly after his birth and subsequently settled in Barrhead. Studied at Glasgow School of Art 1978–83. In 1987 completed six large murals for the People's Palace, Glasgow. Solo exhibitions include several held at the Raab Gallery in Berlin and London from 1988 onwards. Lives in Glasgow.

The following statement by the artist, dated 3 September 1989, was issued on a fold-out brochure which coincided with the publication of *Story from Glasgow*:

'I had always been interested in attempting a "story without words" after seeing the brilliant work of the Belgian woodcutter Frans Masereel. Yet I could never find an appropriate story to tell.

'However, one night in Glasgow about five years ago whilst leaving a city centre bar, I was confronted by an old man outside. I had seen this old man several times before, wandering around the city. He was obviously 'down and out'. He asked me for some money. I gave him a little then asked him what he was doing out there. He blurted out his story: once a skilled worker in the 'Caley', Glasgow's British Rail engineering works at Springburn; a union organiser with a wife, a good home and a flourishing social life. Suddenly his wife died. This was a terrible blow as he loved her dearly. With no immediate family to support him he quickly became depressed, losing his job in an industrial accident, losing his house through mounting debt, becoming an alcoholic and ending up leading a squalid life in the streets of Glasgow.

'Eventually he left Glasgow for London where his situation became worse, nearly dying through starvation, exposure and alcohol poisoning. After a prolonged period of hospitalisation he returned to Glasgow to rebuild his life. Unable to get a start again he was still on the streets and pessimistic about his future. After pouring all this out he burst into tears and wandered off into the night. [...]

'I hope I have done justice to this story, in the tradition of Frans Masereel's novels without words.'

The project was begun in the summer of 1988 and took about a year to complete. It is Currie's most important printed work to date. At an early stage he decided that the prints should be in black and white. He was keen that the images should have a certain rawness and energy, to suit the subject, and therefore chose to work in linocut, which is a very straightforward, immediate and graphic medium: his decision was made in spite of the fact that he had not worked seriously in that medium before. Currie's wife, Marie Barbour, has worked extensively with linocut, and this influenced his choice.

Currie had first seen the narrative woodcuts of Frans Masereel (1889–1972) in the Glasgow School of Art library. Although Currie specialised in painting at the School of Art, he also took a keen interest in film, taking film-making as his secondary subject. The classics of European cinema have had a lasting impact on his painting and graphic work, and it was the cinematic quality of Masereel's prints that particularly impressed him. References to the work of Fernand Léger and Otto Dix, two artists who have influenced Currie's work, can also be found in some of the prints in *Story from Glasgow*.

Currie initially envisaged making just ten to fifteen prints, but the total number eventually grew to ninety-seven. Without writing the story down or plotting the sequence of images, he began with the first print and simply let the story run its course. He acknowledges that: 'It was almost a naïve approach – I didn't calculate anything'. Moreover, the image size had

been determined by the size of the linos he was provided with, rather than by a calculated decision on the artist's part.

Currie made tiny thumb-nail sketches for each print, then painted the broad elements of the composition onto the lino in black gouache. He would heat the lino up over a bar-fire, in order to soften it, before cutting each print. He made one sketch and print per evening at home, after returning from his painting studio: each one – from sketch to finished linocut – took about an hour and a half to do. Most were made while the television was on, in a deliberate attempt to make them direct and raw: 'Any that were becoming too calculated tended not to work… I wanted them to be absolutely raw – something that would flash up on a screen momentarily.' Very few of the blocks were rejected, though some had to be re-worked after proofing.

Having studied film, Currie was conscious of the need to create different levels of pace within the narrative sequence: thus some of the prints are densely-worked and require detailed examination, while others have a more direct, immediate impact, and others are of a more contemplative character. Working in this way, Currie managed to vary the rhythm of the story and enhance the dramatic element. Towards the end of the project Currie began to do two blocks per evening and up to five a day at the weekend. When he had made a batch of about ten linocuts he would send them to the printer, Simon King in Cumbria, who would proof and return them.

The man's tale was related to Currie in only a few minutes and therefore acted as a point of departure rather than as a narrative which had only to be illustrated. Currie expanded, embroidered upon, and re-created the story in visual terms, and also invented many of the situations, while still remaining true to the spirit of the story he had been told. For example, although the man worked as an engineer for British Rail, Currie chose to depict him working on a production line in a television factory, in order to create the feeling of repetitive, soulless work. Most of the cityscapes in the background of the prints are based on buildings in the east end of Glasgow where the artist has his studio. In the last prints the man is shadowed by an almost medieval, skeletal figure who beckons him on to his death; as he does so, the figure of the protagonist becomes more and more skeletal itself.

Printing all the blocks for *Story from Glasgow* was an immense task, since there are one-hundred-and-five sets of ninety-seven prints (plus frontispiece and colophon), making a total of more than 10,000 individual prints. They were hand-printed by Simon King who took six months to produce the entire edition and sew the bindings. All the prints in the portfolio edition were individually signed. Currie had originally planned to print the cover in red and black ink but this proved problematic and the idea was abandoned.

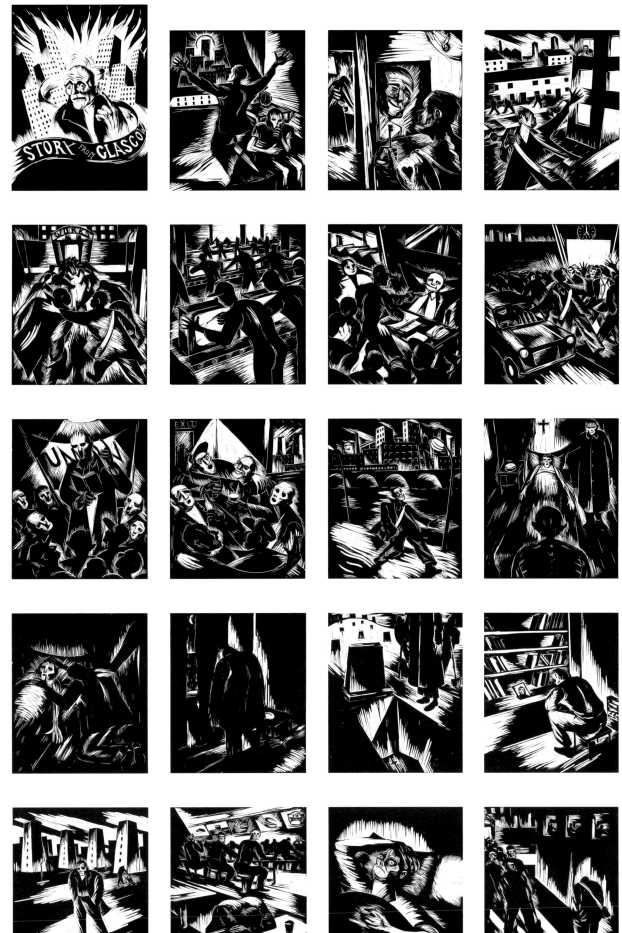

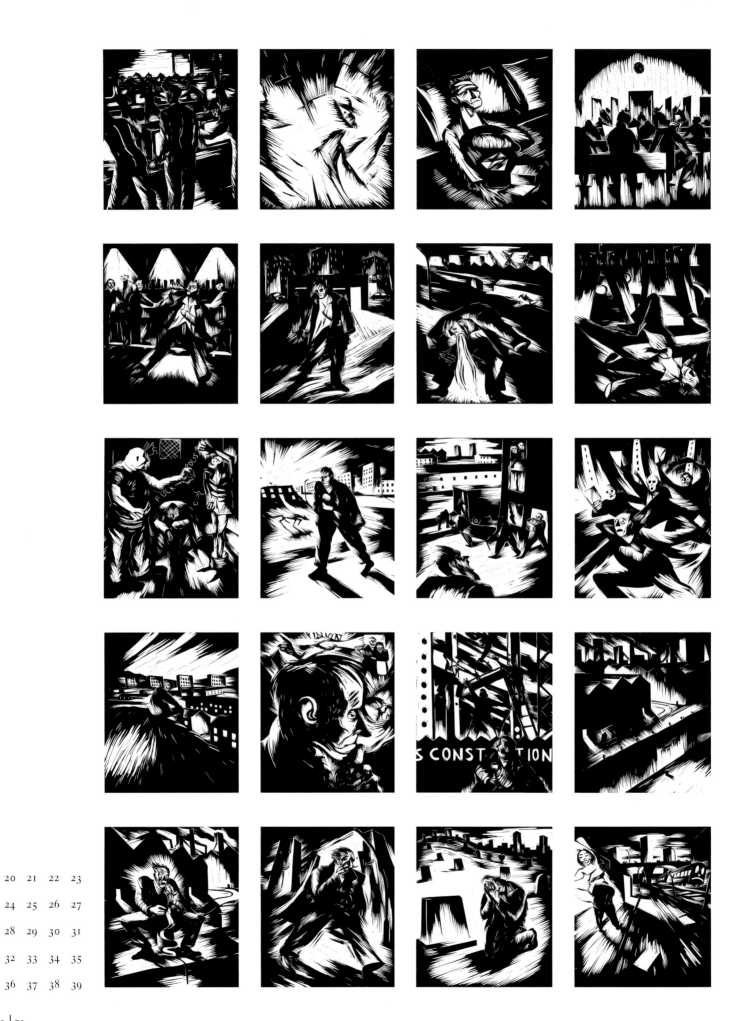

20 21 22 23

24 25 26 27

28 29 30 31

32 33 34 35

36 37 38 39

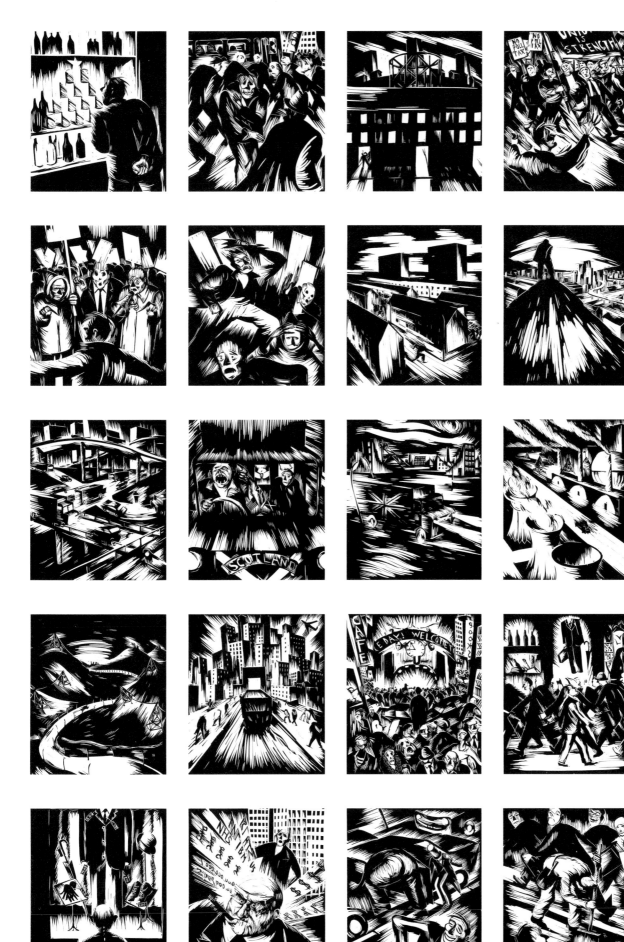

40 41 42 43
44 45 46 47
48 49 50 51
52 53 54 55
56 57 58 59

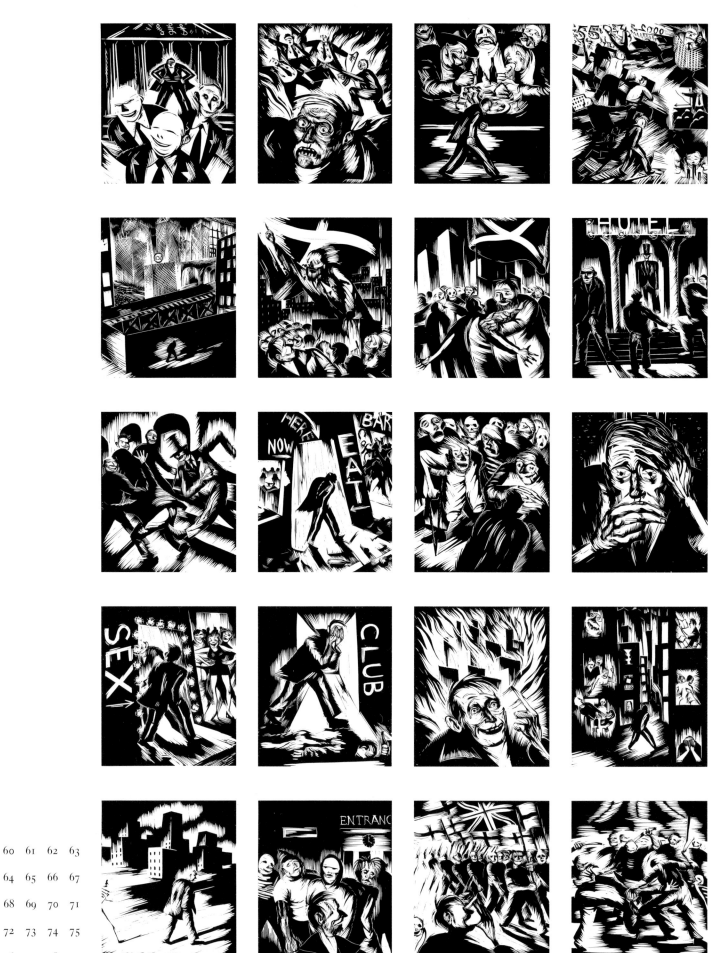

60 61 62 63

64 65 66 67

68 69 70 71

72 73 74 75

76 77 78 79

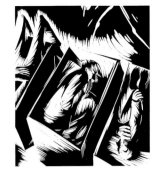
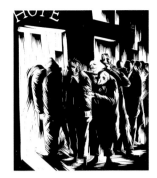

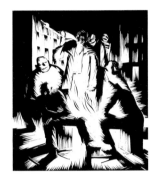
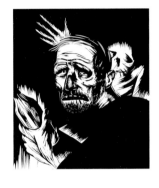
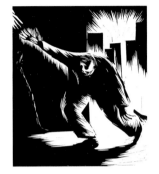
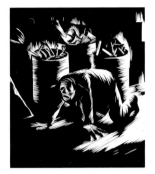

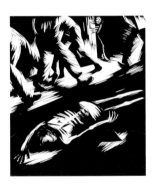
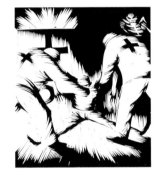

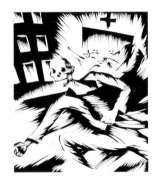
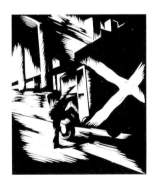

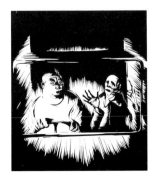
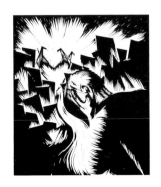

STORY FROM GLASGOW
by
Ken Currie
The portfolio of 97 linocuts were
printed by Simon King on an Albion
Hand Press. All the linocuts including
the title and colophon pages, were cut by
the artist. The paper is 225 gsm
Zerkall. The portfolio has been
printed in an edition of 45 copies
only, plus 5 proof copies. Each print
is signed and numbered by the artist.
Story from Glasgow has been
published by Charles Booth-Clibborn
under his imprint The Paragon Press.
©Ken Currie and The Paragon Press, 1989.

Grenville Davey *Eye*

1993

DESCRIPTION: 6 screenprints in three pairs, the images originated through computer-animation.

EDITION: 40 sets numbered 1 to 40 plus 10 proof sets. Released either as set of six or in pairs.

INSCRIPTIONS: Each print signed and numbered by the artist on verso.

SIZE: Pairs A and B 72 × 83.5cm; pair C 86.5×72cm.

PAPER: 300gsm Somerset Satin.

TECHNIQUE: Photographs fed into Kodak Photo-Disk system and transferred to Apple Macintosh II F x System. Images computer analysed with Acute Focussing and Gauzian Blur techniques. Information digitalised and used to generate colour separations from which screenprints made. The first print of pair A is a 14-colour silkscreen with varnish, the second 11 colours and varnish; the first of pair B has 13 colours and is partially varnished, the second 9 colours and varnish; the first of pair C has 11 colours and spot varnish, the second 10 colours and spot varnish.

PRINTER: Coriander (London) Ltd., London. The computer work was originated with Mark Lucas at After Image, London.

BINDING: None

BIOGRAPHY: Born Launceston, Cornwall, 1961. Studied at Exeter College of Art and Design, 1981, and Goldsmiths' College, London, 1982–85. Solo exhibitions include Lisson Gallery, London, in 1987 and 1989; Kunsthalle, Bern, 1989; Württembergischer Kunstverein, Stuttgart, 1993. Won Turner Prize 1992. Lives in London.

The sculptor Grenville Davey had not made prints for some twelve years (when he was at art school), prior to embarking upon this project. He does, however, make large numbers of drawings though these have rarely been exhibited. Although he had never worked with computers before, Davey decided to use computer technology for this project, which was begun early in 1993 and finished nearly a year later.

Davey visited the Coriander screenprinting studios in Acton, west London, in order to investigate the various options open to him and discuss how computer technology might be used in the creation of prints. He had heard about photo-CD technology, which had recently come on to the market, and went to the After Image studios in Brixton (where he has his studio) to see it in operation.

By this time Davey had decided to base his project on two objects, a glass eye and a glass bottle-stopper. Although he is not a hoarder or collector of objects, these two things had been in his studio or home for some time and he had thought of using them in a work. 'What I was intent on was the relationship between the stopper and the dead glass eye: the two are so closely and obviously related. The stopper is a stylized eye. What I liked about it was the light in the object (it looks like a lightbulb), the bubbles, and that the stopper had more light in it than the eye. A human eye is a fluid thing while a glass eye is an unsuccessful object – perfectly formed but artificial and it doesn't work. The stopper has a lot of the life you would expect to find in its partner, the eye. I like that ambiguity.'

Davey had frequently used circular forms in his sculpture and has used the eye form in particular on several occasions, for example in *Castellated Eye*, *⅓ Eye* and *3 Minute EYE*. These works suggest something that is at once human, mechanical and dysfunctional, and the same concerns are brought together in the *Eye* screenprints. In his sculpture Davey has often paired enigmatic, abstract forms together, thus inviting the viewer to make a connection between them, but providing few clues as to what the connection might mean. Again, this concern with relationship, similarity and difference is embodied in the glass eye and glass stopper pictured in *Eye*.

A few days before photographing the objects, the original glass eye broke. Lamenting his bad luck, Davey went out for a drink and, bizarrely, encountered a man who had a large collection of glass eyes! He selected several replacements but decided on a brown one: 'It seemed inappropriate to use live colours like green or blue. The brown is a kind of average.'

Davey mounted the two objects on plasticine bases and had them photographed on 35mm film in forty different positions. The film was then fed into a computer animation programme through a Kodak Photo-Disk system, and this in turn was transferred onto an Apple Macintosh II F x System at the After Image studio. Davey then spent several days at the studio. On the screen he could 'paste' the images into rows, enlarge and alter them. He began working on Pair C, in which 'the stopper looks as if it's falling and rotating, and the eye as if it's in the dark and is watching it fall: it's rather cinematic.' Large photocopies could be taken from the computer, and Davey did much of the work directly on these, cutting and re-pasting the paper, whilst the technicians translated these ideas into the computer.

The other print pairs, in which the computer images of the eye and stopper are examined in close detail (a technique called 'acute focussing'), were made later. As the computer images of the eye and stopper are interrogated through enlargement, so the pixels which make up the image become more apparent and the object loses its identity. It is as if the process of examination and analysis made one understand less, rather than more, about the object – or showed that the object resisted comprehension. This sense of frustrated meaning is paralleled in the glass eye itself, which pretends to gather information, as a real eye does, but on closer inspection is found to be functionally useless. The second print of each pair was done with a computer technique called a 'gauzian blur' which serves to throw the image out of focus.

All the information was digitalised and stored on disk. The edited images were then output from the computer as full-size photo separations. From these, screens were made for screenprinting at Coriander print studios. Davey edited the images and colours quite extensively, darkening or lightening the pixel forms and adding spot-varnishes through stencils to bring the eye and stopper out from the background.

Reflecting on the work, Davey observed: 'It was a very simple computer animation technique and sequence. I didn't want it to be complex. [...] It relates in very concrete ways to what I've been thinking about for four years. That's why it's successful. I found it easy to tie it in with the work I was doing at the time. They're a part, an extension of the sculpture.'

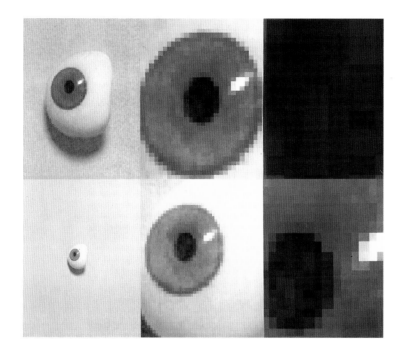

Pair A

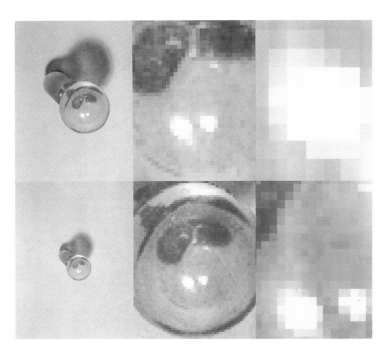

Pair B

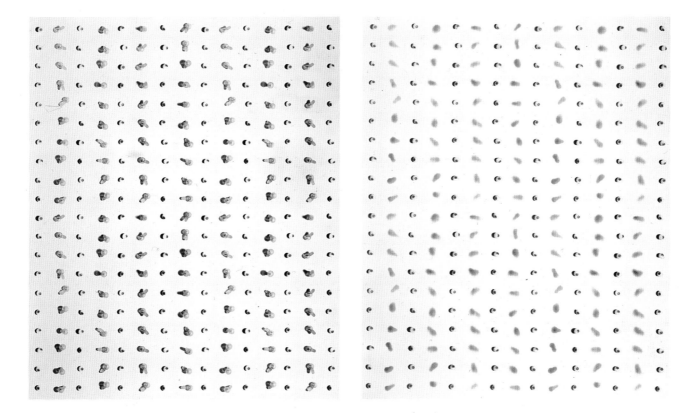

Pair C

Alan Davie *Magic Reader*

1988

DESCRIPTION: 18 two-colour lithographs, frontispiece (screenprint with collaged title) and colophon in book and portfolio editions. Portfolio bound in purple cloth with gold lining; book cover and slip-case both bound in purple cloth with gold linings.

EDITION: Book in edition of 50 copies numbered 1 to 50 plus 3 proof copies; portfolio in edition of 45 copies numbered 1 to 45 plus 3 proof copies.

INSCRIPTIONS: Book edition signed and numbered by the artist on colophon page. Colophon and each print in portfolio edition signed and numbered by the artist.

SIZE: 42.6 × 34.8cm (paper size for book and portfolio editions).

INDIVIDUAL IMAGE SIZES:
1. 20.2 × 18.7cm; 2. 26.3 × 25cm;
3. 15 × 17.5cm; 4. 26.8 × 30cm;
5. 25.4 × 28cm; 6. 24 × 28.5cm;
7. 30 × 28cm; 8. 30 × 24.8cm;
9. 29.8 × 27.5cm; 10. 19 × 28.5cm;
11. 28.5 × 24.5cm; 12. 21 × 25cm;
13. 34 × 28cm; 14. 20.5 × 25.5cm;
15. 28.5 × 30.5cm; 16. 27.5 × 29.5cm;
17. 19 × 28.5cm; 18. 37 × 30cm.

PAPER: 270gsm Arches Velin.

TECHNIQUE: Transfer lithography (two colours) on zinc plates.

PRINTER: Lithography by Ian Lawson, Herefordshire, on a water-powered, Maun direct litho-press; screenprint frontispiece by Arthur Watson, Peacock Printmakers, Aberdeen; colophon by Simon King, Cumbria.

BINDING: Designed by the artist, made by Cathy Robert.

BIOGRAPHY: Born Grangemouth 1920. Studied at Edinburgh College of Art 1937–40. Served in Royal Artillery 1940–46 and developed strong interest in poetry and jazz music. Travelled throughout Europe 1947–48. From late 1940s developed gestural, abstract style, related to American Abstract Expressionism, but has subsequently developed an art uniquely his own. Has exhibited regularly with Gimpel Fils Gallery, London, from 1950 and has had numerous solo exhibitions throughout the world, including retrospectives at Whitechapel Art Gallery, London, 1958; Stedelijk Museum, Amsterdam, 1962; Musée d'Art Contemporain, Montreal, 1970; McLellan Galleries, Glasgow, 1992. His work is represented in the world's major museums. Lives in Hertfordshire and Cornwall.

Davie has made brush drawings in black ink and gouache throughout his career and since the early 1960s has used them as the starting point for colour gouaches and large oil-paintings. He began the present project by making hundreds of brush drawings in black gouache over a period of several months. These developed in a very automatic way, ideas suggested in one drawing being elaborated upon in the next. From these drawings Davie selected eighteen works which acted as prototypes for the lithographs.

In making the lithographs Davie used the brush drawings as a guide but did not copy them with any precision. He drew on transfer paper and these images were then transposed, in reverse, onto zinc lithographic plates (had the artist drawn directly onto the zinc plates the script would have been printed back-to-front). They were the first prints he had made since the early 1970s. Davie tried a variety of background colours before settling on a buff colour which is a mixture of ochre and black: he normally primes his canvases with a similar hue, using it as an overall unifying colour.

The images in *Magic Reader* and in much of Davie's art from the late 1970s onwards were inspired by ancient symbols such as spirals, ankhs and crosses, found in the art of diverse cultures and civilizations from prehistoric to present times. His many sources include Aboriginal art, illuminated manuscripts, the paintings of cavemen, Celtic designs, and the art of the American Indians; religious, alchemical and occult symbols also feature. Of particular importance to Davie were the petroglyphs (engraved rocks) of the Carib Indians of South America. In St Lucia, originally a Carib island, where he and his wife Bili had a second home, a friend had shown him a Venezuelan book on

these petroglyphs (*El Disegno en los Petroglifos Venezolanos* by Jeannine Sujo Volsky). Not only did Davie begin to incorporate the illustrated motifs into his work of the late 1980s, but he also included phrases from the Spanish text and, in *Magic Reader*, even introduced wording found in the bibliography. Turning the pages of the book he would come across words and phrases which he only half-understood (he scarcely reads Spanish), but which were richly suggestive and fired his imagination. He also included invented words and added French and English texts. Of the process he remarks: 'A lot of it is spontaneous, automatic poetry: the words become attached to the imagery. The word isn't consciously related to the imagery but it immediately relates itself. The imagery is all very mysterious, but vaguely familiar. It is a mysterious language which is enigmatic and which is shy of intellectual interpretation.' The meaning of many of the phrases incorporated into the prints can be understood or guessed at by non-linguists: 'invocaciones magicas'; 'sistemas de escritura; 'el secreto'; 'simbolo de fecundidad femenina'. Together, the words and symbols work in suggestive, sometimes contradictory ways, inviting the viewer to make connections between them, though never insisting upon specific readings. In two of the images we even see a little figure, who may represent the reader, holding his arms up in wonder at the richness, power and mystery of the symbols.

Davie has studied the origins and meanings of ancient pictorial symbols in depth, and went to Venezuela to see the Carib petroglyphs for himself. One aspect of these symbols which delighted him was their interchangeability: for example, the ankh symbol (a cross with a loop at the top), is a sign for sandals in early Egypt and a symbol for life in a later dynasty; and the spiral form can be found in cultures throughout the world, though each interprets it differently. This depth of meaning and interchangeability of symbols – and the possibility that they are, at a subconscious level, all related, fascinates Davie and is one of the main inspirations in his art. Symbols are for him a fantastic dictionary or vocabulary, though he does not use them in a systematic way. As the title *Magic Reader* implies, this is no ordinary book and the images are not codes made to be broken. Rather we are invited to wander among the strange symbols and discover a mysterious realm of magic.

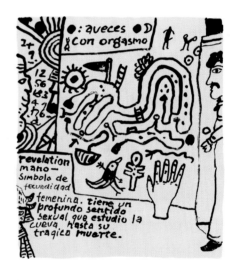

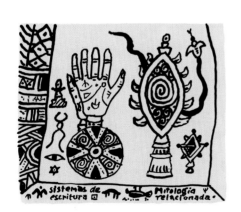

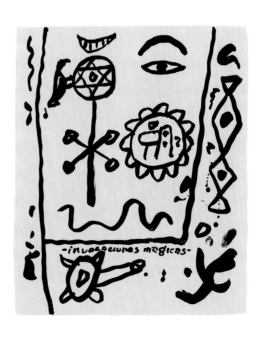

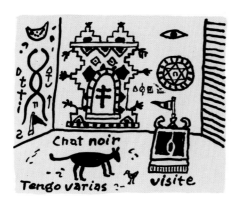

Number 26 of an edition of 45 copies.

The folio contains 18 original lithographs
printed by Ian Lawson
on 270 gsm Vellum Arches paper
on a water powered Mann Direct Press.

The frontispiece has been screenprinted
from the artist's original design
by Arthur Watson, and the colophon
also designed by the artist, printed
by Simon King.

The portfolio case was made by
Cathy Robert to the artist's design.

Published in an edition of 45 copies
with 3 extra copies for the artist,
printer, and publisher,
all signed and numbered by the artist
1 to 45.

A bound book edition of 50 copies has
also been published.

MAGIC READER was published by
Charles Booth-Clibborn in 1988
under his imprint THE PARAGON PRESS

© THE PARAGON PRESS and ALAN DAVIE

14 15

16 17

18

Terry Frost *Trewellard Suns*

1989

DESCRIPTION: 8 linocuts (2 with hand-colouring/pencil additions by the artist) and colophon, in portfolio case bound in blue buckram with circular cut-out orange cloth inlay.

EDITION: 40 sets numbered 1 to 40 plus 5 proof sets. First 30 sets issued in portfolio form.

INSCRIPTIONS: Each print signed, dated and numbered by the artist.

SIZE: 63.5×63.5cm (paper size).

INDIVIDUAL DETAILS: 1. two-colour linocut; 2. five-colour linocut (image size 46.5×38cm); 3. four-colour linocut; 4. two-colour linocut with pencil; 5. two-colour linocut with gouache; 6. two-colour linocut; 7. three-colour linocut (image size 43×44cm); 8. four-colour linocut (image size 30.5×47.8cm).

PAPER: 225gsm Zerkall.

TECHNIQUE: Linocut cut by the artist. One of the prints has hand-colouring, another has pencil additions.

PRINTER: Vivien Hendry, London, on a Columbia Press. Colophon printed by Phil Abel.

BINDING: Designed by the artist, made by Charles Gledhill.

TYPOGRAPHY: Colophon designed by Phil Abel in Monotype Bembo, incorporating a printed text written in reed pen by Frost.

BIOGRAPHY: Born Leamington Spa 1915. Prisoner of War 1941–45 when he was encouraged to draw by artist Adrian Heath. Studied art in St Ives 1946–47, and Camberwell School of Art, London, 1947–50, then moved to St Ives. Lived in Leeds 1954–57 and subsequently taught in Coventry and Reading. Bought a studio in Newlyn, Cornwall, in 1974, and has lived there permanently since 1981. Solo exhibitions include Leicester Galleries, London, 1952; Arts Council touring exhibition 1976; Mayor Gallery, London, 1994.

Frost has made many monotypes, lithographs and screenprints since the late 1940s and early 1950s. He made a number of linocuts from about 1951–54 but has rarely used the technique since, except in making Christmas cards. The prints in the *Trewellard Suns* series are his first major linocuts of recent years and are his largest to date. Moreover, *Trewellard Suns* is only Frost's second print portfolio, the first being the *Lorca Portfolio*, also published in 1989.

The sun has been a recurring motif in Frost's work since 1950, when he moved to St Ives in Cornwall. At his hilltop home in the small fishing-port of Newlyn, he can see the sun rising over the Lizard in the east and setting in the west over the tin-mines near the village of Trewellard in the evening. Prior to being asked to make this series of images Frost had been visiting Trewellard regularly and was working extensively with the circle/sun motif.

He chose the linocut medium because with it you can obtain very deep, solid colours. Frost often paints onto his prints and on two of the *Trewellard Suns* linocuts he made additions in watercolour and pencil. One print in particular, of the circular, orange sun, is surrounded in the illustrated print with swirls of green watercolour, while in other versions of the print he used completely different colours. He remarks that just as the sun changes colour as it sets, creating different moods, so he wanted to exploit the possibilities of linocut and vary the colour of this print to create different moods. Two of the linocuts feature a semi-circular boat shape in the foreground: this motif recurs in different guises throughout Frost's entire oeuvre.

The prints were made between August and October 1989 and were cut at Frost's studio in Newlyn where Vivien Hendry proofed them by hand. Frost produced several other linocuts at the time, printing only one of each by rubbing the paper with the back of a spoon. He selected eight prints for the portfolio: they have no particular sequence. From 1989–92 Frost made a large number of paintings on paper relating to the imagery established in the *Trewellard Suns* portfolio.

I

2 3

4 5

7 8

3⁶/₂₀ Terry Frost 90

Hamish Fulton *Fourteen Works 1982–89*

1989

DESCRIPTION: 14 off-set lithographs in portfolio case bound in black buckram.

INDIVIDUAL TITLES, DATES AND SIZES:
1. *Untitled*. Australia 1982. 46.5 × 111cm.
2. *Mountain Skyline*. Nepal 1983. 86.5 × 99.3cm.
3. *Untitled*. Alberta 1984. 72 × 101.6cm.
4. *Seven Winds*. Scotland 1985. 107 × 82.9cm.
5. *Untitled*. Japan 1986. 98.1 × 68.9cm.
6. *Untitled*. Brittany 1987. 47 × 110.7cm.
7. *Untitled*. 21-Day Walk 1987. 38.2 × 111.8cm.
8. *Fourteen Coast to Coast Walks*. British Isles 1971–87. 98.3 × 70cm.
9. *Full Moon*. Kent 1988. 72 × 99cm.
10. *Rock Fall Echo Dust*. Baffin Island 1988. 104.2 × 88cm.
11. *No Thoughts Counting Seven Paces on Senjoh Dake at Sunset*. Japan 1988. 60.4 × 101.7cm.
12. *Twenty-One Walks Walking from One to Twenty-One Days*. Various countries 1971–88. 70.6 × 111.8cm.
13. *Dead Dogs*. Portugal and Spain 1989. 80 × 111.8cm.
14. *Untitled*. Nepal 1989. 78.7 × 95.8cm.

EDITION: 35 sets numbered 1 to 35 plus 10 proof sets.

INSCRIPTIONS: Each print signed and numbered by the artist on verso.

PAPER: 315gsm Heritage.
TECHNIQUE: Off-set lithography.

PRINTER: Bob Cox at Eclipse Litho Ltd., London. Printed on a flat-bed proofing press.

BINDING: Designed by the artist, made by Ryders, Bletchley.

TYPOGRAPHY: Helvetica and Times. Art-work by Tristram Kent.

BIOGRAPHY: Born London 1946. Studied at Hammersmith School of Art, London, 1964–65; St Martin's School of Art, London, 1966–68; and Royal College of Art, London, 1968–69. Solo exhibitions include Galerie Konrad Fischer, Düsseldorf, 1969; Kunstmuseum, Basel, 1975; touring exhibition organised by the Stedelijk Van Abbemuseum, Eindhoven, 1985; Albright-Knox Art Gallery, Buffalo, and National Gallery of Canada, Ottawa, 1990. Lives in Canterbury, Kent.

Since 1969 Fulton's work has been specifically concerned with the experience of walking. He has written that 'My artform is the short journey – made by walking in the landscape.' From 1969 and throughout the 1970s his walks were re-presented in the form of black and white photographs made on the walks, with accompanying titles and inscriptions set below the photograph. Fulton does not alter the form of the landscape he walks in, rather he photographs it as he finds it: this attitude is in contrast to the growing popularity of outdoor land sculpture. Since the early 1980s much of his work has been in the form of text pieces, either printed in catalogues, painted on walls, or produced as prints. The texts are, in a sense, poetic equivalents for the feelings and thoughts he experiences on the walks. The words record things seen or felt but together contribute towards recreating what might be called the texture of his experience. Spaciously printed in clear typography, they refer directly to thoughts in the mind, to the experience of walking in the landscape rather than to the landscape itself. Sculptors have traditionally used people as their subject matter and worked with bronze, stone or wood, changing these materials into new forms; Fulton's subject matter is the landscape and his relation to it (through walking) and his medium is the word and, to a lesser extent in recent years, the photograph.

For Fulton, walking is a way of making contact with nature. His approach can be understood within an ecological frame of reference and can be related to the ways in which indigenous peoples such as native American Indians and Aborigines try to live in harmony with nature. There are also parallels with Zen and Buddhism, but perhaps most especially with the ancient Japanese religion of Shinto, which stresses the primitive, fundamental relation between man and natural phenomena.

Fulton has made walks in Western Europe, Japan, Nepal, North and South America, and Australia. Some of his walks are made in the company of friends, while others are made alone. On the walks he takes a small notebook in which he records his thoughts. Generally he uses one notebook for each walk though he does also use the same notebook if he returns to a particular area of the world. The notebook records, made in pen, are the direct ancestors of the large text-pieces, and are rarely much altered when transferred into a printed medium. The fourteen works in this series are, as it were, enlarged versions of notations found in the notebook diaries.

Fourteen Works is the largest collection of prints Fulton has yet made: previously he had produced single prints from time to time. He sees prints very much as works in their own right and not as devalued reproductions of a given 'original'. His text-pieces are produced in a broad range of sizes, from postcards to pages in a catalogue, from large prints to vast wall texts. All are made with ink or paint on a flat surface and the artist does not give them a hierarchical value. Although he had produced text-pieces within catalogues and in the form of wall-drawings, these were his first large-scale lithographic texts. Some had previously been made as wall-texts.

Fulton selected all fourteen works from the notebooks, initially choosing a larger number and then editing them. There is no particular sequence to the works, and their selection was a matter of sensibility rather than a desire to find a range of geographic locations, dates or other unifying factor. Fulton has worked extensively with the number seven (several of his walks are a week long) and its multiples, so he chose to include fourteen works in the series. All the works originate in walks made between 1982 and 1989. The portfolio was compiled during the summer and autumn of 1989.

1. The first work relates to an eleven-day wandering walk made with a friend in Australia in July 1982, during a time when the moon was in an eclipse. It features eight paired columns of six words: each pair features adjectives and nouns which are repeated in different permutations across the columns. Each word changes position in the sequence of columns, providing a shifting description of something witnessed. The work mediates on the way perception changes over a number of days in an extraordinary location – the Australian outback. Some of the terms relate to our everyday experiences (blue sky, black crow), while others suggest a mental landscape (black tree, white crow). In 1982 Fulton made a large photographic work, *Dead Fish*, which relates to the same walk.

2. This is Fulton's first print of a mountain skyline, a motif he has since used in book form in *A Twelve Day Walk and Eighty Four Paces* (see pp.94–97). He made his first such notebook drawing on a walk in Switzerland in 1971: it is often the case in Fulton's work that ideas established in the notebooks are only incorporate into his art some years later. The line describes the mountain skyline seen on a twenty-day walking journey from Dumre to Leder and back to Pokhara in Nepal in 1983. On one or two occasions Fulton has used conventional cartographic maps as the basis for his work (for example no. 8 in the present series), but he prefers what he calls 'the eye view' – in other words a kind of personal map-making based on what the eye can see and the individual can experience. Maps offer a sanctioned, objective view of the world, a world measured with scientific devices: Fulton is more concerned with eye-witness information though he has real interest in maps.

```
BLUE    SKY       BLUE    WATER    RED      SKY      COLD     WATER
BLACK   CROW      COLD    SKY      BLUE     CROW     WHITE    CROW
WHITE   TREE      BLACK   FISH     DEAD     TREE     DEAD     SKY
RED     ROCK      DEAD    CROW     COLD     ROCK     BLACK    TREE
COLD    WATER     RED     TREE     BLACK    WATER    RED      FISH
DEAD    FISH      WHITE   ROCK     WHITE    FISH     BLUE     ROCK
```

AN ELEVEN DAY WANDERING WALK IN CENTRAL AUSTRALIA JULY MOON ECLIPSE 1982

MOUNTAIN SKYLINE A TWENTY DAY WALKING JOURNEY FROM DUMRE TO LEDER IN MANANG AND BACK TO POKHARA BY WAY OF KHUDI NEPAL EARLY 1983

1

2

3. The print was first produced as a wall drawing under the title *A Seventeen Day Walk in the Rocky Mountains of Alberta Autumn 1984*. Of it Fulton has remarked: 'Today's maps say my walk was made in two adjoining Canadian national parks, Jasper and Banff in the province of Alberta. However, originally this area was the homeland of native peoples. There are two sacred numbers for some tribes of the Rocky Mountain Plains region: four and seven. My painted wall text consists of seven lines of four columns of four-letter words. The words are in English (the language of the artist) and relate to what was experienced during this seventeen-day walking journey. It is of interest to me how many four-letter words in English describe aspects of the natural environment; unlike for example, German where the same words vary from three to nine letters. The grid gives equal importance to each word so that a grizzly BEAR is not more dominant than MOSS.' Fulton has been interested in the plight of the native American Indian since the 1960s. His first artworks relating to walks were made after a car journey through their homelands in South Dakota, Wyoming and Montana in 1969.

4. *Seven Winds* refers to Fulton's first seven-day walk in the Cairngorm mountains in the Scottish Highlands in 1985. By 1994 he had made eleven such walks in the area: the series of prints *Ten Toes Towards the Rainbow* (see pp.98–103) refers specifically to these walks. Fulton has employed the number seven in his work since the 1970s but has used it increasingly since the early 1980s. The number can be considered almost as a natural marker, relating as it does to the days in the week and the colours of the rainbow. This walk was done in March 1985, when he camped alone and walked along red deer tracks for seven days. The wind had brought down twigs and branches which covered the paths. In Fulton's work it is always the independent action or presence of natural elements which is highlighted and recreated in poetic terms, instead of natural material being moved and rearranged (a sculptural practice which he rejects). The process of selection and rearrangement is, as it were, done in the artist's mind. There is also, in Fulton's work, a concern with the particular and the general. Specific events or experiences are referred to (seven paths for example) but the precise nature or location of those paths remains open.

5. This was a sixteen-day walk in Japan from the ship at Nachi Katsuura to the train at Horyuji, travelling by way of Nara in early 1986. The walk took him along the Wakayama peninsula, which is an area containing ancient pilgrim routes. Prior to setting out on the walk he had been shown a book on temple pagodas. Almost all of these pagodas are constructed with five stages, corresponding to the five elements, but there were also rarer seven-stage pagodas. He discovered that in Japanese the same written character corresponds to the seven days of the week and to specific elements: Moon is Monday, Fire is Tuesday, Water is Wednesday and so on. In this work Fulton deals with the correspondence between the Japanese character for the days of the week and the elements they also signify. The sixteen characters correspond to the duration of the walk and the colours of the typography to the week-long unit. Fulton's approach has direct parallels with Japanese Shinto and Buddhism, religions which are fundamentally concerned with the unity of man and nature .

6. This text refers to a road walk Fulton made in Brittany in May 1987. The words, each composed of four letters, are in English and Breton with their corresponding translation. Beneath these words is the caption 'At the Time of the Singing Birds'. On the walk Fulton was particularly aware of the large number of singing birds and wild flowers: this contrasts with the area of Kent in which the artist lives where chemicals are used extensively in farming.

7. A twenty-one day, 640-mile walk from South Wales to North East England. The walk was made by way of seven hill-tops in the Brecon Beacons, Cader Idris, Bleaklow Head, the Cleveland Hills, the Yorkshire Dales, Helvellyn and the Cheviot Hills. The seven groups of three letters were extracted from the maps of each of the seven areas. Just as Fulton moved from one location to another, so the character of the language changed. This text-piece concerns the changing nature of the landscapes he walked through via the shifting nature of the language that is peculiar to those places.

8. The map registers fourteen coast-to-coast walks made by Fulton from 1971–87 in Britain and Ireland. The use of the map is quite unusual in Fulton's work, and he describes it as being contrary to his way of thinking. No towns, cities or geographic forms are marked on the map: it features only the roads Fulton has walked along. He describes this work as being 'my mapping of the country I come from.'

9. Beneath the tiny dot of the moon is the text 'No thoughts counting seven paces facing the rising full moon Kent England 1988'. It is the first of Fulton's black prints: the book *A Twelve Day Walk and Eighty Four Paces*, published in 1991 (see pp.94–97), is concerned specifically with this theme. The direct inspiration behind this work was the realisation that although the moon may dominate the sky at night, its size, in one's field of vision, is minute. Fulton remarks: 'I'm interested in the question of scale. If you look at the moon you don't think of the size of it on your vision. Yet the impact of it is enormous.'

10. Walking along an Arctic valley on Baffin Island in the summer of 1988, Fulton turned a bend and in front of him saw a rock-fall caused by the sun melting ice which had held the rocks in place. The detached rocks fell, producing a loud echo and clouds of dust. The theme of the landscape being active and fundamentally different from human activity is recurrent in Fulton's art.

11. This text corresponds to a profoundly impressive sight Fulton experienced in Japan, on a coast-to-coast walk from Toyama Bay to Suruga Bay on Honshu. Looking out from a ridge he could see Mount Fuji in the far distance, rising up above the clouds, while at the same time the sun was setting and the full moon was visible. It was a moment that Fulton wanted to mark, to fix it in his memory, and to do so he walked seven paces. He describes this ritual as a way of pinpointing a combination of circumstances. In Fulton's work the pace, man's oldest form of measurement, is a way of affirming human presence in and communion with the landscape. Having seen Mount Fuji like this (he walked towards it for a further week before ascending it) he ceased to take photographs of cairns and milestones, recognising that none could match the impression Fuji, a kind of natural cairn, had made on him.

12. This work unites twenty-one separate walks made over the period 1971–88, starting with a one-day walk, and ending with a twenty-one day walk.

13. Fulton made this walk along roads in Portugal and Spain with his close friend the artist Richard Long early in 1989. The walk was 560 miles long and lasted twenty-and-a-half days. On the roads they came across the scattered bodies of dead dogs which had been hit by vehicles.

14. On a walk in Nepal in 1983, Fulton first noted a local custom for decorating the walls of houses. On a 1989 visit he observed that the people would rub their hands in the charcoal of an old fire, then blacken an area of wall above the fireplace. On to this darkened area they added a repeating triangular form made by applying white thumbprints. The white pyramids resembled the snow-covered Himalaya mountains seen through the windows of the house.

```
S N O W  L A K E  L E A F  S T A R
T W I G  H A W K  C R O W  F I S H
H O W L  M I N D  M I S T  W A L K
R A I N  M O S S  B E A R  B O N E
E Y E S  W I N D  R O C K  M O O N
F R O G  D E E R  S E E D  C A M P
D A W N  C O L D  D U S T  F I R E
```

A SEVENTEEN DAY WALK IN THE ROCKY MOUNTAINS OF ALBERTA CANADA AUTUMN 1984

```
S E V E N
W I N D S
S E V E N
T W I G S
S E V E N
P A T H S
```

SEVEN DAYS WALKING AND SEVEN NIGHTS CAMPING IN A WOOD SCOTLAND MARCH 1985

金	ROCK	土	EARTH
土	EARTH	日	SUN
日	SUN	月	MOON
月	MOON	火	FIRE
火	FIRE	水	WATER
水	WATER	木	WOOD
木	WOOD	金	ROCK
金	ROCK	土	EARTH

A SIXTEEN DAY WALKING JOURNEY FROM THE SHIP AT NACHI KATSUURA TO THE TRAIN AT HOFFLU
TRAVELLING BY WAY OF NARA JAPAN EARLY 1986

GOAZ	STREAM	MOON	LOAR
ROCH	ROCK	HAWK	KAOUENN
TROU	VALLEY	CROW	BRAN
HENT	ROAD	WIND	AVEL
INIS	ISLAND	RAIN	GLAV
LANN	HEATH	HILL	TORGENN
GOAT	FOREST	DEER	DEMM

A ROAD WALKING JOURNEY AT THE TIME OF SINGING BIRDS SOUTH COAST TO WEST COAST TO NORTH COAST LA BAULE POINTE DE PEN HIR POINTE DU DOURVEN BRITTANY 15-25 MAY 1987

FOURTEEN COAST TO COAST WALKS

NO THOUGHTS COUNTING SEVEN PACES ON SENJOH DAKE AT SUNSET

FACING MOUNT FUJI AND THE SECOND FULL MOON OF MAY 1988

A 19 DAY COAST TO COAST ROAD WALKING JOURNEY

TOYAMA BAY ONTAKE SUMMIT FUJI SUMMIT SURUGA BAY

HONSHU JAPAN

ROCK
FALL
ECHO
DUST

A TWELVE AND A HALF DAY WALK ON BAFFIN ISLAND ARCTIC CANADA SUMMER 1988

9
10
11
12

D E A D
D O G S

A 20½ DAY 560 MILE COAST TO COAST ROAD WALKING JOURNEY ACROSS PORTUGAL AND SPAIN ATLANTIC OCEAN TO THE MEDITERRANEAN SEA EARLY 1989

AN ELEVEN AND A HALF DAY WANDERING WALK NEPAL APRIL 1989

13

14

TREES = FRAMED WORKS OF ART ON PAPER

In 1969 I left the city and set out to make art <u>about</u> the experience of walking in the landscape – LAND

After a 47 day walk in 1973 I was inspired to make the following committment

ONLY ART RESULTING FROM THE EXPERIENCE OF INDIVIDUAL WALKS

————————

Walking and camping

In my art the flow of influences should be from Nature to me

not from me to Nature — I try to leave as few physical traces of my presence as possible

Since 1969 I have kept a record of all my art-walks B E A D S

Days in the span of a life — *knots on a string* P A C E S

————————

Walking upstream on a river bank

Walking downstream on a river bank

————————

Glacial Boulder — ART = STOPPING PLACES (The hidden industry of art transportation)

Monsoon River — WALKING = MOVEMENT (The need for sleep)

————————

THE ROCKS ARE ALIVE IN THEIR HOMELAND

————————

Absences

The landscape is not — in the exhibition

The walk is not — in the exhibition

————————

Contradictions

The activity of viewing the art work (Indoors)

(OUTDOORS) is not what the walks advocate

————————

The artwork cannot re-present the experience of the walk

————————

No meaning in distant places

Close your eyes and walk in the dark

————————

THERE ARE NO WORDS IN NATURE

Rainbow is a seven letter word

—————————

Of what can we speak?

We speak of what we have seen

—————————

Unrecognizable shape of an indescribable colour

—————————

No talking and talking are of equal importance

—————————

Walks are like clouds

They come and go

—————————

East South West North Walk is a four letter word Walk = No-thing

—————————

W A L K

W O R D

Thoughts silenced by birdsong

—————————

A walk must be experienced it cannot be imagined

—————————

Walking into the distance

Beyond imagination

—————————

A work of art can be purchased

But a walk cannot be sold

—————————

Walking is a medium not an object

Fly weight the weight of a fly the physical lightness of walking

—————————

Between wild plants

Keeping to the trail

Walking on ants

—————————

Hamish Fulton *A Twelve Day Walk and Eighty Four Paces*

1991

DESCRIPTION: 32-page book of 16 double-page spreads. Printed by hand in off-set lithography, bound in black cloth with blind-embossed skyline on front and moon on reverse.

EDITION: 35 copies numbered 1 to 35 plus 10 proof copies.

INSCRIPTIONS: Signed and numbered by the artist on colophon page.

SIZE: 30.5 × 55cm (page size); 30.5 × 110cm (double-page spread size).

PAPER: 270gsm Huntsman Modern Art.

TECHNIQUE: Off-set lithography.

PRINTER: Bob Cox at Eclipse Litho Ltd., London. Printed by hand on a flat-bed proofing press.

BINDING: Designed by the artist, made by Gray's Bookbinder, London.

TYPOGRAPHY: Helvetica and Times. Art-work by Tristram Kent.

The book presents two markedly different locations and two different types of experience. The pages on the left refer to twelve mountain passes in Ladakh, Northern India; and the pages on the right to an area within a one mile radius of Fulton's home near Canterbury in Kent. The twelve-day walking journey in Northern India, made in July 1984, took Fulton across twelve high mountain passes between Lamayura and Dras. The twelve walks in Kent were each seven paces long and were made between May 1988 and July 1990.

The radical differences in the landscapes are conveyed with great economy; similarly the act of making a long walking journey in one and just seven paces in another is suggested by the linear forms on the left pages and the small, focussed images on the right. The work is concerned with scale, with the idea of nearness and distance. The images of the walk made in Northern India are of mountain skylines: the dramatic contours resemble cardiac graphs, and therefore serve to suggest the arduous nature of the walk. By contrast, the minimal images of the moon, sun and stars over Kent suggest a flat landscape and a mind clear of all thought. Printing the book proved extremely complex. The very large double-page spread dictated the type of paper used which had to be over-printed with cream on the first pages and black on the remaining pages.

Note: The double-page spreads shown here are a selection taken from the book.

```
              S
              N
      P       I                               P
      R       O       B              N    P   A        R
      I       U       O              E    I   R        U
      N   S   G   S   U   S          T    N   K        N
      K   U   O   M   M   E   K   B  U    G   A   U    C
      I   R   I   I   S   N   U   A  K     D   C   M   H
      T   S   T   S   S   G   B   M  S     O   H   B   E
      I   I   S   I   G   B   S   M  M     N   H   B   N
          R   E   R   E   I   M   O  I          I   A
              R   R   I   A   I   K              K
                      E           A              A
```

NO THOUGHTS COUNTING EIGHTY FOUR PACES KENT ENGLAND 1988 1989 1990

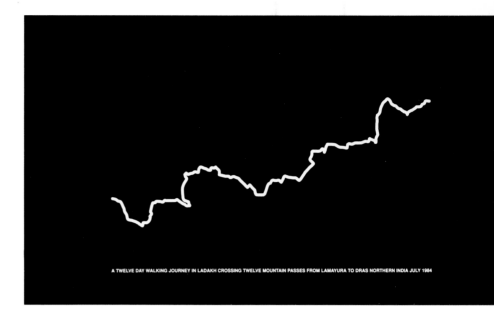

A TWELVE DAY WALKING JOURNEY IN LADAKH CROSSING TWELVE MOUNTAIN PASSES FROM LAMAYURA TO DRAS NORTHERN INDIA JULY 1984

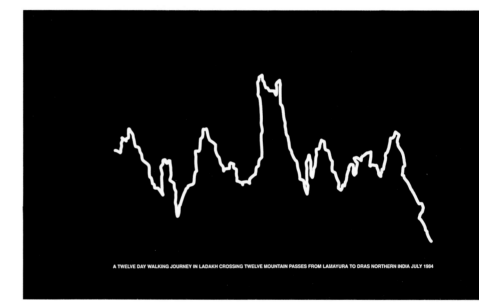

A TWELVE DAY WALKING JOURNEY IN LADAKH CROSSING TWELVE MOUNTAIN PASSES FROM LAMAYURA TO DRAS NORTHERN INDIA JULY 1984

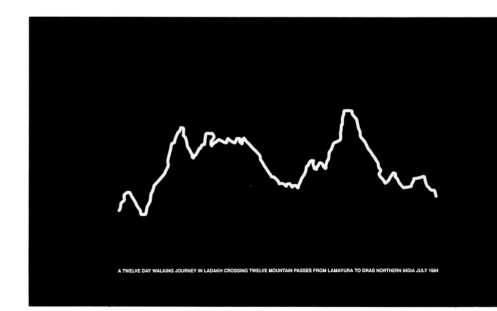

A TWELVE DAY WALKING JOURNEY IN LADAKH CROSSING TWELVE MOUNTAIN PASSES FROM LAMAYURA TO DRAS NORTHERN INDIA JULY 1984

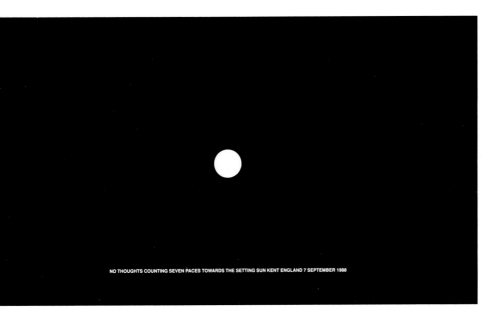

NO THOUGHTS COUNTING SEVEN PACES TOWARDS THE SETTING SUN KENT ENGLAND 7 SEPTEMBER 1988

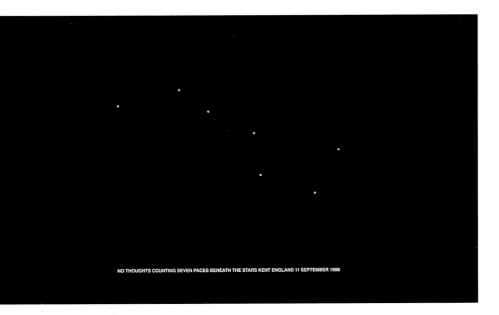

NO THOUGHTS COUNTING SEVEN PACES BENEATH THE STARS KENT ENGLAND 11 SEPTEMBER 1988

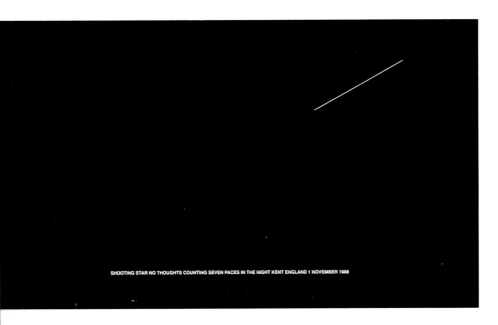

SHOOTING STAR NO THOUGHTS COUNTING SEVEN PACES IN THE NIGHT KENT ENGLAND 1 NOVEMBER 1989

Hamish Fulton *Ten Toes Towards the Rainbow*

1993

(Ten Seven-Day Walks Cairngorm Mountains Scotland March 1985–January 1993)

DESCRIPTION: 9 screenprints with certificate and statement in portfolio case bound in grey buckram.

INDIVIDUAL TITLES, DATES AND SIZES:
1. *Night Life*. (One walk, March 1991). 95.7×62.7cm.
2. *No Talking for Seven Days*. (One walk, February 1988). 44.3×95.3cm.
3. *The Crow Speaks*. (Two walks, summer 1991 and June 1986). 63.1×93.2cm.
4. *Seven 7 Day Walks*. (Seven walks, March 1985, June 1986, February 1988, September 1988, September 1990, March 1991, April 1991). 95.5×63cm.
5. *Seven Days Walking and Seven Nights Camping in a Wood Scotland*. (One walk, March 1985). 61.3×94.8cm.
6. *Eroded Rock Outline Beinn Mheadhoin*. (Two walks, summer 1991 and September 1988). 63.2×91.2cm.
7. *Geese Flying South*. (One walk, September 1990). 63×96.6cm.
8. *Wind Through the Pines*. (Two walks, March 1985 and April 1991). 58.6×93cm.
9. *Song Path*. (Two walks, January 1992 and January 1993). 62.7×93.3cm.

EDITION: 35 sets numbered 1 to 35 plus 10 proof sets.

INSCRIPTIONS: Signed and numbered by the artist on certificate.

PAPER: 300gsm Somerset Satin.

TECHNIQUE: Screenprints, using up to eleven separate mezzotint screens for each image. In the photographic and black images, the images were printed first, with the text areas stencilled out, and the text was added, in white ink, over the top.

PRINTER: Coriander (London) Ltd.

BINDING: Designed by the artist, made by Ryders, Bletchley.

TYPOGRAPHY: Helvetica and Times. Art-work by Tristram Kent.

Born of Scottish parents, Fulton has made walks in the Highlands and Islands of Scotland since the early 1970s. He made his first seven-day walk in the Cairngorms in March 1985, a walk commemorated in the print *Seven Winds* from the *Fourteen Works* series (see pp.86–91). By the time the present series was published he had made ten such walks, hence the title of the portfolio. He has often returned to the same location, partly in order to gain a greater familiarity with the environment and also so that he might appreciate the changes the place undergoes at different times of the year. As noted in the discussion of *Fourteen Works*, the number seven holds a special significance for Fulton. All the walks were done alone except one which was made with his son, Casey.

Like the individual prints in *Fourteen Works*, these prints originated in the notes Fulton made on the walks. The relation of the print to the small pen notation is very direct: even the photographic works are recorded in his notebooks as small sketches with accompanying texts. Fulton's walks from the late 1960s and throughout the 1970s are principally recorded in photographic form, and only in the 1980s did he turn increasingly to the text form: this portfolio combines both approaches. Fulton's work is political in the broadest sense, and can be associated with the environmental movement. The Cairngorm Mountains, which lie west of Aberdeen, are among the last of the wilderness areas left in Britain and these works are concerned with preserving that status.

The nine works refer to the intense experience of nature, to the idea of the landscape as an active rather than a passive force, and to the qualities of peace and tranquillity found in the wilderness. They also call attention to the gulf that lies between the direct, personal experience of nature and the language one uses to describe that experience. In constructing this view of nature, Fulton draws upon a wide range of feelings and experiences, from the observation of fox tracks melting in the snow to the sound of geese migrating and to the sight of rocks eroded by wind, ice and rain.

Night Life: Life of a River Rock turns the conventional assumption about night life (normally associated with bright lights, noisy cities, pubs and clubs) on its head. The work also offers an oblique critique of 'nature sculpture', that is the practice of taking rocks and other found natural objects out of their context and displaying them in galleries. The third work in the series, *The Crow Speaks*, makes direct reference to this practice, and to the artist's objection to it, in the phrase 'The Rocks are Alive in their Homeland'.

Fulton remarks that 'there are no words in nature', rather there are sights and sounds. The work *No Talking for Seven Days* could be seen as a homage to the silence of nature (as well as being an oblique comment on the signs which warn trespassers off the land), as could *Wind Through the Pines*, which refers to the sounds of wind and birds – as opposed to the sounds of the city. Fulton observes that we very rarely experience a silence uninterrupted by urban noise, be it of traffic, people or the humming of electrical items. The third work, *The Crow Speaks*, highlights the dislocated interface between nature and human language. Instead of speaking, say, English or Gaelic, the crow speaks crow; in other words nature has its own language, and it is a language we are becoming increasingly detached from. The fifth work contains a list of words referring to nature: it is Fulton's first work of this type though he sees it as one of an inexhaustible series.

The works reflect the times of the year when the walks were made. *Geese Flying South* refers to the annual migration of birds in September, to their almost magical ability to unite and travel in a precise direction at a particular time of year without requiring roads or paths. *Song Path* brings together walks made in the same location in January 1992 and January 1993. In the first Fulton traced the tracks a fox had made in the snow and in the second he walked barefoot along a deer path. The song of the title was the bird-song he heard while walking along the path.

Fulton's art pleads for a greater respect and understanding of the environment. Through his walks in different parts of the world he highlights the magical, poetic element in the landscape and counterpoints this, by implication rather than by direct statement, with the types of urban experience to which we have grown accustomed.

Artist's statement issued with portfolio:

THERE ARE NO WORDS IN NATURE
RAINBOW IS A SEVEN LETTER WORD

R A I N B O W – TRANSITORY
W A L K I N G – INTO

OF WHAT CAN WE SPEAK ?
WE SPEAK OF WHAT WE HAVE SEEN

IF IN DOUBT KEEP TALKING WALKING

NIGHT LIFE

LIFE OF A RIVER ROCK

A SEVEN DAY WANDERING WALK CAIRNGORMS SCOTLAND MARCH 1991

NO TALKING
FOR SEVEN DAYS

WALKING FOR SEVEN DAYS IN A WOOD FEBRUARY FULL MOON CAIRNGORMS SCOTLAND 1988

THE CROW SPEAKS

COLOURS OF THE RAINBOW

A SEVEN DAY WANDERING WALK CAIRNGORMS SCOTLAND SUMMER SOLSTICE 1991

THE ROCKS ARE ALIVE IN THEIR HOMELAND

SOLSTICE FULL MOON

A SEVEN DAY CIRCULAR WALK CAIRNGORMS SCOTLAND JUNE 1986

2

3

SEVEN 7 DAY WALKS

CAIRNGORMS SCOTLAND

SEVEN DAYS WALKING AND SEVEN NIGHTS CAMPING IN A WOOD MARCH 1985

SOLSTICE FULL MOON A SEVEN DAY CIRCULAR WALK JUNE 1986

WALKING FOR SEVEN DAYS IN A WOOD FEBRUARY FULL MOON 1988

WALKING FOR SEVEN DAYS SEPTEMBER FULL MOON 1988

A SEVEN DAY WANDERING WALK SEPTEMBER 1990

A SEVEN DAY WANDERING WALK MARCH 1991

WALKING FOR SEVEN DAYS IN A WOOD APRIL 1991

SEVEN DAYS WALKING AND SEVEN NIGHTS CAMPING IN A WOOD SCOTLAND MARCH 1985

SOUND OF THE STREAM · NO BIRDS SINGING · DAWN · BIRDS SINGING · NO BIRDS SINGING · SOUND OF THE STREAM · FALLEN TREES ACROSS THE STREAM · WHITE ROCKS · GREY DRY RIVERBED ROCKS · PEBBLES · SAND · PINE NEEDLES · PINE CONES · STONES · SOUND OF THE STREAM · DEAD TREES · FALLEN TREES · FALLEN BRANCHES ON A DEER PATH · NO BIRD SONG · WIND THROUGH THE PINE TREES · ROUNDED MOUNTAINS · WIND BLOWN CLOUDS · RAIN SHOWER · SNOWFALL · PINE NEEDLES · SAND · WET GROUND · MELTED SNOW · BROWN BARK · GREY BARK · FALLEN BARK ON A DEER PATH · DEER TRACKS ON THE SAND · BIRD SONG HEARD IN THE SOUND OF THE STREAM · SPLASHED ROCKS · DRY GREY RIVERBED ROCKS · ROTTING TREES · MOSS COVERED BOULDERS · ANTHILLS · SMALL LANDSLIDE · WHITE ROCKS · WET ROCKS · RUSHING STREAM AT NIGHT · NO BIRD SONG AT NIGHT · BIRD SONG AT DAWN · NO BIRD SONG · GREY CLOUD · MOVING MIST OVER THE HILLS · POOLS OF WATER ON FLAT ROCK · COLD WIND · SPLASHED ROCK · SAND · PINE CONES · DEAD BRACKEN · OLD RIVERBED · NEW ANT HILL · ANCIENT ROUNDED MOUNTAINS · WHITE HARE · SCATTERED WHITE ROCKS · ON THE HILLSIDE · PTARMIGAN · DRY GREY RIVERBED ROCK · SPLASHED ROCK · WET GROUND · BROWN BARK · WET TREE · BROWN PINE NEEDLES · DEER PATH · MORNING LIGHT · NIGHT SNOWFALL · SNOW COVERED SAND · SNOW COVERED ROCKS · SOUND OF THE STREAM · TWIGS IN THE SNOW · GREEN PINE NEEDLES · BROWN BRACKEN · SNOW ON FALLEN TREES ACROSS THE STREAM · REEDS · SNOW FILLED DEER PATH · DEER TRACKS IN THE SNOW ON THE PATH · FRESH DEER TRAIL THROUGH THE HEATHER BRUSHING OFF THE SNOW · STONES NOT COVERED BY SNOW BELOW A TREE · PINE CONES · A ROBIN STANDS ON AN ANTHILL · A CROW CALLING · ROBIN SINGING · GREY SKY · A FEW SNOWFLAKES FALLING · GRASS AND GREEN LEAVES BENEATH OLD TREES · GREY TREE TRUNKS BROWN BRANCHES GREEN NEEDLES · A PIGEON FLYING BETWEEN THE DEAD TREES · GREY SKY · BLUE SKY · WHITE CLOUDS · UPROOTED TREE · SNOW ON GREY DEAD BRANCHES · GREEN LEAVES ON OLD ANTHILLS · PINE NEEDLES · MELTING SNOW IN THE MIDDLE OF THE DAY · A FEW FLAKES OF FALLING SNOW · SUN THROUGH CLOUDS · UPROOTED TREE · A DEER STANDING STILL LOOKING MOVING DISAPPEARING · BIRD SONG · MELTING SNOW · CRACKED DEAD TREE TRUNKS · FALLING SNOW FROM BRANCHES CATCHING THE SUNLIGHT · PINE CONES · TWIGS · PINE NEEDLES · SOUND OF THE STREAM · MOSS · LICHEN · MELTING SNOW · SNOW ON HEATHER · BRANCHES · TWIGS · MOVING GREY CLOUDS · MUDDY SQUIRREL TRACKS IN THE SNOW · GREY ROCKS AND GREEN LICHEN · BROWN AND GREEN HEATHER · DEER DROPPINGS BENEATH THE TREES · LIGHT GREEN MOSS · BIRD SONG · SOUND OF THE STREAM · HUNDREDS OF ANTS AMONG THE PINE NEEDLES · DEER TRACKS IN THE SNOW · DEER DROPPINGS BY AN ANTHILL · OLD BRACKEN STALKS · MOLEHILL · SOUND OF THE STREAM · GREY BROWN AND PINK ROCKS · ISLANDS OF ROCK IN THE STREAM · HALF FALLEN TREES · STANDING DEAD TREES · REEDS · PINE BRANCHES IN THE STREAM · BROKEN PINE BRANCHES · SNOW CAPPED ROCKS IN THE STREAM · SNOW FILLED DEER PATHS WITHOUT DEER TRACKS · FEEDING DEER · DISAPPEARING DEER · DEER TRACKS ON FLAT SNOW COVERED GROUND · DEAD GRASS · A FEW SNOWFLAKES FALLING · OLD TREES · DROPS OF WATER FALLING FROM BRANCHES INTO THE SNOW · GREEN LEAVES · DEAD GRASS · WIND THROUGH THE PINE TREES · NO SOUND OF THE STREAM · DISTANT BIRD SONG · ANTHILLS FACING SOUTH · SOUND OF THE STREAM · SMALL HERDS OF DEER STANDING MOVING DISAPPEARING · SUNLIGHT ON THE WATER · SOUND OF THE STREAM · A CLEAR REPEATED BIRD SONG · COLD AIR · SMALL BIRD · SNOW ON A HILL NOT FACING THE SUN · PALE BLUE AND PINK EVENING SKY · NO STARS · SOUND OF THE STREAM · TALL GREEN JUNIPER BUSHES AMONG THE BROWN HEATHER AND GREEN COVERED ANT HILLS · LINE OF SNOW ON A FALLEN TREE TRUNK · LIGHT THROUGH THE TREES FROM THE WEST · PINE CONES · TWIGS AND BRANCHES BENEATH AN OLD TREE · DEER PATH · NO BIRD SONG · DUSK · SOUND OF THE STREAM · DEER TRACKS ON FLAT SNOW COVERED GROUND · AN AREA OF SNOW BENEATH PINE TREES · GREEN NEEDLES · FLECKS OF SNOW AGAINST A PALE BLUE GREY EVENING SKY · A BRANCH OVER THE STREAM · A BRANCH IN THE STREAM · A TALL PINE TREE · DRY TOPPED ROCKS IN THE STREAM · FOX TRACKS IN THE SNOW THROUGH THE DEAD BRACKEN · DARKNESS · SOUND OF THE STREAM · BRIGHT MORNING SUNLIGHT ON THE FACES OF ROCKS IN THE STREAM · FLICKERING WATER REFLECTING ON THE SIDES OF ROCKS · THE REPEATED SONG OF A BIRD · A SHOWER OF SUNLIT SNOW FALLING FROM A BRANCH · ROCKS IN SHADOW · REPEATED BIRD SONG · SMALL STREAM · WET GROUND · DEER · DEER RUBBING TREE · FRESH DEER TRACKS THROUGH THE BOG · OLD TREE · SMELL OF DEER · CAPERCAILLIE FLYING LOW THROUGH THE TREES · WIND BROKEN BRANCH · DEER RUBBING BRANCH · HAIL · CAPERCAILLIE FLYING LOW THROUGH THE TREES · NO SOUNDS OF THE BIG STREAM · HAIL · LIGHT SNOW FALL · SOUND OF THE SMALL STREAM · WIND BLOWING THROUGH THE PINE TREES · COLD EVENING · STARS · WARMER NIGHT · HEAVY SNOWFALL IN THE DARK · GREY LIGHT · SNOWFLAKES FALLING · SNOW ROUNDED HEATHER AND ROCKS · ROUNDED SNOW ON PINE BRANCHES · SNOW COVERED ANTHILLS · SUDDEN LOW FLYING CAPERCAILLIE BETWEEN THE TREES · SNOW SPRAYED TREE TRUNKS · WHITE LINES OF SNOW ON FALLEN TREES · A HERD OF DEER SITTING STANDING MOVING SLOWLY RUNNING DISAPPEARING INTO THE SNOW COVERED PINE TREES · RUNNING UPHILL · DOWNHILL · FRESH TRACKS · BRANCHES BENT LOW WITH THE WEIGHT OF SNOW · IN THE DISTANCE TWO DARK DEER STILL · RUNNING · FRESH DEER TRACKS · DEER LYING PLACES · DEER TRACKS · SUDDEN DISTURBED CAPERCAILLIE FLAPPING WINGS THROUGH TREES · DARK GROUND OF UPROOTED TREES IN THE SNOW · FIVE OR SIX DEER RUNNING IN A LINE UPHILL · ROUNDED ANTHILLS · OLD DEAD PINE TREE ALONE · WIND BLOWN SNOWFLAKES SIDEWAYS · CROW FLYING IN THE WIND · CROW SITTING ON THE TOP OF A TALL PINE TREE CALLING IN THE WIND AND SNOW · ROUNDED ANTHILLS · ARCHING REEDS ON FLAT GROUND · SOUND OF THE STREAM · GREY DEAD FALLEN TREES · SNOW FILLING DEER TRACKS · ROUNDED SNOW ON THE BUSHES · LIGHT GREY SKY · SNOWING · BLUE SKY WHITE SKY GREY SKY · SUNSHINE · A ROBIN SINGS FROM THE VERY TOP OF A TALL LIVING PINE TREE · GREY SKY · LIGHT SNOWFALL · TWO DEER RUN BETWEEN THE SNOW ROUNDED ANTHILLS AND STOP RUN UPHILL INTO THE TREES STOP RUN DISAPPEAR · FRESH DEER TRACKS · ROUNDED SNOW AT THE VERY EDGE OF THE STREAM · FALLEN DEAD TREES ACROSS THE STREAM · SNAKING COURSE OF THE STREAM · SNOW COVERED ANTHILLS AND BUSHES · SNOW COVERED SAND · DRY GREY RIVERBED ROCKS · ARCHING REEDS ON FLAT GROUND · SNOW COVERED TWISTING PINE TREE ON THE SLOPE · SNOW SMOOTHED DEER PATH · SUDDEN DISTURBED CAPERCAILLIE FLYING LOW THROUGH THE TREES · SNOW SMOOTHED DEER PATH CROSSED BY DEER TRACKS FILLING WITH SNOW · BRANCHES BENDING WITH THE WEIGHT OF SNOW · SOUND OF THE SMALL STREAM · SUNSHINE · PATCHES OF SUNLIT SNOW · ROUNDED ANTHILLS · DARK TREE TRUNKS · GREY SKY · NO SNOW FALLING · SOUND OF THE SMALL STREAM · PALE GREY PALE BLUE YELLOW SKY IN THE LATE AFTERNOON · SMALL HERD OF DEER ONE RUBBING A BRANCH STOP LOOK TURN AND RUN MANY DARK LEGS PASSING TREE TRUNKS · UNSEEN DEER BARKING · EVENING PALE BLUE SKY BEHIND THE TREES · STRAIGHT TREES · TWISTED TREES · BRANCHES WEIGHED DOWN WITH SNOW · GREY TREE TRUNKS LIGHT BROWN BRANCHES GREEN NEEDLES · LIGHT FALL OF HAIL · COLD · STILL · SOUND OF THE STREAM · PALE BRIGHT SUNLIGHT · SETTING SUN BETWEEN THE TREES · A FEW SNOWFLAKES FALLING · NO SNOWFLAKES FALLING · SNOWING · GREY SKY · NO SNOW FALLING · SOUND OF THE SMALL STREAM RUNNING OVER ROCKS INTO POOLS AND ON DOWN HILL TO A BIGGER STREAM · DARKNESS · NIGHT · LIGHT SNOW SHOWERS · MORNING BRIGHT SUN THROUGH THE TREES BLUE SKY · SUN MELTING SNOW IN THE TREES · SNOW FALLS FROM THE BRANCHES · WARMTH FROM THE SUN · A BRIGHT BLUE CLOUDLESS SKY · FALLING SNOW FROM THE BRANCHES · HOLES IN THE SNOW ON THE GROUND · AT THE VERY TOP OF A LIVING TREE A SMALL GREY BREASTED BIRD SINGING A TWO NOTE SONG · FOUR SINGLE BARKS FROM AN UNSEEN DEER UP A SLOPE IN THE TREES · PALE GREY CLOUDS MOVING OVER THE HILLTOPS

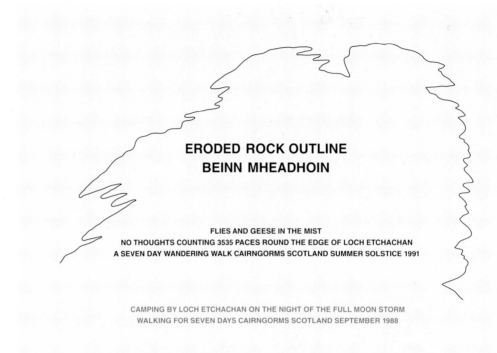

**ERODED ROCK OUTLINE
BEINN MHEADHOIN**

FLIES AND GEESE IN THE MIST
NO THOUGHTS COUNTING 3535 PACES ROUND THE EDGE OF LOCH ETCHACHAN
A SEVEN DAY WANDERING WALK CAIRNGORMS SCOTLAND SUMMER SOLSTICE 1991

CAMPING BY LOCH ETCHACHAN ON THE NIGHT OF THE FULL MOON STORM
WALKING FOR SEVEN DAYS CAIRNGORMS SCOTLAND SEPTEMBER 1988

GEESE FLYING SOUTH

NO

THOUGHTS

COUNTING

396

BAREFOOT

PACES

ON

ONE

DEER

PATH

A SEVEN DAY WANDERING WALK CAIRNGORMS SCOTLAND SEPTEMBER 1990

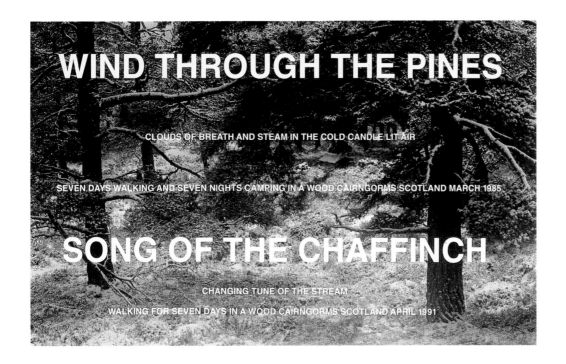

WIND THROUGH THE PINES

CLOUDS OF BREATH AND STEAM IN THE COLD CANDLE LIT AIR

SEVEN DAYS WALKING AND SEVEN NIGHTS CAMPING IN A WOOD CAIRNGORMS SCOTLAND MARCH 1985

SONG OF THE CHAFFINCH

CHANGING TUNE OF THE STREAM

WALKING FOR SEVEN DAYS IN A WOOD CAIRNGORMS SCOTLAND APRIL 1991

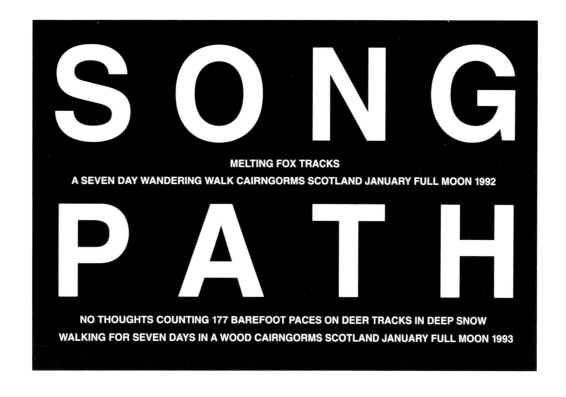

SONG

MELTING FOX TRACKS

A SEVEN DAY WANDERING WALK CAIRNGORMS SCOTLAND JANUARY FULL MOON 1992

PATH

NO THOUGHTS COUNTING 177 BAREFOOT PACES ON DEER TRACKS IN DEEP SNOW

WALKING FOR SEVEN DAYS IN A WOOD CAIRNGORMS SCOTLAND JANUARY FULL MOON 1993

Antony Gormley *Body and Soul*

1990

DESCRIPTION: 9 etchings with title-page and colophon in portfolio case bound in black buckram.

EDITION: 30 sets numbered 1 to 30 plus 6 proof sets and 1 BAT. First 25 sets issued in portfolio form, 5 sets split up and released separately.

INSCRIPTIONS: Each print signed and numbered by the artist on verso.

SIZE: 50 × 58.1cm (paper size); 30 × 40cm (plate size).

PAPER: 300gsm Somerset TP Textured.

TECHNIQUE: The white prints made in softground etching from one copper plate, the black from three separate copper plates. The black prints are a mixture of softground etching with hardground etched lines and aquatint.

PRINTER: Hope Sufferance Studios, London: proofed and printed by Simon Marsh and Peter Kosowicz with Niall Finn and Gordon Robertson. Title and colophon printed by Phil Abel.

BINDING: Made by Ryders, Bletchley.

TYPOGRAPHY: Title-page and colophon designed by the artist with Phil Abel in Monotype Bembo.

BIOGRAPHY: Born London 1950. Studied archaeology, anthropology and art history at Trinity College, Cambridge, 1968–70. Attended Central School of Art and Design, London, 1973–74; Goldsmiths' College, London, 1974–77; Slade School of Art, London, 1977–79. Solo exhibitions include Whitechapel Art Gallery, London, 1981; Kunstverein, Frankfurt, 1985; Louisiana Museum of Modern Art, Humlebaek, 1989; Malmö Konsthall, 1993; Tate Gallery Liverpool and Irish Museum of Modern Art, 1993–94. Won Turner Prize 1994. Lives in London.

Gormley's approach to making sculpture has a direct correlation with the processes involved in printmaking. Just as his lead and concrete sculptures are generated from casts of his own body, so an etching or engraving is essentially a cast or impression of a metal or wooden printing plate. Yet prior to this project Gormley's experience of etching was confined to a few prints he had made as a student. His only other printed work was a series of woodblock prints entitled *Bearing Light*, made in Los Angeles in 1989 and published by Okeanos Press.

For the present project Gormley worked at the Hope Sufferance studios in London from April to September 1990, producing over one-hundred prints. Rather than set out with a preconceived plan he preferred to work on the plates in the studio, experimenting with different techniques and trying out different approaches. His first works were drawn images, some of which were later developed into sculptures in cast concrete.

Whilst making the drawings in softground etching, Gormley became aware of the marks his thumbprints made at the edge of the plate and realised that instead of drawing images with an etching tool he could make the marks directly with his body: the process has clear parallels with his method of making sculpture. The first of these 'body prints' was an image of a brain formed by two thumb-prints. He subsequently made prints directly from different parts of his body, and of these he selected nine for the *Body and Soul* portfolio. They are impressions of five of the artist's orifices (mouth, nostrils, anus, penis and ears), plus his hands, knees, forehead and spine. In making these works he pressed parts of his body onto the softground metal plates to leave an impression, and, in the case of the orifice prints, aquatinted large areas of the plate to produce a black print. The five orifice prints are thus white marks on a black ground while the external parts of his body are printed as black marks on a white ground. On the five black prints he added a series of very fine engraved lines, which

articulate the darkness and seem to radiate outwards from the centre. The effect achieved in the black prints is of being inside the body and looking out through the body's apertures.

The artist has written that: 'The etchings try to express touch as gravity made conscious and gravity as the attraction that binds us to the earth. The five dark plates are impressions of the five main orifices: a vision of the inner realm of the body irradiated by the light and energy of what Blake called "the windows of the soul"'

Empathy lies at the heart of Gormley's art. Instead of employing narrative or putting formalist, aesthetic or theory-based concerns to the fore, it is Gormley's aim to communicate directly through feeling. Since the one common denominator shared by all humans is that we have bodies, it is with the body that Gormley creates his art. Rather than draw, paint or model representations of another body, he uses his own directly. He thus circumvents the traditional artistic preoccupation with gestural mark-making and iconography. In confronting his lead body-cases we are invited to imagine ourselves within that body and become conscious of our own selves, of our inward state. In this way Gormley's work addresses the viewer's experience very directly. The *Body and Soul* prints work in a similar way. The artist regards them as key works in his oeuvre, because in them the exterior and interior spaces of the body – the body and the soul – are unified.

The prints have a sequence and can, in the artist's words, be seen as 'a meditation on twoness and oneness. The body has within it unity and division, single foci like the mouth, the navel, the penis, that lie on the body's central axis; and dualities like the hands or the eyes that function in pairs.'

The origin of the individual marks is not immediately apparent and this was the artist's intention. The ears have a certain affinity with shells, the anus appears like a comet in the sky and the penis like the planet earth seen from space. In this way parts of the body have a metaphorical significance which binds them to

other natural forms in the universe: this approach has evident parallels with Buddhist and Zen philosophies.

Referring specifically to the *Body and Soul* project, the artist comments that: *'At first I spent some time considering objects with which I shared the world, that both existed within the sphere of a personal life and threatened it – they seemed to have a certainty about them – some hold on time and place.*

Now I have crossed the threshold and have come to this closed ground of the body and I feel less certain. Before I was happy to explore at arm's length the abstract relations of form and content – now my horizons are both more circumscribed and more infinite for one cannot touch the body without considering the soul – these things cannot be described, cannot be represented but somehow if the certainty can be focussed – if a true account can be given of the material facts, a potential might be expressed – which is where these prints may be relevant.

There is something about printing and the way that it encourages the maker of a plate to think about the mirror of his image and the reversal of his negatives and positives that links with the oppositions that have driven and exasperated me. Printing makes one treat day as night, and relieves the monotony of always living in one or the other.

In the work generally I have tried to make a bridge between the inner and outer worlds to bring light to weight and weight to light and these prints are a continuation of the attempt. Printing was invented to touch the mind by disseminating the word. I am trying to return the mind to the body.'

1

3

4

7

8

John Hilliard *Seven Monoprints*

1990

DESCRIPTION: 7 monoprints. Each is a photographic montage scanned onto paper in ink with areas individually masked out. Each print dry-mounted onto board and framed. Each print in the edition differs slightly owing to individual placing of masked-out areas.

INDIVIDUAL TITLES AND SIZES:
1. *Shower*, 126×153cm;
2. *Demand*, 120×155.5cm;
3. *Exclusion*, 114×148cm;
4. *Capture*, 132×162.5cm;
5. *Compound*, 135×161.5cm;
6. *Imperative*, 124×153.5cm;
7. *Incident*, 126×126.5cm.

EDITION: Seven sets of seven images. No proofs.

INSCRIPTIONS: Each print issued with a certificate signed by the artist.

PAPER: 350gsm Waterford.

TECHNIQUE: Scanachrome ink-jet printing with individually masked-out elements (see text below for details).

PRINTER: Scanachrome Ltd., Skelmersdale.

BINDING: None.

BIOGRAPHY: Born Lancaster 1945. Studied at Lancaster College of Art 1962–64 and in the sculpture department at St Martin's School of Art, London, 1964–67. Numerous solo exhibitions throughout Europe and USA since 1969 including Museum of Modern Art, Oxford, 1974; Sprengel Museum, Hanover, 1987; and Kunstverein, Stuttgart, 1990. Has shown with the Lisson Gallery, London, since 1970, and the Galerie Durand-Dessert, Paris, since 1976.

Each image has its origin in a small, black and white photographic montage, all the photography having been done by the artist. Hilliard began by making sketches and then took specific photographs. For example, the seventh print, *Incident* combines a photograph of the pedestrian tunnel which runs from Greenwich to the Isle of Dogs with a photograph of a man (in this case Hilliard's neighbour) holding a gun. Hilliard collaged the two photographs together and re-photographed them to produce a single, unified image. Once he had made all seven images via this procedure, he took them to the Scanachrome printing studios at Skelmersdale, near Liverpool. There his black and white original (transferred onto photographic film) was scanned with a beam of photo-optic light, digitalised, and recreated in much enlarged form with a four-colour ink-jet machine. Hilliard made numerous test-strips, introducing different colours, before making the final prints. He had the images printed onto very large sheets of watercolour paper onto which he had stuck cut-out paper forms, words and masking-tape grids. The ink-jet mechanism moved slowly across the paper and once it had printed the entire image the masked elements were removed to leave 'negative', unprinted, white forms. Seven of each of the seven images were made and each differs slightly owing to the individual placement of these masking devices. Production of the set was carried out over two days.

The Scanachrome system was designed for the production of very large advertising hoardings and signs. Hilliard, whose work is all photography-based, began using the process in 1983, following some discussion with the artist Tim Head, who used the same process at a later date. In *Seven Monoprints* two very different traditions, that of fine-art watercolour and that of computer technology, are brought together. The quality of the final image is as much painterly as it is photographic: on close examination one can see the rows of tiny dot-marks made by the ink-jet as well as the random granular form of the enlarged photograph and the texture of the watercolour paper.

Hilliard wanted to establish a narrative (which alludes, broadly, to city violence) but employ a minimal number of narrative devices. Each of the images combines deep spatial recession with elements which seem to thrust out of the picture plane (in the case of *Capture* and *Compound* it is the gaze of the eyes and shine of the lights which project out) and confront the spectator in an alarmingly aggressive manner. Hilliard's work is much concerned with the processes of picturing and picture-making and with the ambiguities that lie within these conventions. His work invites the spectator to question the way in which space is created within the image, how that image relates to real space, and how the work is made on the surface of the paper or canvas. Just as Cubism is concerned with the relationship between real space and fictive, pictorial space, with multiple readings and with the ambiguous nature of vision, so these issues are addressed by Hilliard through the medium of photography and computer technology. The themes he deals with - such as power, violence, control, surveillance and fear – are similarly contemporary and are associated through his images with modern, post-industrial, city life.

The particular photographic images in *Seven Monoprints* are varied and are used to create the idea of violence and oppression rather than establish a specific narrative. *Shower* is based on a photograph of a man in a workshop angle-grinding, with sparks flying out. *Capture* is a montage of two photographs of a shaven-headed woman with a grid projected onto her face, suggesting imprisonment. *Compound* is a montage of photographs of lights and wire netting. *Imperative* includes a photograph of buildings in the city of London. The male symbols in *Incident* derive from men's toilet signs: Hilliard wanted to recreate the dank, oppressive feel of public subways and toilets and conflate it with contemporary violence. He made a second, larger version of this work, *Incident (Extreme Prejudice)*, which included ten white figures: the allusion to the song *Ten Little Indians* hints at racial violence.

1 *Shower*

2 *Demand*

In January 1990 the artist wrote the following statement, titled *Backwards, Forwards and Sideways* specifically about this group of mono-prints:

'A dominant sense of 'beyond' notwithstanding (established in painting, but utterly compounded in film, photography and television), there are ordinarily three potential picture spaces. The illusion of events 'behind' the surface has its obverse in an equally optical phenomenon – the experience of a pictorial intrusion into the space before the surface. This may be achieved through the challengingly direct gaze of one or more of the picture's 'occupants'; through dramatic foreshortening of insistently 'protruding' objects; through the disturbing spatial shifts of complementary colours; or simply through an outpouring of reflected or radiated light. Thirdly, there are incidents within the picture-plane itself, the 'real' site of the picture, the facts of the matter, whether of paint on canvas, pixels on a TV screen, shimmering granulated projections in the cinema, or the petrified grain of still photography. Within the remit of the fixed image, it is this latter where the balance seems most to need redress, where the smooth illusions, manoeuvering the gaze backwards and forwards in a play of deceits, beg the sideways rupturing of that seamless emulsion which they inhabit – a stripping back to the pallid skin of the support.

The seemingly aggressive preferment of the matière in this description is misleading, however (and only given emphasis because the actual medium is generally downplayed in photography). It is not a question of favouring any one of these picture spaces over the others; rather, it should be acknowledged that each has a distinct role to play, each has different capabilities, and all may be deployed interactively. If we are talking about language, about the grammar of picturing, then it may be useful to effect a comparative demonstration of the equivalents offered at these three levels. Equally, and more informally, we may simply choose elements that 'need' or extend each other. Either way, there is the prospect of establishing a 'conversation' between the spaces, a three-way exchange of utterance and silence, an incomplete stammer that nevertheless maps the co-ordinates that allow for the induction of a complete 'story'.

Such a mean reduction of the notion of 'story', to only a small number of elements within a single picture, especially when achieved through superimposition and a set of overtly graphic strategies, consciously references the parallel reductiveness of the book jacket or the film poster. These are not only devices that must similarly carry the sense of an entire narrative through an impossibly condensed 'extract'; they also form part of that extended visual field which art both feeds into and can in turn feed from. Far from being 'poor relations', the best images produced from within commercial art include examples that are as richly inventive and as highly resolved as those of their fine-art cousins.

In discussing (and demonstrating) issues that are in part historically recurrent, in part rooted in late-Twentieth-Century experience, it seems fitting to be able to use the trappings of both – to take the soft, traditional substrates of canvas or watercolour paper, and adorn them with scanned and digitized images from Ektachrome film. The images themselves, however, in contrast to the gentleness of the former or the mechanistic neutrality of the latter, are assertively confrontational, provocative, in order to force the inter-spatial debate. They blatantly threaten the spectator with lethal weapons, deploy a blinding battery of floodlights, point an accusing finger or level a baleful stare. Yet this brutality is itself suppressed, blockaded by grilles and meshes, punctured by cut-outs that literally excise parts of the picture, or avoided by an escape into recessive tunnels and vistas. Both image and spectator are by turns assailant and victim, caught up in an alternating pursuit, skipping in and out of the picture and occasionally colliding head-on, a flattening obliteration in the picture-plane – the site of an opaque support that cuts boldly across this optical to-and-fro, stunning it into a bleached white silence.'

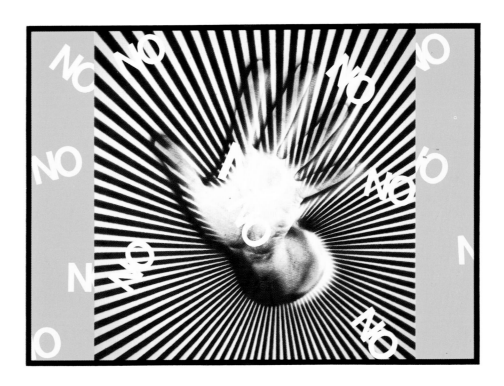

3 *Exclusion*

4 *Capture*

5 *Compound*

6 *Imperative*

Shirazeh Houshiary *Round Dance*

1992

DESCRIPTION: 5 colour etchings and 5 poems by Jajal al-Din Rumi (printed on separate sheets) and colophon in portfolio case bound in grey buckram and lead with hand-embossed title.

EDITION: 20 sets numbered 1 to 20 plus 6 proof sets and 1 BAT.

INSCRIPTIONS: Each print signed and numbered by the artist on verso.

SIZE: 77 × 76cm (paper size); 60 × 60cm (plate size). Poems printed on paper 71 × 71cm.

PAPER: 450gsm Zerkall (etchings); 350gsm Zerkall (poems).

TECHNIQUE: Each print made from five separate plates. The square plate printed in green aquatint; the second plate had black spitbite in the corner areas; and three additional plates in hardground etching.

PRINTER: Hope Sufferance Press, London. Proofed and printed by Peter Kosowicz. Poems and colophon printed by Simon King, Cumbria, on an Albion Press.

BINDING: Designed by the artist with Charles Gledhill and made by Gledhill.

TYPOGRAPHY: Text layout designed by the artist and Phil Baines in 36-point Monotype Baskerville Roman.

BIOGRAPHY: Born in Iran 1955. Moved to London 1973. Graduated from Chelsea School of Art 1979. Solo exhibitions at Lisson Gallery, London, 1992 and 1994; Camden Arts Centre, London, 1993; touring exhibition in USA 1993; and Le Magasin, Grenoble, 1995. Showed at Venice Biennale 1993. Lives in London.

Round Dance, Houshiary's first prints, relate directly to a series of five large chalk and mixed-media drawings entitled *Enclosure of Sanctity*, which she created early in 1992. Having been asked by Booth-Clibborn to make a series of prints she began by experimenting on small copper etching plates and discovered that the process of etching, in which layers are built up, very much suited her way of working.

Houshiary was born in Iran and moved to Britain in 1973: her work combines elements derived from Iranian culture and western art traditions. The *Enclosure of Sanctity* drawings and *Round Dance* etchings were inspired by the poems of Jajal al-Din Rumi. Rumi was a thirteenth-century mystic, poet and teacher who greatly influenced the spiritual philosophy of Sufism. It is recorded that Rumi met a mystic named Shams (the Sun) and fell in love with him. When Shams disappeared Rumi was distraught and began a quest for wholeness. Houshiary states that she makes her art in order 'to manifest stages of the journey towards wholeness, which is the root of humanity.' In Sufi thought, it is believed that three movements make up the creation of the universe: ascent, descent and expansion. At the centre of this universe is the point of knowledge, in a state of purity, around which all forms of existence move. In her art Houshiary is concerned with finding visual equivalents for this state of spiritual purity.

Much of Houshiary's sculpture and recent painted work is based on the unity that exists between the square, the triangle, the cube and the circle; the *Round Dance* prints relate particularly to the rotation of the earth and the planetary system. As in the *Enclosure of Sanctity* drawings, the drawn forms of the etchings are made up of closely-written Arabic chants and prayers. The script is so densely overlaid that the words are indecipherable, but it was not the artist's intention for the viewer to be able to read the script, rather for the words to become images. As Houshiary says: 'The word loses its meaning and form is born from this. It is revealing the invisible.' This is a process the artist likens to the way breath, which is invisible and immaterial, can create speech and meaning.

The five etchings contained in the portfolio are accompanied by five poems by Rumi, each printed on slightly smaller sheets than the etchings. The images do not illustrate the poems, nor do the poems act as titles for the images; indeed when the five chalk drawings were first exhibited in 1992 four of the poems which accompanied them were different to those inserted into the portfolio. The portfolio poems are as follows:

1. *The waves of earth are our imagination and understanding and thought; the waves of water are self-effacement and intoxication and death.*
2. *Walk to the well. Turn as the earth and moon turn, Circling what they love. Whatever circles comes from the centre.*
3. *When the blossom is shed, the fruit comes to a head: when the body is shattered, the spirit lifts up its head.*
4. *The roof of the seventh sky is certainly high, yet even this roof does not reach where reaches the ladder of round-dance.*
5. *When I looked at myself, I saw myself no more, because by grace my body had become fine.*

Just as one can obtain a different intensity of mark with a pencil by varying the pressure applied, so this was a quality Houshiary sought in the etchings. To achieve this, Peter Kosowicz and Simon Marsh at Hope Sufferance press advised her to work on several plates, and they left the plates in acid for different lengths of time in order to obtain light and strong marks. Each print was made from five separate copper plates, printed one on top of the other, though the order in which the plates were printed varies. There are two square aquatint plates, each of which was painted by hand for each print in the entire edition. One of these aquatint plates carries the green colour which is a mixture of veridian green and geranium red; the other carries black at the corners of the plate which serves to focus the eye on the central part of the image. The etched circular forms were built up on three separate plates, each of which was bitten with acid for a different length of time.

Houshiary has written about the *Enclosure of Sanctity* drawings as follows:

'The five drawings each contain the representation of the world as a vortex. Its substance is woven from the incantation of these words given to man by God: "There is no Divinity, if it is not Divine." The nature of the words is like the weft and warp of the threads from which the fabric of the universe is woven. Criss-crossing these Divine words gives rise to forms of the manifested world which are covered by the existence of light and dark patterns. To know the Universal Man that exists in our original centre, we have to unravel these patterns.

Within the vortex of each image, there is a square whose substance is also woven from the weft and warp of Divine words, and symbolizes the sun within the planetary system. Each of these squares is further divided into 36 squares, the division of six by six. The dance of light and dark within the squares expresses the relationship between odd and even numbers, and points to the multiplicity of our being. We are the one rotating around this sun; we are on the edge of the vortex, seeking to be at the convergence of time, space and number. It is at this junction that we know the timeless present, where we can glance 'outside' of time.

When the odd and even numbers are equal, we come to know the original androgynous state. Sometimes, the even numbers, or light areas, dominate the odd numbers or dark areas; at other times, the dark areas replace the light. To sense the original vibrations of these patterns, even and odd, light and dark, we have to experience the two phases of concentration and expansion. The simultaneous appearance of these two complementary phases is the complete form of the Universal Man, whom God commanded the angels to adore.

The colour green is used in all of the images and has special meaning in many traditional cultures. In Sufism the meaning of the colour is personified as a green man called Khizr, a timeless sage who mysteriously appears throughout time. Khizr is the guardian of the "water of life" and has been the invisible Master for many Sufi.

In both the Celtic and Christian traditions, green appears as the colour of the Holy Grail, the vessel which contained the blood of Christ. Christ's blood symbolizes the "water of life" and its sense of eternity. Legend has it that the grail was fashioned by angels from an emerald that dropped from Lucifer's forehead at the time of his fall, a story which parallels man's expulsion from the Garden of Eden. Green, then, represents the primordial state which became hidden at the time of man's fall from grace. Recovering the sense of eternity is to recover the nature of humanity in its heavenly state.'

Since completing the *Round Dance* prints in 1992 Houshiary has made a number of related drawings which are constructed in a similar way. These are made on large square boards, painted black, and are worked on with a very hard-grade pencil. The fine pencil script is built up, layer upon layer, paralleling the technique she had developed for the etchings.

2 3

4 5

Peter Howson *A Hero of the People*

DESCRIPTION: 25-page book with 14 full-page black-and-white linocuts illustrating a story by Crispin Jackson. The portfolio version has 16 black-and-white linocuts, title-page and colophon and no text. Book version bound in grey Quinel cloth and slip-case. Portfolio version bound in grey Quinnel cloth and red buckram.

EDITION: 70 copies of the book numbered 1 to 70 plus 10 proof copies; 40 copies of the portfolio numbered 1 to 40 plus 5 proof copies.

INSCRIPTIONS: Each print in portfolio edition is signed and numbered by the artist. Book edition signed by the artist and author on colophon page.

SIZE: 55 × 38.6cm (page size of portfolio); 53.4 × 36.5cm (page size of book).

INDIVIDUAL IMAGE SIZES:
1. 20.2 × 30cm; 2. 19.5 × 30.1cm; 3. 40.5 × 29.8cm; 4. 40 × 30.1cm; 5. 40.4 × 29.8cm; 6. 30.2 × 19.5cm; 7. 40.5 × 29.8cm; 8. 30.2 × 20.5cm; 9. 36 × 21.6cm; 10. 30.2 × 19.7cm; 11. 20.5 × 30.2cm. 12. 30.2 × 20.2cm; 13. 20.6 × 15.1cm; 14. 40 × 30cm; 15. 20.1 × 15cm; 16. 15.1 × 20cm.

PAPER: 300gsm Somerset White Textured.

TECHNIQUE: Linocuts cut by the artist.

PRINTER: Simon King, Cumbria, on an Albion Press (text and linocuts).

BINDING: First 20 books bound by Cathy Robert. Portfolio version in black chemise within red buckram folder with steel-grey Quinel soft-cloth cover (only 10 made). New binding designed by Charles Gledhill 1990.

TYPOGRAPHY: Designed by Phil Baines in 18-point Monotype Baskerville.

BIOGRAPHY: Born London 1958. Moved to Scotland 1962. Studied at Glasgow School of Art 1975–77 and 1979–81. Artist in Residence St Andrews University, 1985. Official war artist, Bosnia, 1994. Solo exhibitions include Angela Flowers Gallery (and Flowers East), London, 1987 to present; major retrospective at McLellan Galleries, Glasgow, 1993 and Imperial War Museum, London, 1994.

Charles Booth-Clibborn's interest in boxing led him to commission both the text and linocuts for this publication. Crispin Jackson has provided the following synopsis of his text:

'*A Hero of the People* is set in the early 1950s and tells the story of a British boxer, Randolph Turpin and his doomed attempt to defend his world-title against the previous champion, a flamboyant American called Sugar Ray Robinson. It opens with an account of his send-off at Southampton; describes the voyage across the Atlantic, in the course of which he is fed spiked drinks by two gangsters in the pay of his manager; and climaxes with a long description of the fight itself, in which – still feeling the ill-effects of the alcohol – he is defeated. The story concludes with the manager making arrangements for a third, deciding contest between the two men.' In Jackson's text the boxers are referred to as Randolph London and Sugar Ray Patterson.

In the late 1970s Howson spent a brief period in the army and was a member of the army boxing team. On leaving the army he continued his involvement in the sport, becoming a member of the Whitletts boxing club in Ayr. He only ceased boxing after his nose was broken for a third time. In the early 1980s he made a number of drawings of boxers but it was not until 1985, when he was Artist in Residence at St Andrews University, that the figure of the boxer came to assume a central place in his work. In St Andrews he made his first oil-painting of a boxer, hitting a punchbag: he has since reworked that image in paintings and drawings, and a version of it appears as the third linocut in *A Hero of the People*. In Howson's work the boxer is not an overtly aggressive figure, but rather a sad, solitary one who is used and abused, and who evokes our sympathy.

Having read Jackson's text, Howson made the linocuts in the evenings at home. The book version has fourteen linocuts while the portfolio has two additional prints – linocut no.7 cut horizontally to create two separate images. Prior to *A Hero of the People* he had made only a small number of linocuts, none of which had been editioned. The text and prints were made during the autumn of 1987 for publication in January 1988.

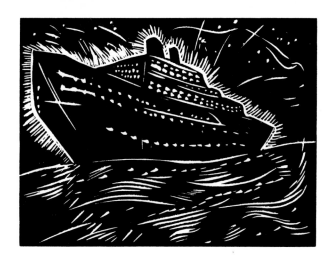

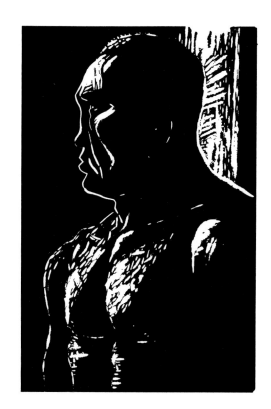

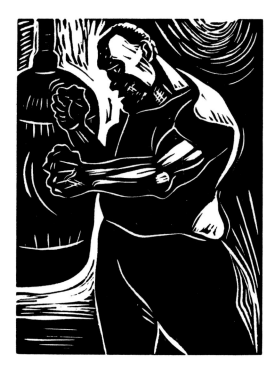

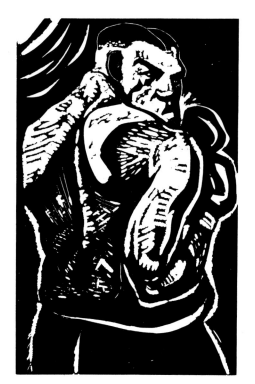

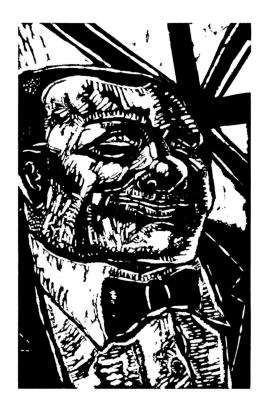

1

2

3

4

5

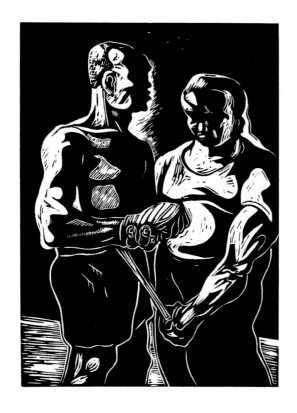

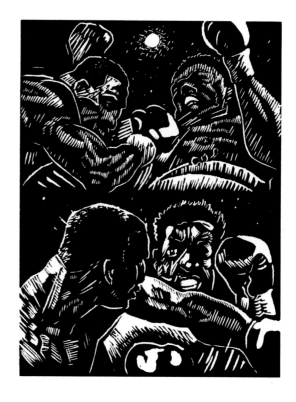

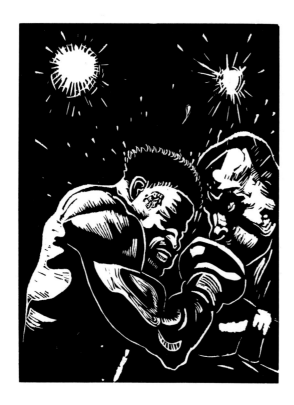

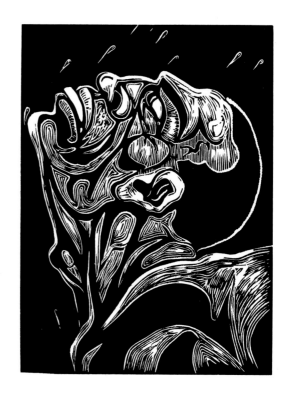

6

7

8

9

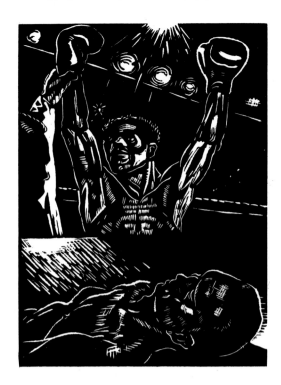

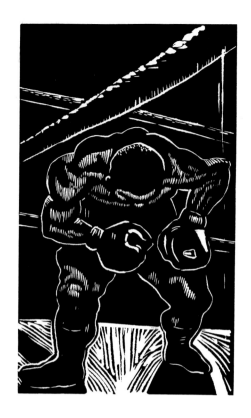

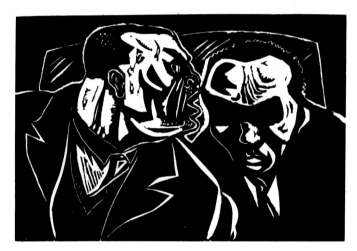

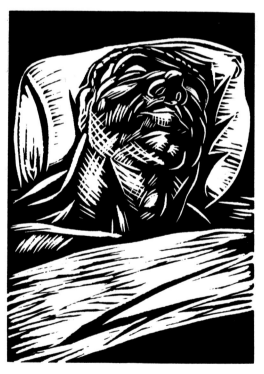

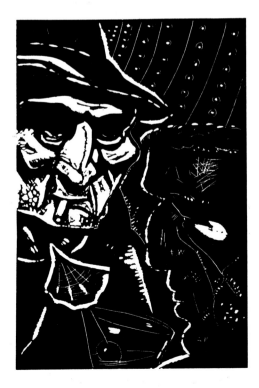

Peter Howson *The Noble Dosser; The Heroic Dosser; The Bodybuilder*

1988

DESCRIPTION: 3 screenprints.

EDITION: 30 of each plus 3 proof copies of each.

INSCRIPTIONS: Each print signed, numbered and dated by the artist.

SIZE: Each 151 × 107cm (paper size).
PAPER: 300gsm Roll Arches

TECHNIQUE: Screenprint, twelve separate screens for the *Dosser* prints, fourteen for *The Bodybuilder*.

PRINTER: Peacock Printmakers, Aberdeen: printed by Arthur Watson.

The three screenprints Howson had produced for *The Scottish Bestiary* (see pp.41 and 45) and the linocuts he had made for *A Hero of the People* (see pp.120–123) were all small in size. The intention in these three screenprints was to produce work on a much larger scale. In 1986–87 Howson had reworked the three *Scottish Bestiary* prints into a large triptych in oil: the present screenprints continue that triptych theme though Howson did not intend them to be hung together in a particular sequence. They were made at Peacock Print-makers in Aberdeen, concurrently with a set of three very large woodcuts, *The Noble Dosser*, *The Heroic Dosser* and *The Lonely Hero*, made at and published by the Glasgow Print Studio. The two Dosser images in the screenprint and woodcut series are very close, though in the woodcuts the image is reversed.

Howson continually reworks motifs (for example the boxer, the dosser, the 'patriotic' yob with baseball-cap), introducing the same cast of characters into paintings, prints and drawings. Each of the images in these three screenprints develops from a painting or drawing Howson had made in the previous two years. *The Bodybuilder* was first made as a small pastel drawing in 1986. He subsequently developed it into a large oil-painting in order to establish the correct scale for the screenprint. Rather than generate the screenprint photographically from the painting, Howson painted all the colour separations by hand onto separate acetate sheets (there are fourteen colours). A different version of this wrestler figure, with broken nose, featured in *A Hero of the People*.

The Heroic Dosser and *The Noble Dosser* screenprints were preceded by large charcoal studies, though again they relate to specific paintings. *The Heroic Dosser* was first made as a painting (collection Scottish National Gallery of Modern Art, Edinburgh) in 1987 and was the first of a series of dosser pictures made in a variety of different medium. At the time Howson had a studio in the Gallowgate area of Glasgow, close to a hostel for the homeless. He saw the dosser holding onto a rail and painted him from memory, adding a Gallowgate building behind him so that it appears to rise out from his shoulders.

The Noble Dosser was first executed as a large oil-painting (shortly after *The Heroic Dosser* painting) and was subsequently made as a lithograph at Edinburgh Printmakers. Like the figure in *The Heroic Dosser*, it is based on a person Howson saw though it was done from memory.

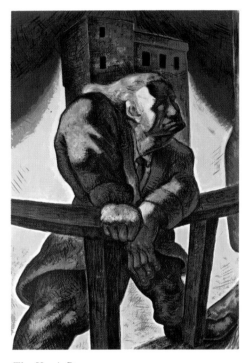

The Heroic Dosser

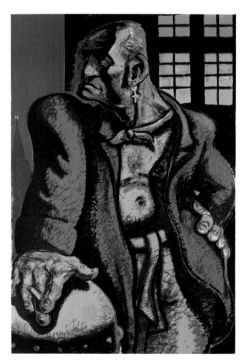

The Noble Dosser

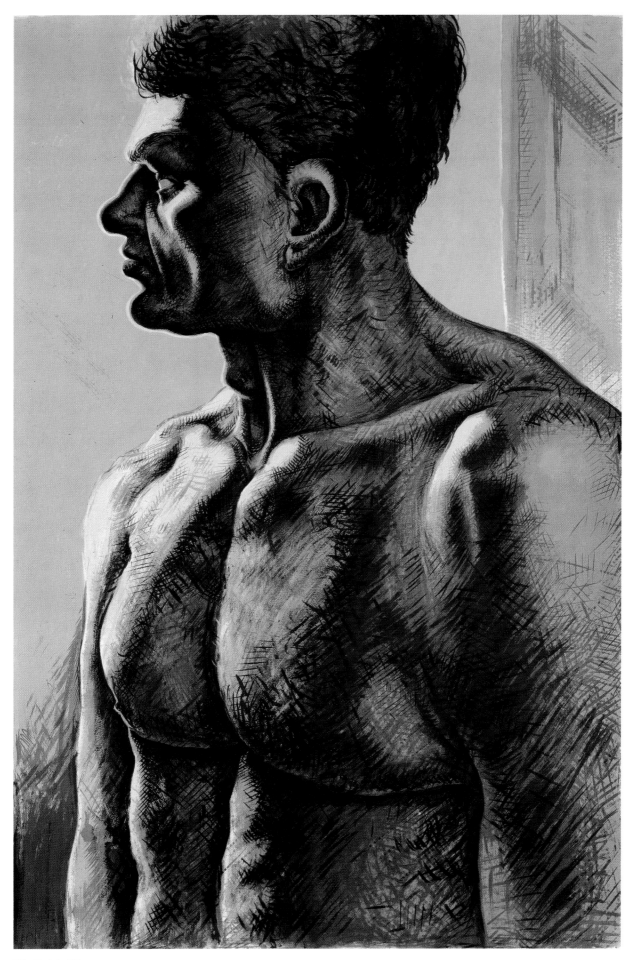

The Bodybuilder

Alan Johnston *Loop*

1994

DESCRIPTION: 12 etchings in 6 pairs, poem by Kenneth White, title-page and colophon, in portfolio case bound in black buckram.

EDITION: 35 sets numbered 1 to 35 plus 10 proof sets.

INSCRIPTIONS: Each print signed, stamped, dated and numbered by the artist on verso.

SIZE: Each 50 × 61cm; pair 50 × 122cm.

PAPER: 225gsm Zerkall.

TECHNIQUE: Hardground etching and drypoint in black and buff ink.

PRINTER: Alfons Bytautas, Edinburgh. Poem, title-page and colophon printed by Simon King, Cumbria, on an Albion Press.

BINDING: Designed by the artist, made by Ryders, Bletchley.

TYPOGRAPHY: Poem, title-page and colophon designed by Simon King in Gill Sans.

BIOGRAPHY: Born Edinburgh 1945. Studied at Edinburgh College of Art 1967–70; Royal College of Art, London, 1970–72 and Kunstakademie Düsseldorf 1972–74. Solo exhibitions include Galerie Konrad Fischer, Düsseldorf, 1973; Van der Heydt Museum, Wuppertal, 1974; Jack Tilton Gallery, New York, 1986–94; Graeme Murray Gallery, Edinburgh, 1977–83; Fruitmarket Gallery, Edinburgh, 1987; and Shimada Gallery, Yamaguchi and Tokyo, 1984–present. Lives in Edinburgh.

Since his student days, Johnston has taken a keen interest in literature, architecture and philosophy, particularly the work of Wittgenstein. In Edinburgh in the mid-1960s he became aware of the work of the artist-poet Ian Hamilton Finlay who was in contact with a wide range of innovative artists and writers throughout the world. He was strongly attracted to Finlay's international approach to cultural activity and has followed this path, travelling widely and exhibiting all over the world. Just as Finlay's writings and activities are an integral part of his art, so it is that Johnston's international outlook is central to an understanding of his art.

This suite of etchings relates to a series of large drawings on linen made by Johnston specifically for exhibition at the Wittgenstein Haus in Vienna in spring 1994. Wittgenstein's house was designed in its entirety by the philosopher for his sister Margarete and was completed in 1928; it has held a special significance for Johnston for many years. In 1968 he travelled with friends by train from Greece to Vienna, partly in order to see the house. However, finding themselves in the midst of uprisings sweeping eastern Europe, he and his companions were stopped in Bulgaria and were briefly imprisoned. Only five years later did he have the opportunity to visit Vienna and see the house, which, by an ironic coincidence, had by then become the Bulgarian Embassy.

Wittgenstein's house is the philosopher's only architectural work. All the measurements within the house (length of walls, height of ceilings etc.) are divisible by a 3cm unit, though the reason for this is unknown. Johnston regards the house as a plastic form of thought, as a perfect organisation of philosophical space, and he has returned there year after year since his first visit in 1973.

Since the early 1970s Johnston's work has been conceived in intimate relation to architectural spaces and has been executed in a variety of countries. Most of his work is in graphite or charcoal, and much of it is drawn directly onto walls; in recent years he has also made drawings on linen. Influenced by Zen philosophy (he spends much time in Japan), he has developed a minimalist art-form built up of discrete hatched lines. His works have a quiet but insistent presence which make one become aware of the spaces in which they are shown. When in 1992 he was invited to have a solo exhibition at the 1994 Vienna Festival, Johnston immediately thought of having the show in the Wittgenstein Haus and making works specifically for it. After repeated visits to Vienna, he managed to gain agreement to use six rooms on the ground floor of the Bulgarian Embassy. He created sixteen new works for the exhibition: fifteen of them were in pencil on linen and one was a sculpture. Each piece was made to fit the wall on which it is hung and each, like the house itself, is based upon a 3cm unit of measurement (together with a 4.5cm unit which Johnston has used in the past in his work).

Charles Booth-Clibborn came to Johnston with the suggestion for a print project in the spring of 1993, at a time when the artist was engaged on the Vienna exhibition. The etchings were begun immediately after the exhibition in April 1994. While the structures established in the linen drawings find their echo in the etchings, they are not identical in form. The prints were initially begun as softground etchings but for technical reasons Johnston abandoned these and changed instead to hardground. He made the etched lines by hatching in small square areas and then building up the density of the tones by adding layers of hatching at right angles to the previous layer. Johnston describes this approach as creating 'a compilation of spaces through pressure.' The dark etchings have a certain amount of drypoint on the final layer to give a rich black. The twelve etchings are in the form of six pairs.

Like the Wittgenstein drawings, they are based on a grid structure. The tones in the etchings range from large white, untouched areas, through grey to near black. Johnston describes this range of tones as paralleling the tactile element of perception: 'I'm alluding to a type of spatial contemplation. In my work there is a very strong passage of reductivism. It's an anti-technological view of art – a tactile, geometric sensibility, refering to cosmological thought as a tangible thing. I want to touch the intangible.'

Each of the pairs is based on a kind of mirroring, hence the title *Loop*. The left and right-hand images do not reflect one another in a direct way, but relate in a negative-positive and sometimes inverted sense. The title *Loop* comes from an essay by Donald Kuspit and refers to the loop as an analogy of the mind as a mirror. For several centuries, an important debate among philosophers has been the question of whether knowledge is a mirror of reality or whether the two are entirely separate. Johnston's suite of etchings plays with this mirroring analogy of the mind to the world. At another level, one the artist acknowledges is hidden and private, the series relates to philosophical ideas which have passed from Edinburgh to Vienna and back again – as if in a looping movement – since the Enlightenment.

The portfolio contains a specially commissioned poem by the Scottish writer Kenneth White (b.1936). White holds the Chair of Twentieth-Century Geopoetics at the Sorbonne, Paris:

Tractatus cosmo-poeticus

take it from Hume / forgetting the human / at least the all-too-human

'the field is the world'

from the sharp lines of sceptical Scotland / move on, say, to

an ice-field in the vicinity of Reykjavik / a high plateau in Utah / a raked zen garden in Kyoto / the house of Wittgenstein in Vienna

the *tractatuslogico-philosophicus* / has this: / 'a picture presents a situation / in logical space / the existence and non-existence / of states of affairs'

the mind loves elements / related to one another / in a determinate way

and from there reaches out / to the sum-total of reality

forms and voids / bulk and blanks

it is difficult / to avoid drawing distinctions and conclusions / so pleasant / to enter an area / beyond the climate of opinion / and over particularized existence / where the less you say / the more is said

I think of a room in Otterhal / and snow drifting / across a silent window frame

Pair 1

Pair 2

Pair 3

Pair 4

Pair 5

Pair 6

Anish Kapoor

1994–95 DESCRIPTION: Series of etchings still in progress in January 1995 and not yet titled.

SIZE: 28 × 35cm or 35 × 28cm (plate size).

PAPER: 300gsm Zerkall.

TECHNIQUE: Spitbite etching using between one and three copper plates for each print. So far, one of the etchings is printed on *chine collé*.

PRINTER: Hope Sufferance Press, London. Proofed and printed by Peter Kosowicz and Simon Marsh.

BIOGRAPHY: Born Bombay, India, 1954. Studied at Hornsey College of Art, London, 1973–77 and Chelsea School of Art 1977–78. Artist in Residence Walker Art Gallery, Liverpool, 1982. Solo exhibitions include Kunsthalle Basel 1985; British Pavilion, XLIV Venice Biennale, 1990 (awarded *Premio Duemila*); Tate Gallery, London, 1991 (drawings only); Kunstverein, Hannover, 1991; and Lisson Gallery, London, since 1982. Won Turner Prize 1991. Lives in London.

The artist was still working on this series of etchings when the present catalogue went to press in January 1995. Kapoor began the prints at the Hope Sufferance Press, London, in October 1994. He has, to date, made about eighteen prints though only eight of these will be included in the portfolio. The completed series is expected to comprise up to twenty etchings. Of the eight etchings so far made, seven are in black ink and one is in red ink.

In making the series Kapoor has worked on four or five prints at a time. The imagery established in them has a cyclical rather than a narrative character. The artist comments that: 'I think there is some element of narrative in the prints but it's not a sequential narrative. It's a content that is bounced around between the images. It allows certain imagery to have a home within the framework of the rest of the images. Over the years, in my main body of work, I've moved towards an emptying out of the form, towards a vacant space. I'm trying to find that in these prints.'

Thus far, all the prints have been in spitbite etching. This technique involves coating a copper plate with a layer of waxy rosin and painting or applying acid onto it (one of Kapoor's methods was to drip the acid onto the plate with a syringe). The areas bitten with acid print as black. Kapoor also used another method, effectively the opposite of the first, in which he began with an aquatinted plate (in other words a copper plate that would print as an even black tone) and applied acid to this: the bitten areas print as white.

Before embarking on this series, Kapoor had made three other etching projects at Crown Point Studios in San Francisco in 1987 and 1990. It was there that he learned the spitbite technique. The method appealed to him because with it one can produce very subtle, watery effects without using a hard line – in other words one can create form without drawing it. In his sculpture and drawing Kapoor has tended away from the descriptive towards the suggestive, so this etching technique perfectly suited his method of work. He comments that: 'It makes the whole image appear as if it's floating or is like an x-ray. The imagery in the prints is sometimes clearly biological, sometimes atmospheric. You could say that it's a kind of interior landscape.' This search for something interior is a quality that runs throughout Kapoor's sculpture, and is seen, for example, in his large sandstone-block pieces *Adam* and *Void Field*. These feature single holes or 'windows' lined with dark pigment so that one has the impression of looking into the heart of the stone and seeing an infinite, bottomless void. These sculptures, like the prints, are conceived as metaphors for the self, suggesting the dark space within and alluding, in a general sense, to the world of the subconscious.

Shortly before starting work on the prints Kapoor made a series of ink drawings. The prints are about the same size as the drawings and develop from them. After beginning the etchings Kapoor stopped drawing, conscious that printing can become a medium in which the artist replicates work originated in drawing, painting or sculpture, and this is something he was keen to avoid.

Note: The seven plates illustrated will be included in the portfolio.

Christopher Le Brun *Seven Lithographs*

1989

DESCRIPTION: 7 two-colour litho-
graphs with title-page and colophon
in portfolio bound in red buckram.

EDITION: 35 sets numbered 1 to 35
plus 5 proof sets; first 25 sets in
portfolio form numbered 1 to 25 and
10 sets to be split up and released
separately.

INSCRIPTIONS: Each print signed and
numbered by the artist.

SIZE: 91.5 × 76cm (five prints),
76 × 91.5cm (two prints).

PAPER: 450gsm mould-made Zerkall.

TECHNIQUE: Lithography on metal
plates.

PRINTER: Proofed and editioned by
Alan Cox at Sky Editions, London.
Title-page and colophon in letterpress
by Ian Mortimer at I.M.Imprimit,
London.

BINDING: Designed by the artist and
made by Cathy Robert.

TYPOGRAPHY: Title-page and
colophon designed by Ian Mortimer
and the artist in Caslon Old Face.

BIOGRAPHY: Born Portsmouth 1951.
Studied at Slade School of Fine Art,
London, 1970–74 and Chelsea School
of Art 1974–75. Solo exhibitions
include Fruitmarket Gallery,
Edinburgh, 1985. Exhibited with
Nigel Greenwood Gallery, London,
and Sperone Westwater Gallery,
New York, and subsequently, since
1992, with Marlborough Fine Art.
Trustee of the Tate Gallery, London,
since 1990. Lives in London.

Seven Lithographs was the first of a series of projects made by Le Brun for the Paragon Press. Prior to embarking upon this project, Le Brun's experience of printmaking was limited to the etchings he had made at the Slade School of Fine Art under the tutelage of Anthony Gross and Bartholomeu dos Santos, and to a series of coloured monotypes he had made with Garner Tullis in Santa Barbara, California, in 1986 and 1988.

The lithographs were made between October 1988 and January 1989 and have a close rapport with the monotypes he had recently completed, particularly the large sixty-part print measuring 15 × 36 feet made in November 1986 (this has never been exhibited). The rapid improvisation which monotype printing on such a scale required (the whole print was completed in just two days) provided the key to the method employed in *Seven Lithographs*, where some of the prints were invented directly on the plate. However in *Seven Lithographs* Le Brun could adopt the more considered approach that lithography offered, and, above all, was able to work on the project in London over a longer period.

Although the portfolio features only seven lithographs the artist made a larger number of prints which he edited down. This method of working in series, developing ideas in the work itself and responding directly to the nature of the medium is a constant in Le Brun's art.

The imagery in the lithographs has its origin in the paintings Le Brun made in Berlin where he lived and worked as a guest of the DAAD from 1987–88. These were paintings such as *Theory* of 1987 with its single tree set against light and dark bordered with a curving line; *Grove* with its line of trees; and *Tree between Walls* of 1986–87. The image of a recumbent lion, developed in one of the horizontal prints in *Seven Lithographs*, is particularly rich in implication. In this print the figure with his arm raised holding a sword was later developed into the Siegfried figure in the *Wagner* paintings and prints (see pp.146–149); and the group of horsemen in the background inspired the prints and paintings of the *Four Riders* sequence (see pp.144–145). The lion itself recently reappeared in Le Brun's etching *Atlanta and Hippomenes*, made for Ted Hughes' translation of Ovid's *Metamorphoses*.

These lithographs relate quite closely to the paintings Le Brun was making at the time though the same could not be said of his etchings. The reason for this has much to do with the technique and process particular to each medium. For Le Brun the technique is very much a part of the image-making process, and just as he would wield the brush with his arm to make a painting, allowing his physical movement and sense of rhythm to affect the work, so he could do the same in making lithographs on large metal plates. Consequently these prints have a gestural, painterly resonance.

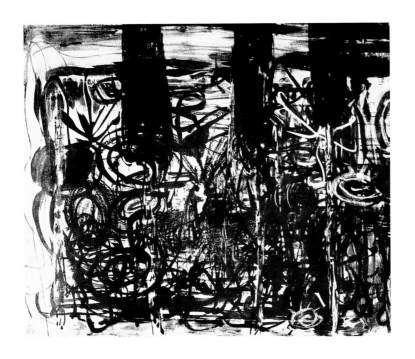

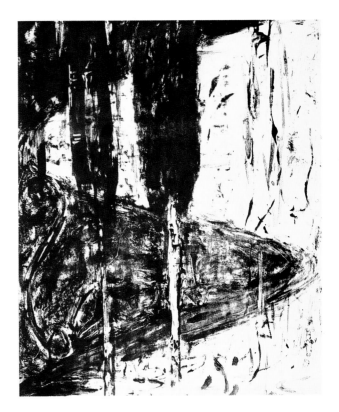

1 2 3

4 6 7

Christopher Le Brun *Fifty Etchings*

1990

DESCRIPTION: 50 etchings, title-page and colophon in portfolio case bound in brown leather and buckram.

EDITION: 30 sets numbered 1 to 30 plus 6 proof sets, 1 BAT set, 1 PP set, 1 museum set, 1 unsigned reproduction set, and 2 unsigned sets to be bound into books. Sets 1 to 20 and the 6 proof sets presented in portfolio cases. Sets 21 to 30 split up and released separately.

INSCRIPTIONS: Each print signed and numbered by the artist.

SIZE: 50 × 42cm (paper size). Plate sizes vary from 17.8 × 12.4cm to 20.5 × 19.2cm.

PAPER: 300gsm Somerset TP Textured.

TECHNIQUE: Full range of etching techniques on copper plates, including softground, hardground, drypoint, aquatint, sugarlift, burnishing, open-bite and varnish stop-out.

PRINTER: Hope Sufferance Studios, London. Proofing and plate-making by Peter Kosowicz, Simon Marsh and Niall Finn; printing by Kosowicz, Marsh, Finn, Gordon Robertson, François Guéry and Stella Whalley. Title-page and colophon printed by Ian Mortimer.

BINDING: Designed by the artist and Charles Gledhill and made by Gledhill.

TYPOGRAPHY: Title-page and colophon designed by Ian Mortimer in Monotype Baskerville.

This project was begun in January 1990. Le Brun was given no specific remit regarding size, number of prints or theme, Charles Booth-Clibborn simply having asked him to make a group of etchings. Le Brun was keen to try etching since he felt that one of the limitations of lithography on metal plates (the technique he had used for *Seven Lithographs* (see pp.134–137), was that the image could not easily be altered or developed once the mark had been made. Booth-Clibborn introduced the artist to various studios in London; Le Brun chose to work at the Hope Sufferance studio which was then in Rotherhithe, London.

Le Brun had made etchings as a student at the Slade School but otherwise had little experience with the medium. He began by working on a large number of preparatory plates and drawings. Not being accustomed to the medium and to the very fine gauge of the etching needle, he initially had difficulty establishing the scale of the work, but after several weeks of experimentation began producing the first of what evolved into a series of fifty prints.

Le Brun worked in close collaboration with the technicians at Hope Sufferance studios, Peter Kosowicz and Simon Marsh: they would prepare the etching plates with soft-grounds and hard-grounds and help him achieve the effects he desired, but at no point did they prompt him to use particular techniques. He worked on four or five plates at a time, and the technicians would proof them at regular intervals. Consequently each print relates to and develops from the others. Since he was discovering a new technique and a new language of marks, the process of etching itself was driving much of the image making. Experimenting with the etching tools, he would create a line or form in one plate and would then develop it in a different direction in another plate.

Some of the prints were done quickly and exist in just one state while others were taken through as many as thirty different trial states. Hence an etching begun early in the sequence of fifty might have been finished half-way through the series. This intricate, cyclical approach, working on several plates at a time and not in a strictly linear sequence, meant that motifs appear and reappear throughout the whole suite of fifty etchings. The final series of etchings could be viewed as a narrative about the language of Le Brun's art, his coming to terms with the etching process, and his journey of discovery.

Stephen Bann, in his book on Le Brun's *Fifty Etchings*, uses the metaphor of the 'prince entering the Briar Wood' to provide a guide to understanding the work. The entanglement of the line, the barbed figure and the glowing light of the paper, show how the technique of etching itself engenders its own 'natural' imagery. In the vast, sixty-part monotype Le Brun had made in 1986, the overall image is of a forest woven with representational, figurative elements, and marks which represent the painting process itself. Whereas in that very large work those events are presented simultaneously within the image of the forest, in the *FiftyEtchings* the images occur and must be seen laterally or in sequence.

The issue of concealment had been very much in the artist's mind in the preceding period. His paintings are normally made up of layer upon layer of different images which cover and conceal one another. In a group of large-format paintings, *Forest* (1987–88), *Tristan* (1989), *Aram Nemus Vult* (1990) and the *Briar Wood* (1991), he had exploited the monolithic and mysterious properties of painting as a covering skin, where the tension of concealment dominates. He was acutely aware of the destruction and waste of buried imagery on which the strength of these paintings depended. Etching, however, because of the use of line, inclines to the web or net, favouring transparency and enabling images to gather by addition and modification rather than by cancellation. The period Le Brun spent working on *Fifty Etchings* corresponded with a period when he was trying to find a way to retain images conceived in the painted medium, particularly figures, that had previously been covered.

In the *Fifty Etchings* series the images move backwards and forward between abstract and figurative motifs. On the copper plates he would explore the possibilities latent in the etching medium, and then introduce a figurative

 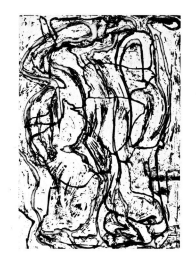 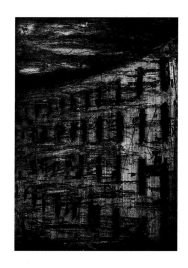

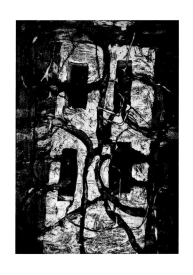 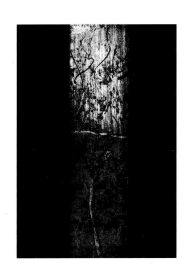

I II III IV

V VI VII VIII

IX X XI XII

image – a building or a tree or an image taken taken directly from one of his paintings (the horse for example in etching XVIII). In subsequent plates he might then work with that image and incorporate a new range and layering of marks.

In the early prints in the sequence Le Brun introduced figurative images which had already featured in his painted work and analysed them in the etching medium. In etching XX he introduced a new image of four riders standing before a building. He later developed this particular image into a separate series of etchings (the *Four Riders* series, see pp.144–145) and also into a painting, *Riders Before a Castle*. Similarly, etching XXV is a figure with shield and sword-arm raised which the artist developed throughout the sequence culminating in etching XLIX (subsequently realised as the painting *Study for Siegfried*). By this stage Le Brun had come to understand the importance that etching could have in his art, as a way of inventing new images through the etching process. Because he was working in a new medium he felt he could invent and allow images to remain with greater freedom than in painting. Furthermore, the act of working in reverse on a copper plate meant that the proofed prints had a striking freshness and intensity. In late May, once Le Brun had made about twenty etchings, he decided to make the project into a suite of fifty works.

Many of the plates following etching XXV are composed of meandering lines which relate to foliage and trees and images obscured by things. These images may be seen as an analogue of Le Brun's working method in painting, which involves the layering of one painted image over another. In learning the etching process Le Brun was required to experiment with the marks made by the various etching tools and it was through this process that he found that he could invent all manner of new marks, forms and images. Images which were invented directly on the plate and were later developed into paintings include XLI which became the *Bay Muse* (1993).

In *Fifty Etchings* we are offered an extraordinary insight into the thinking and processes which lie behind an artist's work. Le Brun sees

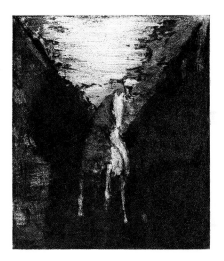

the series as a kind of narrative and acknowledges the general influence of Ezra Pound's *Cantos*, in which there are a range of texts and images of different types which are built up with a rolling accumulation of motifs – the ideogrammatic method. Le Brun remarks that 'Pound's method has affected my work, in fact the second etching I ever made in 1970 was based on lines from *Canto* IV.'

A 124-page book on *Fifty Etchings*, with an essay by Stephen Bann, was published by the Paragon Press in 1991.

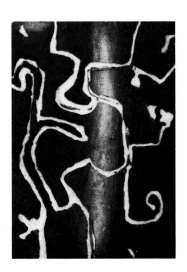

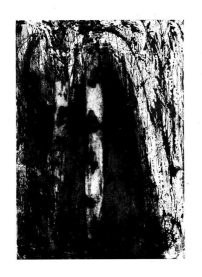
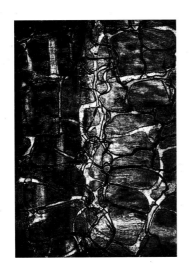
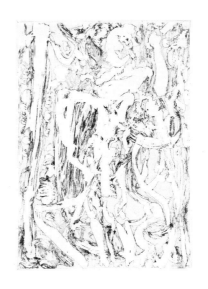
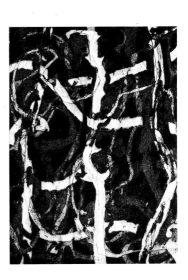

XIII XIV XV XVI XVII

XVIII XIX XX XXI

XXII XXIII XXIV XXV XXVI

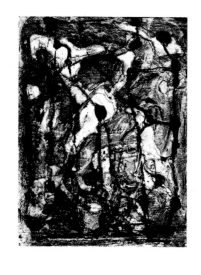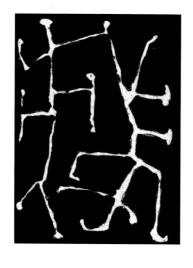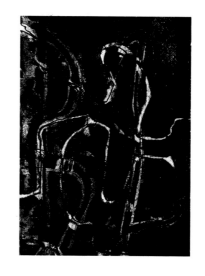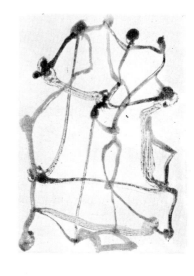

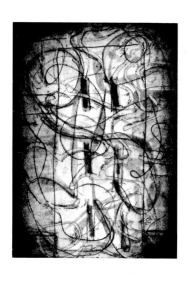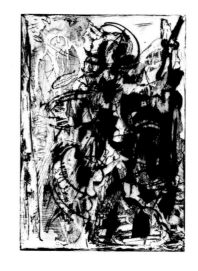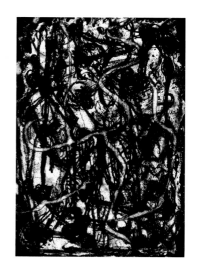

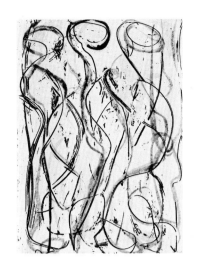 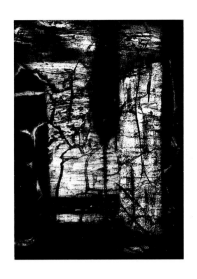 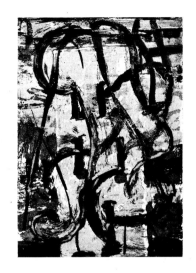 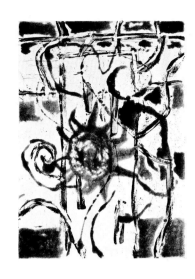

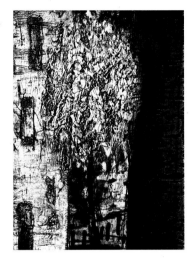 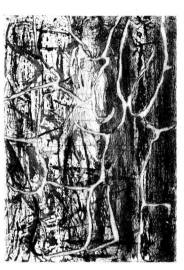 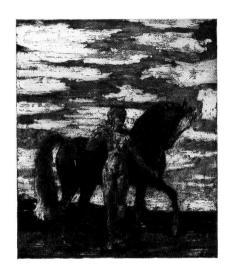

XXVII XXVIII XXIX XXX XXXI XXXII XXXIII XXXIV

XXXV XXXVI XXXVII XXXVIII XXXIX XL XLI XLII

XLIII XLIV XLV XLVI XLVII XLVIII XLIX L

Christopher Le Brun *Four Riders*

1992–93 DESCRIPTION: 4 etchings. No title-page, binding or folio case.

EDITION: 30 of each plus 8 proofs, 1 BAT and 1 PP.

INSCRIPTIONS: Each signed and numbered by the artist.

SIZE: LI and LII are 27 × 28cm (image size), 58 × 57cm (paper size); LIII is 27 × 28cm (image size), 58.5 × 57cm (paper size); LIV is 25.5 × 25.5cm (image size), 58 × 57cm (paper size).

PAPER: 300gsm Somerset TP Textured for numbers LI, LII and LIV; and LIII on a special 100% cotton aquapel sized paper, made by Ruscombe Mill, designed by John van Oosterom.

TECHNIQUE: LII is hardground etching; LI, LIII and LIV are hardground with aquatint and some burnishing. LII was made from one plate; LI and LIII made from two plates; LIV made from three plates.

PRINTER: Hope Sufferance Press, London. Proofed and printed by Peter Kosowicz and Simon Marsh.

These four prints grew out of Le Brun's work on *Fifty Etchings* (see pp.138–143) and continue the same numbering sequence in roman numerals (LI to LIV). They are variants of etching XX from *Fifty Etchings*, which shows four riders in front of a castle. Although the image of the medieval rider occurs throughout Le Brun's work from the early 1980s (for example, a painting of *Sir Tristram* in Southampton Art Gallery features a rider with a plumed helmet), the group of riders was a new image in his oeuvre. Etching XX was developed into a large painting, *Riders Before a Castle* (1990–92), which is now in a private collection in the USA.

In contrast to the previous project with its developing cycle of interconnected imagery, the *Four Riders* was a deliberate attempt to construct a monumental single work in etching. The image of the armoured figure occured increasingly in Le Brun's work of the early 1990s. In general terms the artist likens his use of an image 'out of its time' to the device employed by Georg Baselitz of turning the image upside-down. Both strategies dramatise the autonomy of the work of art. But whereas in Baselitz's case the painting can be readily assimilated into the formal development of modern art, Le Brun also attempts to engage directly with the subject of Time and art's relationship to it.

Concurrent with his work on these prints Le Brun was reading Tennyson's *The Idylls of the King*, the long narrative poem based on Malory's *Morte d'Arthur*. He points out that it is a mark of the difficulties inherent in the use of allegorical form in modern times that there has been prolonged controversy over the relative success or failure of Tennyson's book ever since it was written.

Etching LII, which is a hardground etching, closely follows the composition of the *Riders Before a Castle* painting. Although its numbering sequence puts it after etching LI, LII was begun first but was proofed slightly later. Number LI was made with two etching plates: the plate used for making LII (with a fourth rider added), and a second plate which gave extra tone and depth. Etching LIII is a reworking of both plates, with the castle and three of the riders burnished out (though their ghostly presence is still discernable); LIV uses these same two plates (one inverted) and incorporates a third.

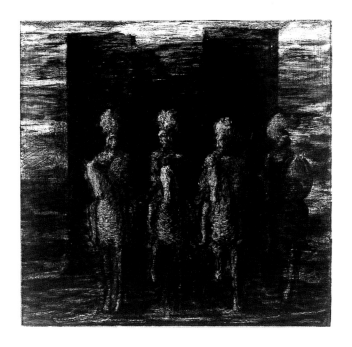

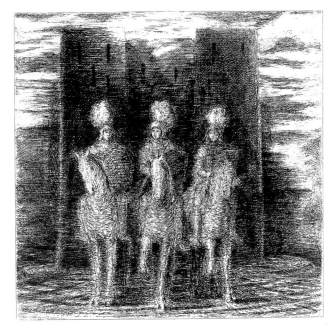

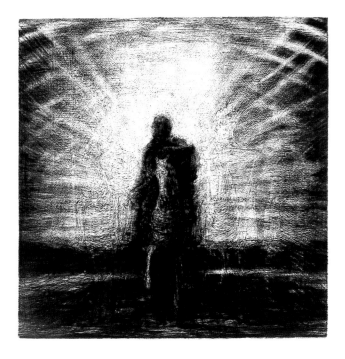

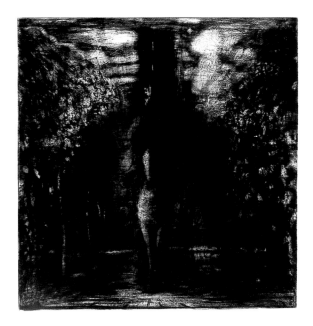

LI LII

LIII LIV

Christopher Le Brun *Wagner*

1994

DESCRIPTION: 8 etchings in portfolio bound in green buckram. One additional etching, *The Rhine*, LIX, belongs to the series but is not included in the portfolio, being too large.

EDITION: 50 sets numbered 1 to 50 plus 4 proof sets, 4 Hors commerce, 1 printer's proof and 1 BAT. First 40 sets presented in portfolio form. The ninth image, *The Rhine*, LIX, (excluded from the portfolio) in edition of 30 plus 4 proofs and 4 Hors commerce.

INSCRIPTIONS: Each print signed and numbered by the artist.

SIZES:
The Rainbow Bridge, LX, 50 × 52.5cm.
Siegfried, LXI, 50 × 48cm.
Fafner, LXII, 50.5 × 52.5cm.
Siegfried and Fafner, LXIII, 50.5 × 52cm.
The Valkyrie, LXIV, 50 × 52cm.
Brünnhilde, LXV, 50 × 52cm.
Brünnhilde II, LXVI, 50.5 × 53.5cm.
Brünnhilde III, LXVII, 51 × 54cm.
All paper sizes 71 × 71cm.
Additional image, *The Rhine*, LIX: 50 × 75cm (plate), 74 × 97cm (paper).

PAPER: 300gsm Somerset Cream TP Textured.

TECHNIQUE: Photogravure (produced by Hugh Stoneman) with etching, aquatint, scraping and burnishing.

PRINTER: Hope Sufferance Press, London. Proofed and printed by Simon Marsh and Peter Kosowicz. Title-page and colophon printed by Graham Bignall, London.

BINDING: Designed by the artist and Charles Gledhill and made by Charles Gledhill.

TYPOGRAPHY: Title-page and colophon designed by Graham Bignall and the artist in Caslon Old Face.

In 1992 Le Brun received a commission from a private collector for four large paintings on the theme of Wagner's *Ring Cycle*. By 1994 three of the four paintings had been completed: *The Rhine, Siegfried* and *Brünnhilde*. In making the works Le Brun produced numerous studies and other paintings: he decided to record, consolidate and develop these in printed form.

The *Wagner* print portfolio contains eight etchings of similar size. Le Brun made several other etchings on the same theme, including two small etchings of *Brünnhilde* (subsequently issued as individual prints: see appendix) and one large one of *The Rhine*. The size of the latter precluded its inclusion within the portfolio though the artist does see it as part of the same series.

The eight etchings are all developed from photogravures. Photogravure is a technique usually associated with nineteenth-century printmaking and is rarely used today. Essentially it is a process of transferring photographs – in this case of Le Brun's *Ring Cycle* paintings – onto copper etching plates. The photogravure plates for the *Wagner* suite were made by Hugh Stoneman, one of very few printers capable of carrying out the process (for a full technical description, see the Glossary of Print Terms, pp.206–207). As an initial experiment four photogravure plates were made of one of the paintings. Le Brun worked on these plates (the images have never been editioned) and then proceeded with the complete project, ordering a total of forty further plates of paintings from the *Ring Cycle* project.

Le Brun began, then, with copper plates bearing etched reproductions of his own paintings; he then proceeded to alter the plates with conventional etching techniques. He made relatively few alterations to some of the photogravure plates but substantially reworked others.

Le Brun's painting and etching now relate to one another in complex ways: ideas generated in etching may be developed in his paintings and later reintroduced into subsequent etchings. In a sense he uses etching in the same way that some artists use drawing, formulating his ideas in the medium. The etching *The Rainbow Bridge*, LX, develops from a photogravure plate of his oil painting of the same title, only the photograph for it was taken some time before the painting was completed, so the finished painting and etching differ in fundamental ways. The second etching, titled *Siegfried*, LXI, was done from a photogravure of Le Brun's painted study for the main Siegfried painting. Le Brun reworked the plates for these two etchings, erasing some elements by burnishing them out and adding to other areas. In the third etching, *Fafner*, LXII, Le Brun removed the sky which had featured in the original version of the painting and rebit the plate with spit-bite. The painting was subsequently re-worked so now differs quite considerably from the etched version.

The fourth etching, *Siegfried and Fafner*, LXIII, was generated from the final version of the oil painting; and the fifth etching, *The Valkyrie*, LXIV, from an oil study for the Brünnhilde painting. The last three prints all develop from the same Brünnhilde image (the final version of the oil painting), though Le Brun altered them in different ways. The first, *Brünnhilde*, LXV, was heavily burnished; the second, *Brünnhilde II*, LXVI, has very strong acid biting; and the third, *Brünnhilde III*, LXVII was heavily re-drawn and went through a total of forty proof states.

The Wagner portfolio was published by the Paragon Press in conjunction with Marlborough Graphics Ltd. The series was exhibited simultaneously at Marlborough Galleries, in New York and London, in October 1994, alongside the *Ring Cycle* paintings and oil studies.

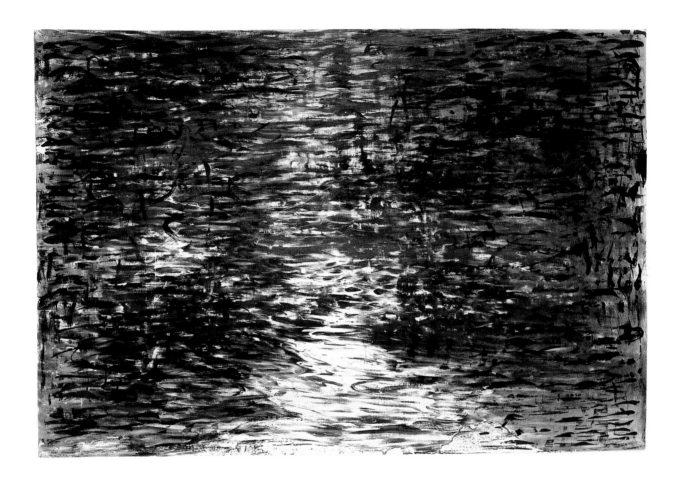

The Rhine, LIX

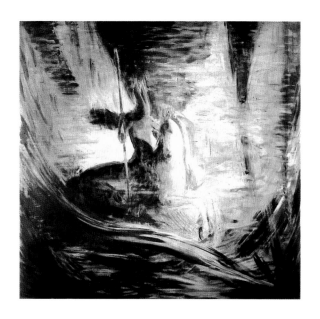

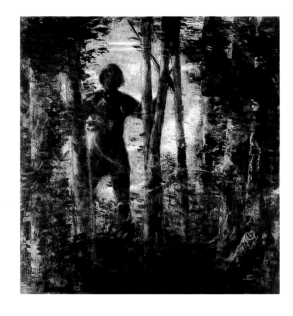

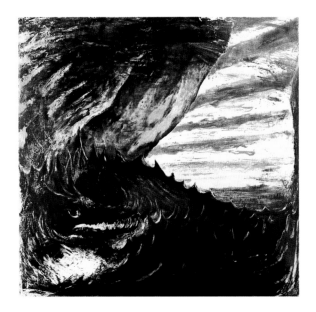

The Rainbow Bridge, LX

Siegfried, LXI

Fafner, LXII

Siegfried and Fafner, LXIII

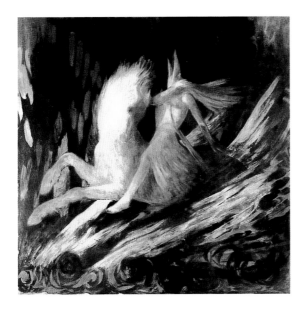

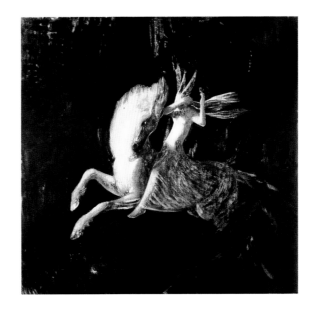

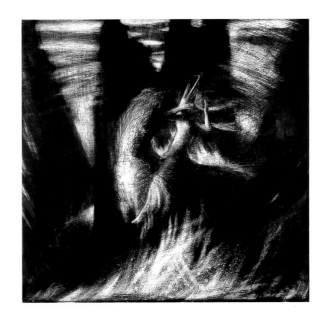

The Valkyrie, LXIV

Brünnhilde, LXV

Brünnhilde II, LXVI

Brünnhilde III, LXVII

Richard Long *Rock Drawings*

1994

Rock Drawings: an Eight Day Walk in the Rimrock area of the Mojave Desert, Southern California

DESCRIPTION: 13 screenprints (12 rock drawings and one photo-piece) and certificate in portfolio case bound in black buckram.

EDITION: 35 sets numbered 1 to 35 plus 10 proof sets.

INSCRIPTIONS: Certificate signed, dated and numbered by the artist.

SIZE: 79 × 73.5cm (sheet size rock drawings); 49 × 73.5cm (sheet size photo-piece); 51cm (diameter rock drawings).

PAPER: 300gsm Velin Arches (rock drawings); 300gsm Somerset Satin (photo-piece)

TECHNIQUE: Screenprint. Three screens for each rock drawing, eight screens for photo-piece.

PRINTER: Coriander (London) Ltd.

BINDING: Made by Ryders, Bletchley.

TYPOGRAPHY: Certificate designed by the artist.

BIOGRAPHY: Born Bristol 1945. Studied at St Martin's School of Art, London, 1966–68. First solo exhibition at Galerie Konrad Fischer, Düsseldorf, 1968. Has exhibited in museums all over the world, including Scottish National Gallery of Modern Art, Edinburgh, 1974; Solomon R. Guggenheim Museum, New York, 1986; Hayward Gallery, London, 1991; Kunstsammlung Nordrhein-Westfalen, Düsseldorf 1994 and Palazzo Delle Esposizioni, Rome, 1994. Lives near Bristol.

Long has made walking into a form of sculpture. His first walks recorded in photographic form date from 1967. He has remarked that 'A walk is a line of footsteps, a sculpture is a line of stones. They're interchangeable and complementary. For me, walking can liberate the imagination. Through the rhythms of walking, sleeping, walking, sleeping, I can understand better the rhythms of nature.'

Although many of Long's works are recorded in a photographic (and therefore printed) form, the technical aspects of photography and printing are of little interest to him: the photograph is simply a vehicle for his art. Similarly, although he has made a number of single prints over the years, he has no interest in the technical process of printmaking. Since his work is intimately concerned with natural phenomena and the experience of being in contact with nature, the art of printmaking – so often associated with studios, hand-crafting and technique – held little attraction for him. There is, however, a theme in his art which relates directly to printing, for his walking lines, in which the feet create a trodden path, and his mudprints made with the hands and feet, are all forms of printmaking, albeit of an entirely different kind to that presented here.

Rock Drawings is Long's first print series. Each of the screenprints is made from a photograph of an original rock rubbing, done on an eight-day walk in the Rimrock area of the Mojave Desert in Southern California, in January 1994. The area is extremely dry and the landscape is studded with rocks and boulders. The dryness made it the perfect location for making rock rubbings (wet, mossy rocks on Dartmoor would be unsuitable); this was the first time Long had done such rubbings. During the walk he made a total of seventy-eight rubbings, each of which is about the size of a hand. They were made by placing the page of a sketchbook over the rock and rubbing a black crayon through a circular stencil. The rubbings finished at the end of the last crayon. At the time he had intended using the rubbings as the basis for a book (yet to be realised) in which each would be reproduced to scale. Subsequently, when asked to make a print series, he decided to use a selection of twelve of the rubbings and enlarge them. The twelve are presented in chronological sequence though this order is not crucial to the series.

Like many of Long's works, the *Rock Drawings* are circular in form. The circle is a primitive, elemental sign rather than an artful composition. It is perhaps the most powerful symbol of man's relationship with nature since, in prehistory, men arranged rocks into circles as a means of communing with the earth, the sun and their gods. The circle suggests a concentrated field of force or focus of energy, and calls to mind ancient cairns, prehistoric sites such as Stonehenge, and the earth and planets.

Every rock surface in the world, hence each of the rock drawings, is unique and different. Long remarks that 'They are like fingerprints. They have a cosmic variety.' The drawings have an ambiguity of scale which suggests something microcosmic or macrocosmic – a cell seen through a microscope or a planet viewed through a telescope. Although each of the drawings relates to a particular boulder in a remote desert location, the series mediates on this metamorphosis of the individual into the cosmic. Just as a fingerprint or handprint may be seen as the mark of an individual and also as the mark of man, so it is that rock surfaces are at once unique and universal: they are like the fingerprints of the earth.

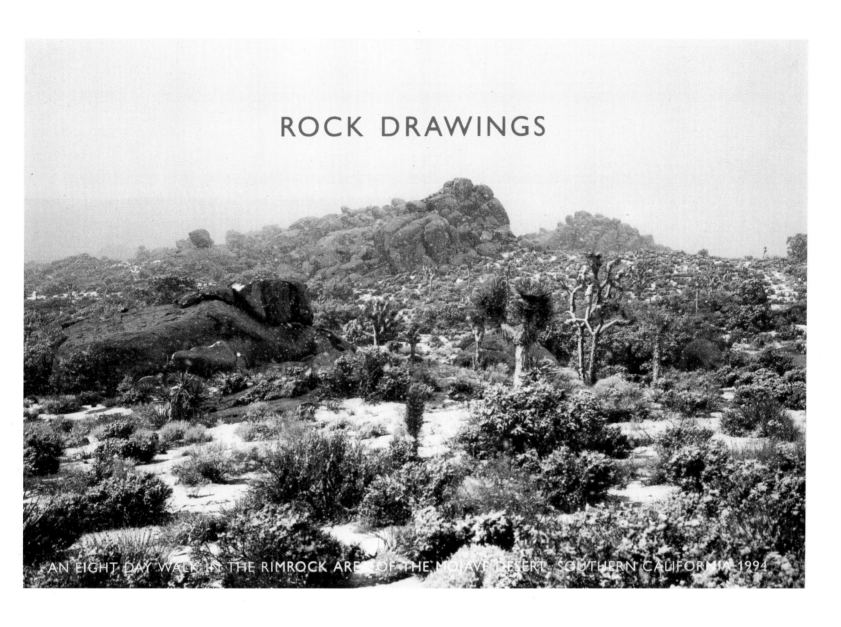

ROCK DRAWINGS

AN EIGHT DAY WALK IN THE RIMROCK AREA OF THE MOJAVE DESERT, SOUTHERN CALIFORNIA 1994

Will Maclean *A Night of Islands*

1991

Ten Etchings from Gaelic Poems and Prose

DESCRIPTION: 10 colour etchings, 10 poems in Gaelic and English, title-page and colophon in portfolio case bound in blue buckram. The poems are printed on individual sheets, the Gaelic on recto and the English translation printed in grey and in smaller typeface on verso.

TITLES OF INDIVIDUAL WORKS:
1. *Marbhrann do Chaiptean Fearghustan (Elegy to Captain Ferguson)* by John Maccodrum.
2. *Dannsairean (Dancers)* by Angus Martin.
3. *Fraoch* (traditional Gaelic story).
4. *Sioladh na Gaidhlige (The Loss of Gaelic)* by Meg Bateman.
5. *A Tri (Trio)* by Valerie Gillies.
6. *Iasg an Righ (The King's Fish)* (traditional Gaelic story).
7. *Srath Nabhair (Strathnavar)* by Derick Thomson.
8. *Auctor Huius… (The Author of this is…)* by the Bard MacIntyre.
9. *Ban-Ghàidheal (A Highland Woman)* by Sorley Maclean.
10. *Clann Adhaimh (Adam's Clan)* by George Campbell Hay.

EDITION: 40 sets numbered 1 to 40 in portfolio form, 15 sets numbered I to XV split up and released separately, and 10 additional proof sets. (There is also a separate edition of the central image of each print in an edition of 30 plus 5 proof sets: these are in black ink).

INSCRIPTIONS: Each print signed, titled, dated and numbered by the artist on verso.

SIZE: Paper size: 75.4 × 54.3cm. Central plate size: 1. 49 × 32.5cm; 2. 49 × 32.5cm; 3. 49 × 33cm; 4. 49 × 33.1cm; 5. 48.8 × 33.4cm; 6. 40 × 33cm; 7. 48.8 × 32.1cm; 8. 49.8 × 32.8cm; 9. 40.2 × 32.6cm; 10. 49 × 33cm.

PAPER: 250gsm Velin Arches Blanc.

TECHNIQUE: Wide range of etching techniques. Between three to five separate plates used for each print.

PRINTER: Peacock Printmakers, Aberdeen. Co-ordinated by Arthur Watson. Proofed by Beth Fisher; editioned by Beth Fisher (first 20 sets) and Tonia Mathews, assisted by Jo Gantor and Michael Agnew. Texts printed by Simon King, Cumbria, on an Albion Press.

BINDING: Made by Ryders, Bletchley.

TYPOGRAPHY: Texts, title-page and colophon designed by Phil Baines in Monotype Baskerville.

BIOGRAPHY: Born Inverness 1941. Served at sea 1957–59. Studied at Gray's School of Art, Aberdeen, and Hospitalfield, Arbroath, 1961–65. British School in Rome 1966. Worked as fisherman 1968. Has taught at Duncan of Jordanstone College of Art, Dundee, since 1981. Much of his work is in the form of painted, three-dimensional constructions. Numerous solo exhibitions in Glasgow, Edinburgh, Cambridge and London. Major retrospective at Talbot Rice Gallery, Edinburgh and Glasgow Art Gallery, 1992. Lives in Tayport, near Dundee.

The project was begun late in 1989. Each of the ten images was conceived in response to a particular Gaelic poem or text chosen by the artist; these texts range from traditional tales to contemporary poems written by acquaintances of the artist and to new translations commissioned specifically for the project. Gaelic culture, or more specifically the threatened survival of Gaelic culture, plays a central part in Maclean's art.

Maclean took about six months to select the texts, his aim being 'to find poems which had a Gaelic origin but had an imagery open enough to allow me to make an independent print image rather than an illustration.' Having made a large number of drawings for the project Maclean began etching the central images (the 'key' plates) at his home near Dundee and travelled to Peacock Printmakers in Aberdeen to have them individually proofed. Before commencing the etchings he had spoken with Arthur Watson, Director of Peacock, about ways of broadening the scope of the artwork and taking it beyond the simple etched drawing. Bearing in mind Maclean's boxed constructions, in particular the work *Song of the Shellback*, Watson suggested that he might try to incorporate a framing device and this led Maclean to introduce a second image surrounding the basic etching. Although Maclean was an experienced printmaker he had not previously become involved in complex printmaking techniques and required guidance with regard to technical matters. Accordingly Watson and the printmaker Beth Fisher (senior printer at Peacock), together with Jo Gantor, gave Maclean invaluable advice and assistance in the production of these highly complex, layered effects.

Each print is composed of two major elements on two or more separate plates: the central, etched image; and the border area, which is also made via the etching process. Several of these border areas were made by feeding objects such as seaweed, netting and leaves, through an etching press so that their impression was recorded on the softground plate.

Maclean felt strongly that the central image should not resemble a window framed by a decorative border and that the two sections should form a single, unified composition. To achieve this he layered a variety of forms, colours and textures over the whole print, using between three and five separate etching plates for each image: the prints are, then, complex constructions, and as such relate closely to the artist's sculpture. In most of the prints the border area was printed first, with the central part largely burnished out so that Maclean's etched image would remain clear. One or more additional plates were printed over the whole paper to give the print its cohesive structure. The key plates bearing the central image were printed last in nearly every case.

Having made and proofed the key plate, Maclean would describe the type of effect he wanted on the border and overlaying plates and Fisher would help him realise these ideas. At times Maclean would paint onto a preliminary proof of the print in order to show her exactly what he wanted and she would suggest methods of achieving this. Much of the work was done by trial and error and necessitated large numbers of trial proofs. Maclean would generally spend one day a week at Peacock, instructing Fisher on the effects he wanted, and when he returned the following week he would go through the proofs that Fisher had made, try out different colours and motifs and swap the various plates about until he had achieved the result he sought. In the series some of the framing plates and overlaying plates are repeated or inverted in different combinations, and some of the plates were printed twice to get more definition. All the works were printed on white paper.

The prints do not follow a particular sequence, rather they follow the order in which the artist worked on them. He began with *Elegy to Captain Ferguson*, an early eighteenth-century poem by John Maccodrum, who was Bard to Sir James Macdonald of Sleat, Isle of Skye. Maclean's print was begun as a hardground etching on a zinc plate. The hardground coat-

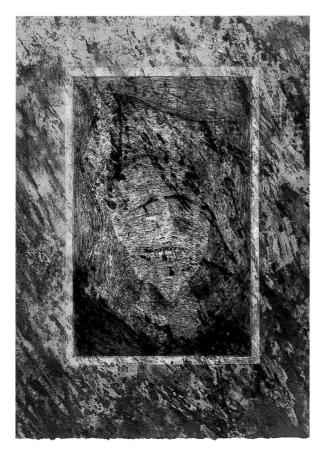

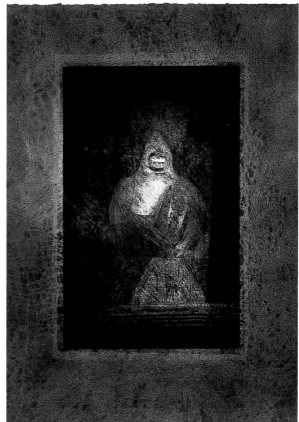

1 *Elegy to Captain Ferguson* 2 *Dancers*

ing had been accidently scratched, leaving a random, weathered look which Maclean liked and chose to retain. The poem is about the reported drowning (false as it turned out) of a tyrant naval officer, Captain Ferguson, who had behaved with particular cruelty after Culloden. The tale is told by five mountains, which, in Maclean's etching, form the contours of the captain's head. An upturned ship, whales and two islands, metamorphose into the captain's face in an effect which recalls the paintings of Archimboldo. The overlaying, smokey effect was printed from an etched 'splash' plate which Maclean worked into. Although Maclean began with this print it was among the last to be finished: as the series evolved so he worked further on this image.

The second print relates to the poem *Dancers* by Angus Martin. Martin, a close friend of the artist, dedicated this poem to Maclean when it was first published. The poem refers to boyhood memories of fishermen in their oilskin suits and alludes to the passing of native fishing traditions. The etching is a variation on a work Maclean had made in 1989, *Skye Fisherman: In Memoriam*. In the 1970s Maclean and Martin had collaborated on an ambitious project to record the disappearing tradition of ring-net herring fishing (the entire project of nearly 400 works is in the Scottish National Gallery of Modern Art, Edinburgh). The border image of this print is formed by the ring-netting itself: it was passed through an etching press onto a softground etching plate so that its impression was recorded. This method of using objects to produce an art-work has evident parallels with Maclean's painted constructions, which feature a wide range of found objects.

Fraoch is a traditional Gaelic story first published in 1862. It is the tale of Fraoch, who is told to swim a loch and pull a berry-tree up by its roots and deliver it to the ruler's sick daughter. In the process he is seized by a sea-monster which drags him under the water. The border edge in this print is composed of rowan leaves and strips of snakeskin, again fed through a press to leave an impression on the etching plate. Both materials make direct reference to the story, the tree being, in one version of the story, a rowan, and the snakeskin echoing the scales on the beast. The image of the beast is influenced by the prints of Gustave Doré.

The Loss of Gaelic is a short poem by the contemporary poet Meg Bateman, lamenting the loss of the Gaelic language and culture. The motifs in the foreground of Maclean's central image – a whale fin, an oilskin suit, a ram's horn, assorted bones – can be found throughout his oeuvre. The inky darkness of the print and the near invisibility of the motifs echo the sentiments expressed in the poem.

Trio is a sprightly poem by Valerie Gillies, again a close friend of the artist, who was Writer in Residence at Duncan of Jordanstone College of Art, Dundee, where Maclean teaches. The poem was composed in response to a question asked by one of her students as to why the number three had an important place in Gaelic culture. In Maclean's central image we have, for example, three moons, three hills, three trees, and the 'spiral with nine turns' made by the maiden who is the central figure in the poem. As with all the texts, Maclean's image relates to the poem in a loose fashion. He states: 'In each case the literary source gave me a starting point but I never held fast to them: they have to adapt themselves to the visual solution.'

The King's Fish, a traditional Gaelic story, was first published in English in 1862 in the same collection as Fraoch. It is the story of two men, the King of Lochlann and Fionn, who, out fishing, hook a dogfish simultaneously. A court ruling declares that the fish belongs to Fionn. Maclean portrayed the struggle for ownership by etching the plate with acid so deeply that it cut in two. The story has its origins in the power struggle between the Celtic and Viking cultures but also relates to a story concerning a mythical hag who appears in West Highland folklore: her shadowy figure can be detected in the right plate. Maclean associated her evil presence with the submarines based at Raasay, and added a submarine in the water to the left. The motif on the outer border, which also covers the central portion, was made by running seaweed through the etching press onto a steel softground plate.

Strathnavar, written by contemporary poet Professor Derick Thomson, refers to the Highland Clearances, which did so much to destroy Gaelic culture. In Maclean's print we see the remains of a Highland dwelling, with two smoking roof-timbers and a creel full of rams' horns. The smoke is repeated on a plate which overlaps the border and the central image.

Just as the second print, *Dancers*, repeated an image found in one of the artist's painted constructions, so this is the case with Bard MacIntyre's poem (here given the title *The Author of this is...*), which closely follows a construction made in 1984, *Bard MacIntyre's Box*. A remarkable early sixteenth-century poem, it tells of a mysterious ship, crewed by a band of 'noxious women' who are 'of mind disordered'. Responding to the dark, menacing tones in the poem, Maclean's original construction rendered the three women in a provocatively sexual manner, using shells, bones and seals' teeth. The framing plate is derived from a photo-enlargement of fishing corks which was screen-printed onto the etching plate.

Sorley Maclean's *A Highland Woman* is a poem which tells of a woman who labours hard, carrying seaweed from the shore to feed her family; the poet comments on the difficulty of reconciling her hard lot with God's love. Will Maclean's image shows a windswept cemetery with an open grave at Ashaig in Skye. In the distance women are gathering seaweed, and on the horizon we see the island of Raasay, where Sorley Maclean was born. The border area features two separate seaweed plates, one of which had previously been used in *The King's Fish*.

Adam's Clan by George Campbell Hay, refers to a sailing ship 'with the grievous burden of an eternal wind on her worn sails, climbing an ocean that has no coast.' The ship is employed as a metaphor for Gaelic culture: it is a speck on the ocean, buffeted by the wind, and its future is uncertain. Maclean took a small section of a print found in an old book (*The Sea* by F. Whymper) and had it enlarged and transferred photographically onto the zinc etching plate. He then made a free copy of a segment of a stage-design by the Russian artist Vladimir Tatlin (for *The Flying Dutchman*), drawing it on transparent paper, and had this screenprinted onto the plate as an acid resist.

The whole project took nearly two years to complete, being finished towards the end of 1991. At a late stage the artist decided to have the central plates printed in a separate, black and white edition, without the overlaying colour plates. The title derives from a line in Angus Martin's poem *Dancers*.

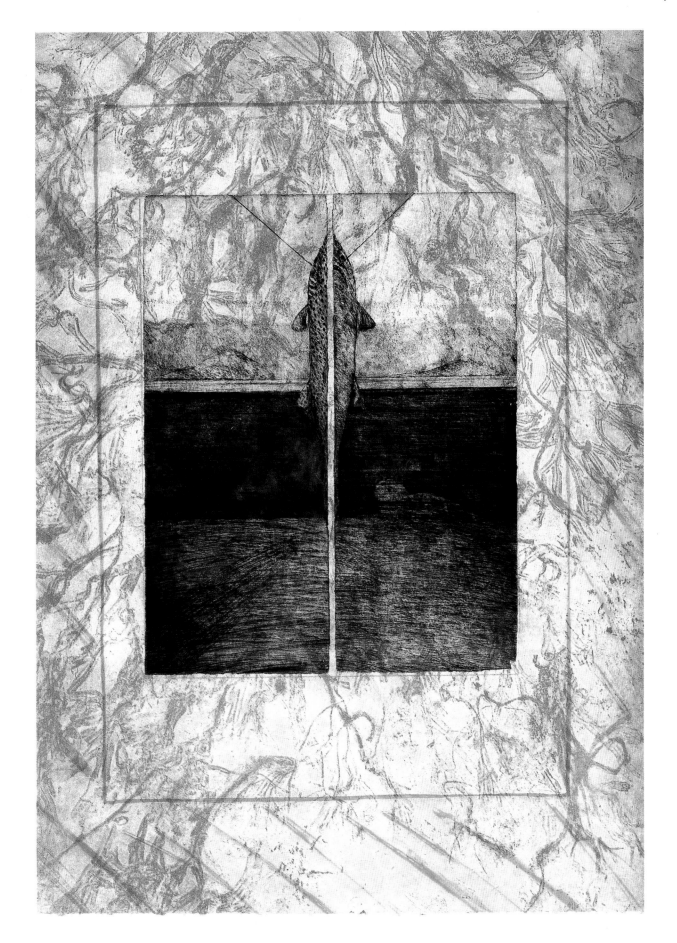

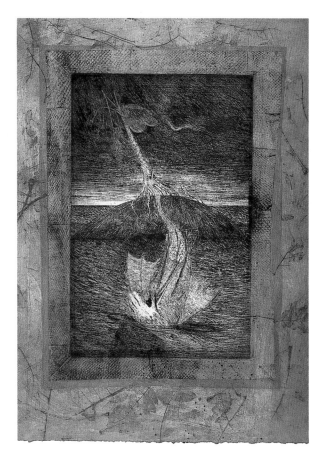

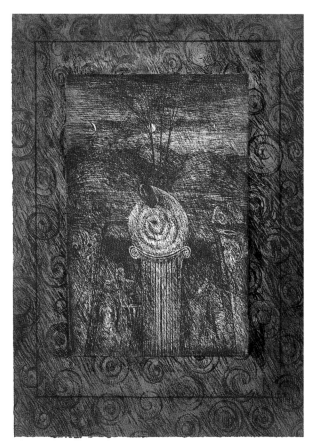

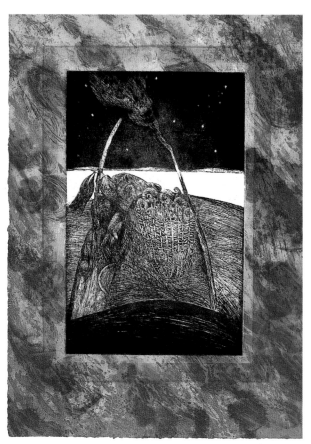

3 *Fraoch*

4 *The Loss of Gaelic*

5 *Trio*

7 *Strathnavar*

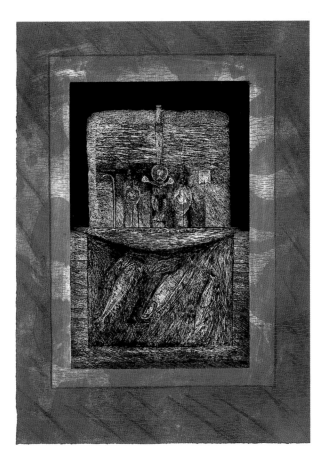

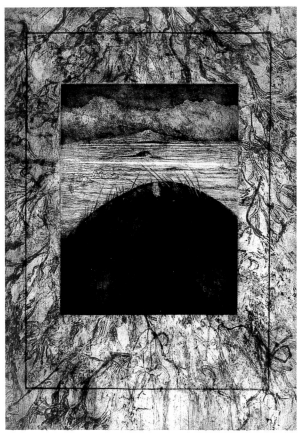

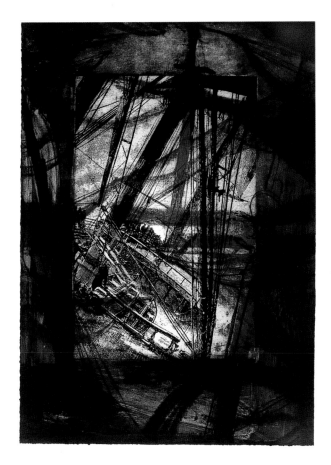

8 *The Author of this is…* 9 *A Highland Woman*

10 *Adam's Clan*

Ian McKeever and Thomas A. Clark *that which appears*

1993

DESCRIPTION: Sequence of 80 poems by Thomas A. Clark with 22 woodcuts by Ian McKeever. 64 unbound pages in solander box bound in blue-grey buckram.

EDITION: 50 copies numbered 1 to 50 plus 12 proof copies.

INSCRIPTIONS: Each copy signed by artist and author on colophon page.

SIZE: 50.5 × 38cm (page size); 50.5 × 76cm (double-page spread).

PAPER: 270gsm BFK Rives.

TECHNIQUE: Woodcuts in plywood and shuttering ply, printed on etching press. 'Blond' woodcuts printed with pressure of a blanket and some finger-printing. Texts printed in letterpress.

PRINTER: Text hand-set and printed by Simon King, Cumbria. Woodcuts proofed and printed by Hugh Stoneman and Michael Ward at The Print Centre, London.

BINDING: Designed and made by Charles Gledhill. There is also a special binding for the book in grey pig-skin spine and paste-grained boards which was designed by McKeever and made by Gledhill.

TYPOGRAPHY: Layout by the artist and author with Phil Baines. Set in Monotype Baskerville in three point sizes, the majority in 36-point with the first stanza in 72-point and part of the second section in 48-point. All set in lower case.

OTHER: Clark's poems were published in a separate edition of 250, 150 of which have a woodcut frontispiece by McKeever (page size 15.2 × 10.8cm).

BIOGRAPHIES: Clark born 1944 in Greenock, Scotland. Moved to England 1967. His books include *Still Life* (1977), *Madder Lake* (1981), *The Tempers of Hazard* (1993) and *Tormentil and Bleached Bones* (1993). In 1985 he and his wife opened the Cairn Gallery in Nailsworth, Gloucester, where artists such as Long, Fulton, Charlton, McKeever and Ackling have exhibited.

McKeever born 1946 at Withernsea, Yorkshire, to Irish parents. Moved to London in 1965 to study English Literature. Self-taught, he began painting in 1969. First solo exhibition 1971 at Cardiff Arts Centre. Retro-spectives at Kunstverein Braunschweig 1987 and Whitechapel Art Gallery, London, 1990. Since 1991 has lived on a farm in Hartgrove, Dorset.

The project originated with Charles Booth-Clibborn commissioning a text from the poet Thomas A. Clark. Booth-Clibborn's original idea had been to publish the text together with prints by a number of the 'land artists' who had exhibited at Clark's Cairn Gallery in Nailsworth, Gloucester (Long, Fulton and Ackling are some of those who had shown there), but Clark decided to collaborate instead with just one artist and suggested Ian McKeever, whose work he felt was compatible with his own. They had known each other for many years, McKeever having also shown at the Cairn Gallery.

From the outset it was agreed by both poet and artist that their work on the project should run parallel, but that the images would not illustrate the text and that the text would not describe the images. As Clark recalls: 'It was important that both parts of the book should have equal authority'. They began their work independently of one another and only saw the other's contribution at a later stage.

McKeever had made etchings before (with Hugh Stoneman in London and Kurt Zein in Vienna) but had never made woodcuts. However, with Booth-Clibborn's encourage-ment he decided that woodcut was the medium he would use. He went to a local builder's mer-chants and selected 8 × 4 ft sheets of wood including chipboard, plywood and a type of plywood called 'shuttering ply' which is used by builders for casting concrete. McKeever states: 'All of the surfaces are actually 'found' surfaces. My input was cutting out the forms. I was looking for a form that ran parallel with the feel of the surface inherent in the wood. In none of the blocks did I work into it. Some of the ragged edges are hammered; the others are cut out with a jig-saw and the edge was what-

ever was found.' The images in the book are printed directly from the inked-up sections of wood. Initially it was envisaged that he would make about ten prints but the scope of the project soon expanded.

The work of both author and artist is grounded in a personal reaction to nature. Clark describes his work as being 'All about walking in the landscape, about a certain kind of silence.' McKeever's work, whether in painting or print, generally has its origin in his travels in remote parts of the world, such as the Sahara, Greenland and New Guinea. The sketchbooks he keeps provide the foundation for most of his subsequent work, though the precise sketchbook images often undergo a rad-ical transformation. Several of the images in *that which appears* can be related to the sketch-books and to particular things seen on his trav-els. For example, the forms which resemble a head on a torso are devices used by the Inuit peoples of Siberia for lighting fires; the castel-lated square shapes derive from simple win-dows made of undressed stone seen in the Russian gulags; and the undulating humped form printed over a double-page spread derives from a group of huts seen in New Guinea. More generally, the vastness of the landscape, the texture of rocks, the feel of earth, air, light and stillness, are all concerns which permeate McKeever's work, as they do Clark's.

McKeever produced about one-hundred prints for the project, knowing that the number would eventually have to be reduced. They were proofed by Hugh Stoneman and Michael Ward at The Print Centre in London from August to September 1993. The very rich blacks, in which the ink lies in relief on the paper, were obtained by printing the blocks through the rollers of a heavy etching press

(normally wood-block prints would be made on a much lighter flat-bed press). The 'blond' prints were arrived at by a fortuitous accident. McKeever noticed that the cushioning blanket which lay on top of an inked-up board prior to passing it through the press, provided sufficient pressure to leave a ghostly impression of the board on the paper. By fixing the time the blanket rested on the paper and ply-board (about thirty seconds) it was possible to achieve identical prints for the full edition of the book. The black contour of these 'blond' prints was emphasised by lightly rubbing the edges of the inked-up board through the paper.

Once McKeever had made most of the prints, Clark sent him his text and McKeever sent some of the images in return. McKeever recalls: 'He could see what I had done and I saw the nature of his text. We both went in blind. He didn't want to feel that my images were forming his text and vice versa. We combined half way through it. We both felt in a sense that we had declared the nature of our statement; we both came in from a point of strength. Then Tom started refining his text and I started going through the images.'

Six months into the project Clark's text, comprising a sequence of eighty poems, some no more than a line in length, was nearly finished. Although they can be read as individual poems they are, as Clark says, 'woven together so that they make one single work.' By this stage McKeever had decided to use forty woodcuts. Together Clark and McKeever laid out the images and poems, and began to establish a rhythm between them. With regard to the order of the images and text McKeever noted that: 'We wanted to get the thing flowing. We never at any point wanted the crossover between image and text to be blatant. If the

crossover was immediately obvious we would re-think and re-position the images.' Clark also refers to the aim of creating a 'visual balance', and felt that it was right to print several poems on some pages and none on others.

Two months later they laid all the prints and texts on the floor of McKeever's studio. McKeever recalls that 'by then we felt that it was functioning. I had a body of images and all they had to do was function as a body. I'm not dealing with a story – it's not sequential or linear. It jumps forward and backwards. I needed to sense its body, not its sequence.' For Clark too, the poems were 'not a narrative. It's more to do with all the individual parts having a uniform tone, though there is a variety of pace. There are echoes across the poems and ideas and images coming through in a variety of ways. There are intuitive links across the poems in terms of association of ideas and elements.'

Clark and McKeever then met with Booth-Clibborn and the typographer Phil Baines to discuss the layout of text and images. Baines had printed test samples of the text onto very thin paper so that they could be laid over McKeever's woodcuts and seen together. A neutral, elegant typeface (Monotype Baskerville) was chosen so that the emphasis would be on the text and the images, not on the typeface.

The texts were printed first, in letterpress by Simon King in Cumbria. The woodcuts were printed onto these same sheets at The Print Centre in London. The title was chosen by Clark and is taken from one of the poems: 'The title felt right. The text is very much about appearances – walking in the landscape, seeing things, touching things, feeling things. There are moments when appearances are

questioned, when they are not entirely manifest. This phrase, "that which appears", encapsulates this ambiguity.'

Reflecting on the project McKeever said: 'From start to finish the whole project took nearly a year. There were periods when I was deeply involved in it, then would paint in-between. It was quite an intense activity. Prior to doing this I'd worked with a lot of etching – which is about line and tone. The woodcut is much more about form and it's much more robust. I could put down a form with a clarity and simplicity I could never do in etching. It was a great help in actually simplifying forms in terms of making the paintings. I found it a very productive medium.'

Note: The five double-spread pages illustrated here are only a selection taken from the book.

snow on moss on stone

out in the wind
burning

out of the wind
glowing

a pool in the forest
a place where the stillness
looks back at itself

thin frosted
birch branch
more frost
than branch

an extension
where every
direction is foiled
intention is stilled
an openness
sheltered

beneath the ripples
on the green lake
the sublucustrine
ripples of light

thin lichened
birch branch
more lichen
than branch

air is filtered
through pine needles
held by alder
scrubbed by juniper

between birch and mist
an affinity

as I go
through the trees
I am led
through the trees
I progress
by implication

a recess
of green
guarded
by thorns
and lit
by its own
internal light

Ian McKeever *Hartgrove*

1993

DESCRIPTION: 10 woodcuts (2 form a pair, the others are single images), title-page, statement and colophon in portfolio case bound in blue-grey buckram.

EDITION: 35 sets numbered 1 to 35 plus 5 proof sets. First 20 sets issued as portfolios; remaining 15 sets split up and released separately.

INSCRIPTIONS: Each print signed and numbered by the artist.

SIZE: 89 × 68.5cm or 68.5 × 89cm.

PAPER: 300gsm BFK Rives.

TECHNIQUE: Woodcuts in plywood and shuttering ply printed on an etching press. Grey prints are second impressions (much of the ink having already been removed). 'Blond' woodcuts printed with pressure of a blanket and some finger-printing.

PRINTER: Proofed and printed by Hugh Stoneman and Michael Ward at The Print Centre, London. Title-page, statement and colophon screen-printed at Coriander (London) Ltd.

BINDING: Designed by the artist and Charles Gledhill and made by Gledhill.

TYPOGRAPHY: Title-page, statement and colophon designed by Phil Baines in Gill Sans and Baskerville.

These prints relate to McKeever's other project for Paragon, *that which appears* (see pp.160–165), but are not accompanied by a text. They were made by the same method, being printed from cut sections of plywood fully or partially inked up. The series is titled after the hamlet in Dorset where McKeever lives and works.

Shortly after beginning work on *that which appears*, McKeever decided that he would also like to make a portfolio version incorporating single images and no text. While working on the book project he was invited to make a print for the Kunstverein in Münster, and produced a woodcut similar to one of the double-spread images in *that which appears* but on a much larger scale. McKeever enjoyed working in the larger scale and decided that rather than make a portfolio version of the book he would work on an entirely separate project. Just as he had made a large number of prints for *that which appears* and then selected a portion of these for the project, so he made about fifty prints for *Hartgrove* before reducing the final selection down to ten. Both projects were finished at about the same time, late in 1993.

The series is composed of three types of print: heavily-inked black prints, in which the ink is so thick that it lies partly in relief on the paper; blond prints, which appear as ghostly, empty forms; and three grey prints which are second impressions, most of the ink having been removed on the first pull. One of the first black pulls is paired with its grey counterpart in the portfolio; the two remaining black pulls were issued separately in editions of twenty-five of each.

The *Hartgrove* prints have an important place in McKeever's recent work, bridging a gap between *that which appears* and a series of fourteen large, black and white paintings he worked on between 1992–94, the *Hartgrove Paintings*. Both series (McKeever works mainly in series, concentrating on themes and variations on themes) have a shared inspiration in nature and architecture. Although McKeever's work of the 1970s and 1980s referred mainly to the landscape, in recent years he has drawn inspiration increasingly from primitive architectural forms seen in landscape settings. Some of the images relate specifically to sketches of huts made on a trip to New Guinea in spring 1991 (for example the two small squarish forms printed on a large white sheet and the large, black, boulder-like form); the castellated square

form derives, like a similar woodcut in *that which appears*, from a sketch of a window opening seen in the Russian gulags. The solid rectangular forms which open out at the edges of the paper also relate to architectural forms, particularly to doors, though McKeever actually developed them out of the painting process. They first appeared in his painted work, in less stylized form, in response to the tensions found in the corners of the stretched canvas and an instinctive desire to paint into these corner areas. Subsequently he incorporated a more clearly articulated version of the form into his prints, beginning with the woodcuts in *that which appears*.

McKeever's sketches, prints and paintings now relate to each other in quite complex ways: ideas established in one medium are carried through to the other, transformed, and then re-incorporated into the first medium. His recent *Hartgrove Paintings*, some of which are more than three metres square, are made up of thin veils of white or black paint which criss-cross over the surface. They bear little apparent resemblance to the prints though generally the form which lies under the veils of paint relates to the forms in the woodcuts. For example, the woodcut featuring a black, boulder-like form, relates closely to *Hartgrove Painting No.1*, a black on black painting, and also to the white on white *Hartgrove Painting No.4*, in which the form is bleached out and present as a veiled, ghostly echo of the first painting.

An artist's statement printed in the portfolio records:

The print was seventy-three sheets of machine packed and neatly stacked plywood. The print was the gap between those seventy-three sheets of machine packed and neatly stacked chipboard and in those neatly stacked sheets of shuttering ply there was a black, which could be light and given every chance was ready to be and from there it begins.

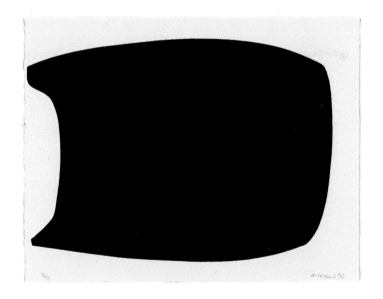

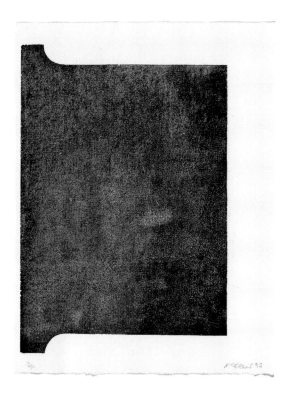

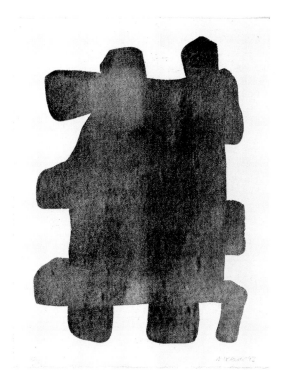

1 2 3 4

5 6 7 9

Lisa Milroy *Rocks, Butterflies and Coins*

1994

DESCRIPTION: 18 colour etchings, 6 of each subject (rocks, butterflies and coins). There are two editions: a boxed edition with each of the 18 prints on separate sheets, each section of 6 prints contained in separate folders within a solander box bound in grey cloth; and an edition of three large sheets, with 6 images printed on each sheet.

EDITION: 30 boxed sets numbered 1 to 30, plus 6 proof sets and 1 BAT. Single sheets: edition of 30 of each, plus 6 proof copies and 1 BAT.

INSCRIPTIONS: Each print in the boxed edition signed and numbered by the artist on verso; each single sheet with six images also signed and numbered by the artist on verso.

SIZE: 66.2 × 87.6cm (sheet featuring all six). Individual print sizes: 30 × 30cm (paper size).

PLATE SIZES: (top row from left to right followed by bottom row from left to right): *Rocks*: 15 × 15cm; 9.8 × 9.8cm; 12.3 × 12.3cm; 14.2 × 14.2cm; 9.8 × 9.8cm; 9.9 × 9.9cm.
Butterflies: 15 × 15cm; 9.8 × 9.8cm; 9.9 × 9.9cm; 9.3 × 9.3cm; 12.5 × 12.5cm; 11.2 × 11.2cm.
Coins: 13.6 × 13.6cm; 11 × 11cm; 9.7 × 9.7cm; 9.6 × 9.6cm; 11.1 × 11.1cm; 12.4 × 12.4cm.

PAPER: 300gsm Somerset Satin.

TECHNIQUE: Softground etching with colour aquatint and extra hardground definition. Each print made from three separate copper plates.

PRINTER: Hope Sufferance Press, London. Proofed and printed by Peter Kosowicz and Simon Marsh. Colophon and folders printed by Simon King, Cumbria, on an Albion Press.

BINDING: Designed by the artist with Charles Gledhill and made by Gledhill.

TYPOGRAPHY: Colophon and folders designed by Simon King in Baskerville.

BIOGRAPHY: Born Vancouver 1959. Studied in Paris 1977–78 then moved to London. Studied at St Martin's School of Art, London, 1978–79, and Goldsmiths' College 1979–82. Solo exhibitions include Third Eye Centre, Glasgow, 1989, Mary Boone Gallery, New York, 1989, Waddington Gallery, London, 1993. Won John Moores Prize 1989. Lives in London.

In the 1980s Milroy became known for her paintings of objects such as shoes, coins, lightbulbs and stamps, depicted in ordered rows on white backgrounds. During 1993 she began to think of the still life no longer in terms of objects, but rather in terms of making pictures of the world; in the last three months of that year she lived in Japan where she produced a series of paintings based on her observations of the city.

In the autumn of 1993, prior to Milroy's departure for Japan, Charles Booth-Clibborn asked her to make a print project of her own choosing. She spent several days at the Hope Sufferance etching studios in London, trying out various techniques and accustoming herself to the medium. Although she had made a series of monoprints of coins, cities, crowds and flowers in February 1993, she had never tried etching.

The artist recalls: 'After living and working in Tokyo, in a world that grew increasingly unfamiliar the more I experienced it, the need to reaffirm connections to my sense of home upon returning was very strong – to draw objects that were familiar to me, and reassuring in their identity being fixed and known, seemed a natural and obvious thing to want to do. Slowing down the process of drawing the way etching allowed me to do, with all the various techniques involved, let me concentrate in a lingering kind of way on what was familiar, let recognition and redefinition of things around me slowly filter through in a way which felt very satisfying. Etching also gave me a much greater control over drawing. It was a wonderful discovery to find I could depict something that had a real immediacy, slowly. The monoprint makes for a relatively fast way of working, and my painting, where the image is built up with a series of quick brushmarks, is also fast. But, as it seemed that the new paintings I was beginning to make of pictures of the world required a different, more intense sense of time about them, I was looking for a way of slowing down my painting and a different way of working altogether, without the image becoming turgid or lifeless. Etching gave me many clues, and this project seemed to come along at exactly the right time.'

The motifs she chose – coins, rocks and butterflies – had all featured in her earlier paintings. They are all small, hand-held objects, and are all collectables. She chose them as a group for the print project on account of the way their inherent qualities contrasted with one another: the butterflies are natural, patterned objects; the coins are man-made; and the rocks can be freely adapted by the artist because they do not have definitive forms. By depicting standard objects in grid-like patterns and in an emphatically direct way, giving equal weight to each

element and eliminating the sense of space or location, Milroy draws attention to the integrity of the object. No metaphorical or metaphysical meaning is implied: the objects are simply objects. One is also very much aware of the processes involved in the making of her art, that these are etchings or paintings rather than the things themselves.

All painting and etching is a matter of making marks, though by making slightly different marks one can produce a picture of, say, a head instead of an apple. The artist observes: 'I liked that the objects were all roughly the same size, and could conceptually be bracketed as things one might collect. I have a lot of pleasure in comparing things, noting similarities and differences: etching allowed me to ground this pleasure. It is the medium of etching that runs as a constant through the three different groups of drawing: what they all have in common are the lines and marks that make them up. Like a kaleidoscope that shifts from one state to another, the coloured bits of glass remaining the same but the pattern they form changing, it seemed quite magical that by altering the marks and lines from one drawing to the next, I could make the image of a butterfly change to that of a rock or a coin. In doing so my sense of awareness of just what these things looked like, and how excited that made me feel, became heightened.'

People generally collect things in order to orientate themselves within their environment: by accumulating, classifying and displaying specific types of objects one gains a sense of security, makes a little world in which one has control and authority. Milroy's art comments on this desire to catalogue, order and name, though the bold, self-assured presence of her objects undermines this mentality and asserts their independent status.

Each of the six specimens in the three groups were, originally, made as individual prints; but once they had been finished and placed in groups of six on a table, Milroy decided that in addition to these eighteen individual prints, all six of the butterflies, rocks and coins should also be printed on large, single sheets. This arrangement follows the regimented compositions established in her paintings, and highlights the relationship between families of objects, between the group and the individual, which is a central theme of Milroy's work. Printing all six together was technically complex, since this required the precise registration of eighteen separate etching plates, three for each object. The eighteen individual prints are contained in a cloth-covered box designed by the artist: 'I wanted the box to have a scientific, collector sort of feel. It looks like a box you might find in a museum – a box for specimens.'

Begun in January 1994, the project was completed in June of that year.

Rocks

Butterflies

Coins

Thérèse Oulton *Undoings*

1989

DESCRIPTION: 6 black-and-white lithographs (three pairs) with title-page and colophon in portfolio bound in red cloth and unsized canvas.

EDITION: 40 sets numbered 1 to 40 plus 5 proof sets. First 25 sets in portfolio form; 15 sets split up and released separately.

INSCRIPTIONS: Each print signed, dated and numbered by the artist.

SIZE: 75.3 × 56.4cm (paper size); 31 × 29cm (image size).

PAPER: 250gsm Zerkall Textured.

TECHNIQUE: Stone lithography.

PRINTER: Jane Anderson, Stone Lithography, London.

BINDING: Designed by the artist, made by Cathy Robert.

TYPOGRAPHY: Title-page and colophon designed by the artist and Vivien Hendry in Baskerville.

BIOGRAPHY: Born Shrewsbury 1953. Studied at St Martin's School of Art, London, 1975–79 and Royal College of Art, London, 1980–83. Solo exhibitions include Museum of Modern Art, Oxford, 1985; Marlborough Fine Art, London, from 1987; L.A.Louver, Venice, California, 1991. Lives in London.

Thérèse Oulton has made a number of etchings and monotypes, but these were her first lithographs. The six prints are presented in the form of three pairs. Using a brush, Oulton drew similar forms onto each pair of lithographic stones. As with her painting, she worked slowly and meticulously, gradually building up the image as she moved the brush across the stone in various directions. The crescent forms which appear in these lithographs (and in much of her work of the late 1980s) do not have particular references but are instead an integral part of the artist's working process; like her cellular structures, they grew out of her work in painting. If the forms 'in' the work of this period suggest vast stellar spaces, they also, to no less an extent, suggest the earth and the spaces of paint and painting.

The three pairs of lithographs present three different types of imagery found in Oulton's painting. The first pair utilises the crescent motifs while the second is composed of a kind of fractured webbing which is laid diagonally across the image. The third has a dissolving grid structure built from hatched brush-strokes. Having made a pair of related images Oulton then bit one of them heavily with acid, removing much of the imagery that she had established. This process of undoing the work gave the series its title.

Oulton's work has frequently centred upon the process of disclosure, removal and undoing. In her painting, the crescent and other forms are emphatically present but obscure (and are obscured by) fissures, chasms and shadowy areas, as if the image we are looking at might be a series of erasures, obscurantisms in the literal sense. But it is not as if the forms can somehow be mentally reconstructed, because the way Oulton paints, and the temporal element in the way she paints, undoes this possibility.

Where much art of the last decade has been associated with gestural, bravura mark-making, Oulton's art is slowly built up and is concerned with effacing the subject. As Andrew Renton has written of her work [L.A. Louver catalogue, 1991]: 'The object of Thérèse Oulton's painting becomes the removal of the object; the gentle dismembering of the skeletal form. What is disclosed is nothing but the fragile seams and spaces, breaks and flows, of an infinitely renewing texture.'

The series was made between June and September 1989.

Pair 1

Pair 2

Pair 3

Adrian Wiszniewski *For Max*

1988

DESCRIPTION: Book of 25 colour linocuts, linocut frontispiece and colophon, in grey cloth covers and box.

EDITION: 100 copies numbered 1 to 100 plus 10 proof copies.

INSCRIPTIONS: Signed and numbered by the artist on colophon page.

SIZE: 26.6 x 21.5cm (page size); 23.3 x 19cm (image size).

PAPER: 225gsm Zerkall.

TECHNIQUE: Linocuts, all cut by the artist.

PRINTER: Vivien Hendry at Hega House, London, on a Vandercook Cylinder Press.

BINDING: Cover with a design by the artist. Collated and sewn in paper covers by Matthew Tyson; covers and slip-case made by Perstella Ltd., Dorset.

BIOGRAPHY: Born Glasgow 1958. Studied at Mackintosh School of Architecture 1975–79 and Glasgow School of Art 1979–83. Artist in Residence at Walker Art Gallery, Liverpool, 1986–87. Solo exhibitions include Air Gallery, London, 1984; Galerie F17, Ghent, 1989; Fruitmarket Gallery, Edinburgh, 1990; and Rex Irwin Gallery, Sydney, Australia, 1995. Lives near Glasgow.

In 1986 Wiszniewski made three prints for *The Scottish Bestiary*. The following year Booth-Clibborn invited him to work on a solo project. A series of prints based on the life of Tristram Tzara and other Surrealist poets was initially envisaged; although the artist made preliminary studies for it the project was later abandoned.

Late in 1987 Booth-Clibborn sent Wiszniewski a batch of linos on which to make linocut prints. At that stage no specific project had been agreed upon. Without making preliminary sketches, Wiszniewski drew onto the lino squares with black felt-tip pen, making the narrative up as he went along, and as he proceeded the story took shape. He completed all the drawing in a single afternoon and spent the following days cutting the images. The resulting book, a pictorial narrative acted out in twenty-five linocuts, relates the tale of a man who discovers a strange object in a box and sets out to discover its function. The prints were drawn and cut in Alnmouth, Northumberland, where the artist and his family lived at the time, and were proofed and editioned in London. They were the first linocuts Wiszniewski had made.

Just as a poem may be divided into verses and stanzas, so Wiszniewski gave the book a rhythm by dividing it into a sequence of frontispiece, three groups of seven images, and a group of four images. He did this by printing the seventh, fourteenth and twenty-first linos in black, while the others are in bright colours. The final four prints pick up colours found in the frontispiece and in the three sections.

The wordless pictorial narrative was an art-form popularised in the twentieth century by the Flemish artist Frans Masereel, but in this work Wiszniewski was more inspired by pedagogic picture-books he had seen as a child: these contained sequences of images to which the 'reader' was invited to add an accompanying story-line, in French, beneath each image. 'For Max' is a dedication to his son Max, who was born in 1987, as well as being the proper title.

The published edition has no text but in August 1994 the artist inscribed one copy with a short narrative to accompany each image (collection Scottish National Gallery of Modern Art, Edinburgh: gift of the artist). Wiszniewski gave this copy of the book the title *Lamp-Light*, a choice which relates to the final image in the sequence. The texts are as follows:

1. A man noticed a box
2. And from the box he uncovered a plant-like object…
3. – and so he decided to plant it in his stony garden.
4. The man was paid a visit…
5. by a fishing-friend.
6. He told him of the box… and took him to the spot in the stony garden.
7. The fishing-friend uprooted the object but it was a plant!
8. It was time for a holiday.
9. 'Hello Paris!'
10. 'Hello Modernity!'
11. An art-lover lost her hat in a gust –
12. and the man lost the art-lover in the rain -
13. – but he had her hat –
14. – and Paris in his heart he set to sleep.
15. It was such a beautiful morning he hardly noticed the crack in the wash-hand basin.
16. He was making a new basin out of the art-lover's hat when he heard the telephone ring.
17. It was his fishing-friend
18. They met by the river –
19. The friend was fortunate
20. and the man caught an old tin.
21. They said goodbye.
22. The man was in a philosophical frame of mind.
23. He noticed a large box -
24. and from the box he uncovered a plant-like object, an art-lover's hat and an old tin.
25. And to this very day he reads his book by Lamp-Light.

I

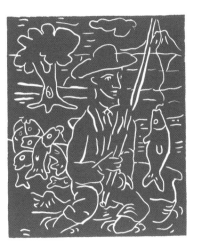
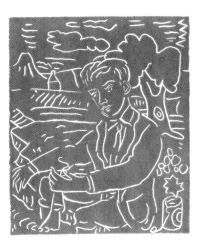

1 2 3 4 5 6

7 8 9 10 11 12

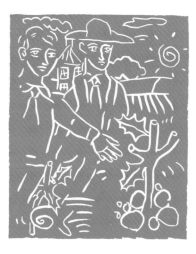
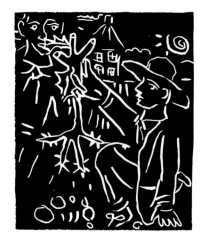
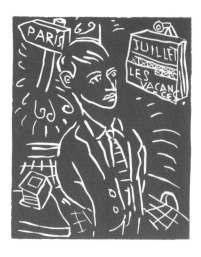

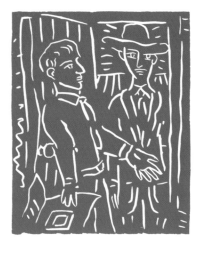
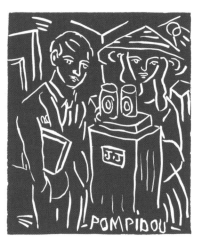

13 14 15 16 17 18 19

20 21 22 23 24 25

Adrian Wiszniewski *Harlequin Series*

1991

DESCRIPTION: 10 etchings, title-page and colophon in portfolio bound in red cloth with diamond folding design.

EDITION: 30 sets, numbered 1 to 30, plus 5 proof sets and 1 BAT. First 20 sets in portfolio form; 10 sets split up and released separately.

INSCRIPTIONS: Each print signed and numbered by the artist.

SIZE: 57.1 × 54.1cm (paper size).

INDIVIDUAL DETAILS:
1. Sugarlift etching, 16.8 × 13.8cm.
2. Sugarlift etching, 30 × 10.5cm.
3. Etching, 42.5 × 42.5cm.
4. Etching, aquatint and spitbite, 29.8 × 30cm.
5. Etching, aquatint and spitbite in red ink, 30 × 30cm.
6. Etching and aquatint in red ink, 30.2 × 30.2cm.
7. Etching in purple ink, 30 × 30cm.
8. Etching, aquatint and stop-out, 29.8 × 30cm.
9. Etching in red ink, 29.9 × 29.9cm.
10. Etching, aquatint, sugarlift and spitbite, 30.2 × 30.2cm.

PAPER: 350gsm Zerkall.

TECHNIQUE: See above. All printed from single copper plates.

PRINTER: Hope Sufferance Studios, London. Proofed by Peter Kosowicz and editioned by Kosowicz, Mary-Claire Smith, Annie Tait, Niall Finn and Richard Spare. Title-page and colophon printed by Simon King, Cumbria, on an Albion Press.

BINDING: Designed by the artist and Charles Gledhill and made by Gledhill.

TYPOGRAPHY: Title-page and colophon designed by Simon King, Cumbria, in Baskerville.

When Charles Booth-Clibborn suggested that Wiszniewski make a portfolio of etchings, the artist immediately thought of basing it on Picasso's celebrated painting of 1907, *Les Desmoiselles d'Avignon* (collection Museum of Modern Art, New York), which he had recently made sketches after. Picasso's painting features five female nudes who are prostitutes in a Barcelona brothel, though the preliminary studies for the painting also include one or more sailors. Wiszniewski's *Harlequin Series* is a gently subversive response to the painting and the various studies. Another source which shaped Wiszniewski's project was David Hockney's print series *A Rake's Progress* (1961–63) in which a young man in New York gradually descends into ruin.

Wiszniewski initially envisaged making a portfolio of just four prints though the number eventually grew to ten. Using square copper plates, he made the hardground etchings at his home in Lochwinnoch, near Glasgow, from July to September 1991. The square format corresponds to a series of twelve paintings relating to the stations of the cross that he had recently completed, and some of the imagery in the *Harlequin Series* also derives from these paintings. He then spent a long weekend at the Hope Sufferance printing studios in London, where he worked closely and intensively with the printer Peter Kosowicz. Wiszniewski made extensive revisions to his etched plates, using aquatint, spitbite and stop-out; he painted varnish onto the first three plates to obtain the even grey tone. Kosowicz proofed the prints while Wiszniewski worked on the remaining plates. During this process the proofed prints were hung up so that the artist could see them in sequence, and at this stage he eliminated some images and changed the order of others until ten finished works remained.

The artist's initial plan had been to base the prints exclusively on the *Desmoiselles* painting, but of the ten prints, only five relate directly to it. The completed series of prints is deliberately obscure, disjointed and non-episodic. A narrative is suggested in places, only to be countered by a print which seems tangential to the others. This idea of suggesting, then frustrating a narrative sequence owes much to Surrealist poetry and imagery, which Wiszniewski greatly admires.

The first two prints feature a man – perhaps the sailor from Picasso's preliminary *Desmoiselles* studies, or perhaps Picasso himself – having disembarked from his boat in the harbour at Barcelona. The man reappears in some of the succeeding prints, walking, as it were, through the series. These two prints, which are smaller than the others, were etched on the same copper plate at the Hope Sufferance studios and were among the last to be made for the portfolio. The third print depicts a despoiled landscape, with remains of classical columns in the foreground. The fourth, fifth and sixth prints are closely based on the *Desmoiselles d'Avignon* painting. In the sixth etching the sailor-figure or Rake enters Picasso's painting from the left, interrupting the proceedings in much the same way as the sailor did in some of Picasso's early studies. The seventh print is a pietà, in which the man, bleeding from a head-wound, is held in the arms of a woman. It is a copy of a painting Wiszniewski had recently made of one of the twelve *Stations of the Cross*, but also relates obliquely to a key episode in Picasso's life: the suicide in 1901 of his close friend Casagemas. In the eighth print half of the *Desmoiselles* image has been erased by shadow. In the ninth we are presented with five figures who replace Picasso's five women: a rock-star (a contemporary counterpart to the sailor) who reclines beside a pool, surrounded by his concubine, a 'groupie', a manager and a song-writer, while a bird moves to peck the chicken-feed at the rock-star's feet. In the tenth and final print the sailor-figure or Rake is confronted by male and female nudes who act almost as keepers of a gate. Wiszniewski wanted this etching to embody the predicament of the artist at the beginning of the twentieth century, faced with freedom of choice but somehow unable to come to a decision.

The title *Harlequin Series* was chosen once the series had been completed. It relates to Picasso's series of Harlequin pictures which preceded the *Desmoiselles*, and also to the design of the portfolio case itself which features a folding, diamond-shaped cover.

The individual prints did not originally have separate titles but the following titles were given at a later date:
1. *Portrait Head*; 2. *Rake's Progress*; 3. *Landscape with Debris*; 4. *Les Desmoiselles / Théâtre*; 5. *Les Hommes d'Avignon*; 6. *Voyeur*; 7. *Pietà*; 8. *Les Desmoiselles / Spotlight*; 9. *Pool-Side Rock-Star*; 10. *Rake Outside*.

Commenting on the series Wiszniewski states: 'The *Desmoiselles d'Avignon* draws open the curtain on the twentieth century. Picasso could not foretell what would unfold – he described the painting as unfinished. As the century draws to a close the *Harlequin Series* is an attempt through ten etchings to complete the picture on Picasso's behalf.'

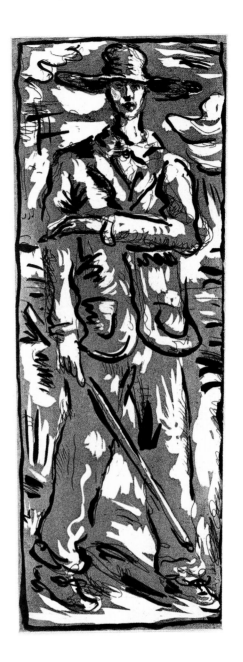

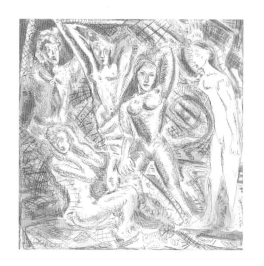

3 4

5 6

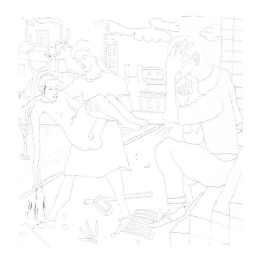

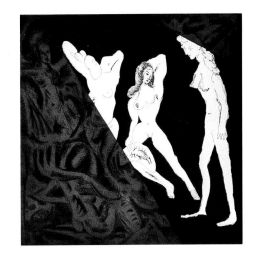

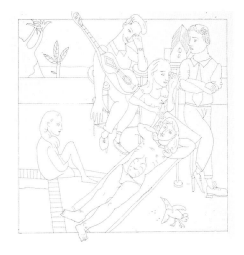

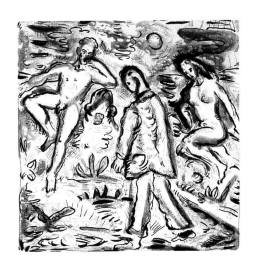

7 8

9 10

Bill Woodrow *Greenleaf*

1992

DESCRIPTION: 5 etchings, title-page and colophon in portfolio case bound in brown-black cloth with 'hair-on' leather insertions.

EDITION: 35 sets numbered 1 to 35 plus 6 proof sets and 1 BAT. First 25 sets issued in portfolio form.

INSCRIPTIONS: Each print signed, dated and numbered by the artist.

SIZE: 68.7 × 76cm or 76 × 68.7cm (paper size); 50.3 × 60.3cm or 60.3 × 50.3cm (plate size).

PAPER: 450gsm Zerkall.

TECHNIQUE: Principally softground etching, with some hardground etching, aquatint and spitbite; each printed from single copper plates.

PRINTER: Hope Sufferance Press, London. Proofed by Peter Kosowicz, and editioned by Kosowicz and Mike Linfield. Title-page and colophon printed by Phil Abel.

BINDING: Case designed by the artist and made by Charles Gledhill.

TYPOGRAPHY: Title-page and colophon designed by Phil Baines in Gill Sans and Baskerville.

BIOGRAPHY: Born 1948 near Henley, Oxfordshire. Studied at Winchester School of Art 1967–68; St Martin's School of Art, London, 1968–71; and Chelsea School of Art 1971–72. Numerous solo exhibitions throughout the world, including Kunsthalle Basel, 1985; Fruitmarket Gallery, Edinburgh, 1986; Kunstverein, Munich, 1987; Imperial War Museum, London, 1989 and 21st São Paolo Biennale, 1991. Lives in London.

Although Woodrow made some prints as a student, he had little experience of printmaking prior to 1989, when he made a series of etchings in Zürich. When Booth-Clibborn asked him to make a portfolio of prints later that same year, Woodrow immediately thought of using woodcut, a medium he had long wanted to try but had never previously used. Employing large sheets of plywood, he made a set of three prints on the theme of Birth, Life and Death, a subject he had treated in some recent sculptures. He did a fourth, unrelated woodcut of a still-life, and a fifth, some seven foot tall, of a giraffe (see Appendix I). Although he was pleased with the results, he decided not to make them the main part of the Paragon project, choosing instead to embark upon a suite of etchings.

As his point of departure he chose a short story by the American writer Flannery O'Connor (1925–64). Woodrow had first encountered O'Connor's writing in Italy, where he chanced upon a collection of her stories, *Wise Blood*, while browsing in a bookshop, waiting for a train. Later he bought another collection of her work which contained the story *Greenleaf*, first published in 1956.

Greenleaf is the story of an elderly widow, Mrs May, who has known better days but now lives on an old farm in the deep south with her two shiftless, unmarried sons. Mr and Mrs Greenleaf live on the estate and help maintain the farm. The Greenleaf sons are grown up and thanks to state grants, which they have skilfully exploited, have become successful farmers on adjoining land. In one sense the story deals with the passing of a certain privileged way of life, seen through the contrasting fortunes and prospects of the sons. This theme is developed through the agency of a scrub bull, which belongs to the Greenleaf sons, and which eats Mrs May's crops, keeps her awake, and eventually kills her. Woodrow used the story as the starting point for his etchings, though rather than illustrating it they develop from it.

In December 1991 Woodrow began making preparatory drawings for the project at the Hope Sufferance print studios in London. He then set to work on the softground etchings. This technique involves drawing directly onto paper which lies on a greased etching plate: the drawn lines press into the greased layer and when the paper is removed it takes with it the drawn 'ground' which can be etched with acid and printed. Woodrow liked the immediacy of the technique, its linearity, and its closeness to drawing; since about 1990 drawing has assumed an increasingly important position in his work.

In each print Woodrow responded to images or words in the story which attracted his attention and seemed to him to be key elements, but he also added motifs of his own choosing. Narrative incidents are overlaid in each print, an approach he first employed in an etching in the portfolio *Pern and Pashm*, which was executed in Zürich and published by Margarete Roeder editions, New York, in 1989.

The first two prints in the *Greenleaf* portfolio contain references gathered from the opening pages of O'Connor's story, and relate to the arrival of the scrub bull in Mrs May's field. The bull's horns are garlanded with Mrs May's greenery, which, in Woodrow's hands, has grown into a type of vine with strange fruit hanging from it. The large letters ET and OT can be distinguished, overlaying the horns: these are the initials of the two Greenleaf sons who own the bull and who are referred to as 'scrub-human' several pages into the story. Woodrow liked the phrase and introduced it at the top of the image.

The second etching refers to a moment signalled in the opening paragraph, where Mrs May is woken by the bull outside her bedroom window and peers at it through the venetian blind. The gap in the blind forms the shape of an eye, the pupil of which doubles as the bull's heart. Only one element of this is mentioned in the story, and Woodrow then developed his drawing from there, adding various motifs. He remarks that 'By that stage it's not referring to the book: I'm making an image, getting the thing to work visually. After the initial start the images build up and take off on their own.'

In the third etching we come across Mrs Greenleaf, whom Mrs May detests. Partly demented, she is fascinated by newspaper articles about rape, crime and catastrophe. She cuts these articles out and buries them in the ground, in quasi-religious ceremonies. We see her as if from the hole in the ground, her words 'Jesus' cut up like the newspaper texts; the hole doubles as a coiled snake. The fourth etching deals with the brawl in the kitchen between Mrs May's two sons. Things fly about everywhere: in the top we see a ring, which refers to their oft-mentioned bachelor status.

O'Connor's story finishes with the bull charging at Mrs May and running her through with his horns. In the centre of Woodrow's fifth image she assumes the appearance of a Venus figure, pierced through the heart by the horn, and framed by her own car-horn; an analogy is made between her pumping heart and the bulb of the car-horn. In the story Mr Greenleaf emerged from the trees and shot the bull four times through the eye: these four gun-shot holes appear in the print and are repeated on the portfolio case, where they are rendered as four circular tufts of bull's hair. The spherical forms, which appear in various guises in the other prints, are, as Woodrow says, an ambiguous blend of molecular structure, empty hole, world and universe.

There is a correlation between Woodrow's approach to sculpture and his approach to making these prints. In his sculpture of the period 1980–87 he would begin with a manufactured article – a car door, a washing-up machine, a chair – and then transform this starting point into something entirely different. By the same token the *Greenleaf* etchings had their starting point in a pre-existing story and then developed at a tangent into a series of visual images. There is also, in his sculpture and prints, a shared concern with narrative structure, and since the late 1980s he has introduced three-dimensional words into his sculpture. Woodrow remarks of his use of the *Greenleaf* text: 'It's a personal way for me to generate images. In a way it was more to do with celebrating the story, acknowledging that this was an important writer. Narrative has always been a key element in my work: I'm interested in the problems of using narrative in a visual language.'

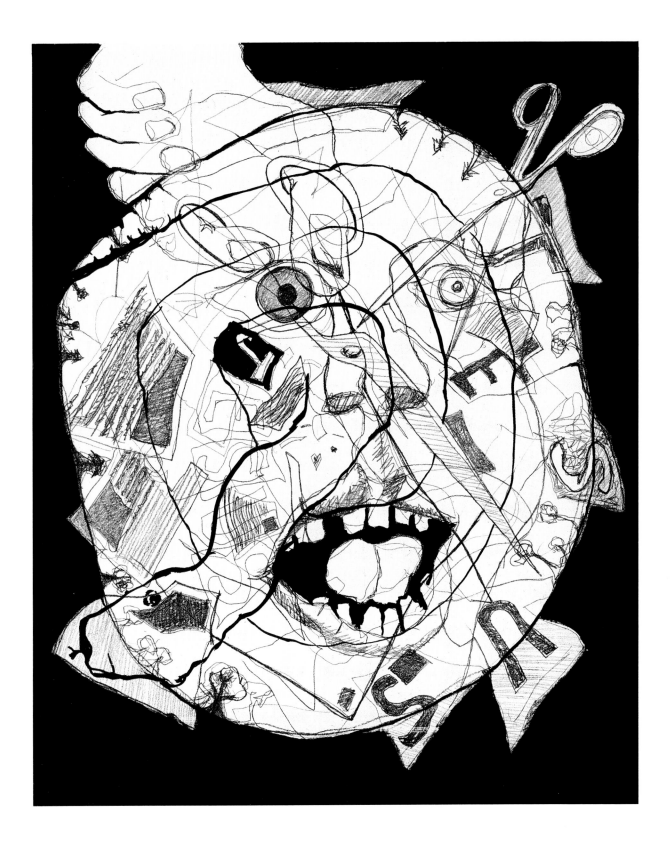

3

1

2

Bill Woodrow *The Periodic Table*

1994

DESCRIPTION: 21 black-and-white linocuts with title-page, index and colophon also in linocut. Book edition bound in full black calf with punched holes tooled in gold; enclosed in black cloth solander box. Portfolio edition in solander box bound in black buckram.

INSCRIPTIONS: Book signed and numbered by the artist on colophon page; each print in portfolio edition signed and numbered by the artist.

EDITION: Book in edition of 30 copies numbered 1 to 30 plus 10 proof copies; portfolio version in edition of 30 copies numbered 1 to 30 plus 10 proof copies.

SIZE: 50 × 43 cm (page size); 38.3 × 35.8 cm (approximate image size).

PAPER: 270gsm BFK Rives.

TECHNIQUE: Linocuts cut by the artist. All printed in black ink.

PRINTER: Simon King, Cumbria, on an Albion Press.

BINDING: Book cover designed by the artist, made by Charles Gledhill. Solander box made by Ryders, Bletchley.

Woodrow began this project a year and a half after finishing *Greenleaf* (see pp.188–191). Each linocut is based on one of the twenty-one chapters of Primo Levi's much acclaimed book *The Periodic Table*, first published in Italian in 1975. Woodrow was given the book by a friend and was immediately struck by it: 'I found the book incredible. It put chemistry into the context of the real world. It was something that stayed with me and I knew I'd make work with it at some time.'

Each of Levi's chapters is called after an element in the Periodic Table. Each chapter contains reference – sometimes slight, sometimes very precise – to one of these elements, and around this theme Levi weaves an autobiographical narrative mixed with fictional material. Levi (1919–87) trained as a chemist in the 1930s, fought in the Resistance, and during the war was imprisoned in Auschwitz. His knowledge of chemistry probably saved his life since he was put to work in the camp's laboratory. Deeply marked by this experience, many of the references in the book are to Fascism, and loose analogies are drawn between the properties of elements and Fascist ideology. Some stories are entirely fictional whilst others relate to Levi's post-war work as a chemist. It was Woodrow's aim to select a key theme or moment in each chapter and produce 'an image which reflected the smell of the story'.

Woodrow had initially thought of making a portfolio of prints, but it later developed into a book project. He had last made linocuts as a student, but chose the technique because it is direct and relatively quick, and also, with such a large number involved, because they could be cut at home. It took about three months of nearly full-time work to complete the set. He conducted various lines of research, reading chemistry texts and talking to knowledgeable friends. He made one or two drawings for each chapter and transferred the finalised drawing onto the lino prior to cutting. Rather than sketch the full set of twenty-one images, he made one drawing and linocut at a time, starting with the first chapter and working his way through. Once he had a batch of three or four linocuts he would proof them at Hope Sufferance studios in London.

In each print the elements are identified by their chemical names, but they are, in order: argon (Ar), hydrogen (H), zinc (Zn), iron (Fe), potassium (K), nickel (Ni), lead (Pb), mercury (Hg), phosphorus (P), gold (A), cerium (Ce), chromium (Cr), sulphur (S), titanium (Ti),

arsenic (As), nitrogen (N), tin (Sn), uranium (U), silver (Ag), vanadium (V) and carbon (C).

As in the *Greenleaf* portfolio, Woodrow used the text as a point of departure rather than something to be illustrated: 'All the way through, with all the prints, the objective is to make a visual image. That finally takes precedence over the story. Hopefully you might be pushed into reading the story, though this wasn't the point of it. The whole exercise is self oriented.' Although Woodrow did consider printing the text alongside the images this idea was rejected on practical grounds.

Each of Levi's chapters relates to elements of the periodic table in sophisticated and often complex ways, and Woodrow selected and adapted particular incidents with ingenuity. Briefly, the references in Woodrow's linocuts are as follows. Levi's first chapter begins with a discussion about *argon* and other rare gasses of which little is known, then develops into an account of his family history, about which only fragmentary anecdotes are remembered. One anecdote refers to a relative, a doctor, who cured stammering children by snipping the skin under their tongues.

Woodrow's second linocut draws on several related incidents in chapter two, particularly Levi's youthful efforts at collecting *hydrogen* in an upturned flask (it blew up) and a mythical story relating to a supposed local custom of using the thread of silkworms for fishing-line. The third image relates to Levi's schoolboy experiment with *zinc*, which in turn is connected with his first bodily contact with a girl and his joy at slipping his arm under hers. The fourth linocut, *Iron*, refers to an expedition Levi and a friend made into the mountains: in the war the friend was shot by Fascists. Levi's fifth chapter, *Potassium*, hinges on an experiment which went wrong owing to the presence of a minute quantity of the element in a flask: this caused the flask to explode when water was added. Potassium's properties are used by Levi as an analogy for the Fascists' obsession with racial purity and Woodrow develops this into a text integrating a swastika.

The sixth image relates to Levi's job in a *nickel* mine, where all the workers have relationships with one another, a process Woodrow renders as a schematic flow chart connecting one individual with another. The seventh chapter is a fable about a man in search of *lead* who travels to a distant, undiscovered island where strange things happen…. The eighth chapter is a fictional tale about a cave where *mercury*

is found. Sensing an 'unmentioned feeling of oppression', Woodrow transformed a crucifix which features in the story into a swastika, thus relating it to Levi's own predicament.

The ninth image refers to a secretive laboratory in which Levi worked. He was told to produce *phosphorous*, but was given no help in doing so. This difficulty in obtaining guidance may be seen as a metaphor for the Fascists' control of information. The tenth chapter tells of Levi's imprisonment in Italy as a member of the Resistance and his encounter with a fellow prisoner who has panned for *gold*: Woodrow's image features a schematic river, complete with bars and gold particles. The eleventh image, *cerium*, refers to Levi's Auschwitz number. He stole some cerium from the laboratory at the concentration camp and with this was able to make three small lighter flints. Each of these could be exchanged for two slices of bread, on which he and his friend could survive for a day. In total he took forty pieces of cerium which allowed the pair to survive for sixty days each, until the Russians came and liberated the camp. Woodrow reduces this lengthy narrative to a neat, chemical equation.

The twelfth chapter refers to Levi's post-war work in a varnish factory, to methods of producing varnish with *chromium* and, in passing, to the tradition of putting two onion-rings in the cooking vat. The thirteenth chapter concerns a man who is employed in the manufacture of *sulphur*, and describes the complex, pressurised nature of this task. The fourteenth chapter is dedicated to a man who is painting kitchen furniture *titanium* white. In order to stop a young girl from interfering in his work he chalks a 'magic' circle around her and prohibits her from crossing it. The fifteenth chapter concerns a man who fears he will be poisoned. He takes samples of sugar to Levi to analyse, convinced, rightly as it turns out, that it contains *arsenic*. Concerned for his well-being, the man climbs four flights of stairs rather than use the lift. As Woodrow says, 'That seemed really to be the hub of the story – something you wouldn't notice but in a strange sort of way the story pivots on it. It sets the atmosphere and tells you about the man.'

The sixteenth image concerns another of Levi's post-war customers, who hopes, vainly, to extract *nitrogen* rich in uric acid from chicken droppings in order to manufacture lipstick and thus make a fortune ('aurum de stercore' means 'gold from dung'). In the seventeenth chapter Levi describes his efforts to set up a laboratory

for the extraction of *tin*: the scheme collapsed, literally (a fracture is apparent in one of the links of Woodrow's chain). The eighteenth chapter is about a man who was given a lump of *uranium* by a German soldier. Listening to the tale Levi is incredulous, but tells him: 'Of course I believe you'. The story turns out not to be true. The nineteenth chapter refers to the use of *silver* in X-rays and highlights the very rigorous nature of chemical experiments. The twentieth chapter concerns professional dealings between Levi and a German company, to the use of *vanadium* in the production of varnish, and to the discovery that the man with whom he is in correspondence was a senior official at Auschwitz. In the final chapter Levi writes the history of a single atom of *carbon*, which finishes its life forming the full-stop at the end of his story.

Woodrow designed the cover of the book. It is in black leather, with the title punched through with hundreds of tiny holes. Each hole is inset in gold leaf to give the impression that it might be a starry sky at night, or perhaps a molecular structure. The project was finished in December 1993.

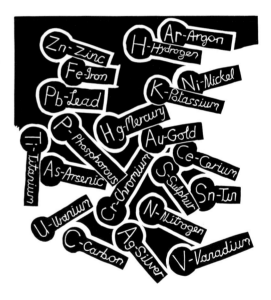

title

index

THE PERIODIC TABLE
21 LINOCUTS BY BILL WOODROW
Each linocut is based on one of the 21
chapters of Primo Levi's book The Periodic
Table. The title-page, index and colophon are
also linocuts by the artist. The linocuts were
printed by Simon King on an Albion press,
the paper is 270 gsm BFK Rives.
The book is published in an edition of 30
copies numbered and signed by the artist on
the colophon page, there are also 10 proof copies.
The binding has been designed by Bill Woodrow
and made by Charles Gledhill. The Portfolio
is published in an edition of 30 copies.
Each print is signed and numbered
by the artist, there are
also 10 proof
copies. Published
by Charles Booth-Clibborn under
his imprint The Paragon Press.
Copyright Bill Woodrow and
Charles Booth-Clibborn.
In the year 1994.

The following prints were commissioned by The Paragon Press but were not conceived as projects.

John Bellany

The seven etchings listed below relate to the project *Images Inspired by Ernest Hemingway's 'The Old Man and the Sea'* (1987) (see pp.54–59) but were not incorporated into the portfolio. Each print was issued in an edition of 10 plus 3 APs. Printed at Peacock Printmakers, Aberdeen, on 300gsm Somerset Textured.

Untitled.
Etching.
47.6 × 32.2cm (paper 75 × 56.8cm).

Untitled.
Etching.
32.4 × 42.7cm (paper 56.8 × 75cm).

Untitled.
Crayon etching.
47.9 × 32.1cm (paper 75 × 56.8cm).

Untitled.
Crayon etching.
47.8 × 32.5cm (paper 75 × 56.8cm).

Untitled.
Crayon etching (blue ink).
47.9 × 32.6cm (paper 75.2 × 57cm).

Untitled.
Etching.
47.8 × 32.5cm (paper 75 × 56.9cm).

Untitled.
Etching (orange ink).
48 × 32.4cm (paper 75.3 × 56.8cm).

Christopher Le Brun

Untitled (Horse and Rider), 1989.
Lithograph.
33 × 26cm.
Edition of 35 plus 10 APs.

The above print is a detail of a much larger plate made as part of the *Seven Lithographs* project (see pp.134–137) but abandoned.

The four prints listed below were not executed as parts of particular projects. Sequentially, they lie between the projects *Four Riders* and *Wagner* (see pp.144–149). They were printed at Hope Sufferance Press, London. *Untitled*, LV relates to etching number XLI (from the series *Fifty Etchings*, see pp.138–143), the sky area having been cut out and other alterations made. It relates closely to a painting of 1992 (Aberdeen Art Gallery) and was begun while the painting was still in progress. *Wing*, LVI is a close transcription of a large oil painting of 1992 (private collection, Belgium). It also relates to four etchings of wings in the *Fifty Etchings* series. The two Brünnhilde etchings (the second is a reworking of the same plate) relate to a commission for a series of four paintings on Wagner's *Ring Cycle* (see pp.146–149). In addition to making preliminary drawings, Le Brun also made these two small etchings in order to establish possible compositions.

Untitled, LV, 1992.
Etching and aquatint.
14 × 16cm (paper 39 × 40cm).
Edition of 23 plus 5 APs and 1 BAT.
Hand-made Queen Anne paper.

Wing, LVI, 1993.
Etching and aquatint.
24.5 × 30.1cm (paper 57 × 58.2cm).
Edition of 35 plus 7 APs and 1 BAT.
Printed on chine collé.

Brünnhilde, LVII, 1993.
Etching and aquatint.
22.2 × 24.8cm (paper 57 × 58.2cm).
Edition of 35 plus 7 APs and 1 BAT.
Printed on chine collé.

Brünnhilde, second state, LVIII, 1994.
Etching and aquatint.
22 × 25cm (paper 57 × 58cm).
Edition of 50 plus 4 APs, 4 HC and 1 BAT.
Printed on chine collé.

Other Men's Flowers, 1994

A publication of 15 text-pieces by 15 London-based artists, curated by Joshua Compston. The artists are: Henry Bond, Stuart Brisley, Don Brown, Helen Chadwick, Mat Collishaw, Itai Doron, Tracey Emin, Angus Fairhurst, Liam Gillick, Andrew Herman, Gary Hume, Sarah Staton, Sam Taylor-Wood, Gavin Turk, Max Wigram.

There are two different editions of *Other Men's Flowers:*
1. A portfolio version consisting of 15 individually signed and numbered prints, a title-page, introduction and colophon page, presented in a box (edition of 50 copies plus 20 APs).
2. A book edition consisting of 15 text pieces, title-page, introduction and a colophon page signed by all the artists, presented in a box (edition of 100 copies plus 20 APs).

Each sheet measures 47 × 61cm. A variety of papers were used, from 150gsm to 225gsm. The text pieces were screenprinted and/or made on a printed letterpress by Thomas Shaw, Chlöe Ruthren and Simon Redington. The printing was co-ordinated by Thomas Shaw.

Matthew Radford

51 Monotypes

In 1993 Booth-Clibborn commissioned and financed Radford to work at the Hope Sufferance Press over a four week period from May to June and make a series of monotypes. Radford produced fifty-one images of varying size: four are 122 × 122cm; nineteen are 61 × 61cm; and the rest are between 15 × 15cm and 30 × 46cm. Some have chine collé and a number were made from two or three plates or printings. 300gsm Somerset TP paper was used for the majority of the prints. Each monotype was given a number from 1 to 51, written on the reverse of the sheet. All are untitled.

that which appears, 1993

Sequence of 80 poems by Thomas A. Clark.
Text version of the book (see pp.160–165), 15 × 11cm. Hand-set and printed letterpress by Simon King, Cumbria. The layout was designed by the author with Phil Baines in Monotype Baskerville; the paper is Rivoli 150gsm. Hand-sewn and bound in paper covers and black endpapers by Simon King. Published in an edition of 250 copies signed by the author on the colophon page: in the first 100 copies there is a frontispiece woodcut by Ian McKeever.

Bill Woodrow

Birth, Life, Death, 1991.
Three woodcuts, each 76 × 122cm (paper and image size).
Each print in an edition of 10 plus 1 AP. Signed and numbered on the image in white crayon. Printed by Hugh Stoneman on 350gsm Arches.

These three prints were made at the instigation of Charles Booth-Clibborn and preceded *Greenleaf* (see pp.188–191). It was decided to make small editions of the three prints and pursue a fuller project in etching: *Greenleaf*. At the same time Woodrow also made two very large untitled prints of a padlock, fruit and knife, and of a giraffe (the latter was subsequently reworked).

RAVEN

Nothing still: the west empty.
The sail useless in this north-westerly.
Sea too rough for the oars.
The raven in the wicker cage,
 he rages more than the seamen.
The seamen have their cheese and beer.
(For the raven, no food.
That raven hated us, through his bars)
Sun went down, russet.
'A good sign,' said the skipper,
But like all of us could hardly speak
For the shaking of his teeth.
We were cold men, from spindrift and hail showers.
A few stars came out
And they had the faces of children.
The young seamen slept.
I lay cold all night.
The raven did not sleep.
The helmsman did not sleep.
Yet there is land in the west: Orcades, Alba, Ireland.
Raven screamed with hunger at dawn.
He screamed, seeing our oatcakes and beer.
Then sudden the wind swung nor-east,
The sail drank the nor-east
And *Seeker* went like a stallion over the gray field
 of the sea white-flowered.
He whose mouth was full of dooms
Pictured us galloping
Over the roaring edge of the world.
The young sailors, cheerful with the wind,
Laughed, and wind laughed,
And laughter of sea lay all about us.
(The hungry raven, he laughed not.)
'Now let the raven go free.'
The boy unlatched the raven's cage
Cautiously, lest the raven have his eye.
But no, all thin as he was,
The raven leapt at the sun, and wheeled
High, and higher, and flung
His hollow eye round the horizon's ring,
And fluttered no bigger than a fly
Westward. Like a black arrow
The raven sped into the empty west.
Then was our skipper glad.
Then he flung his arm about this shoulder and that.
'There is land there.
Our friend raven has smelt worms and carrion.
Raven will be there first.
Seamen, keep your axes well honed.
There is land for us in the west,
Islands, fertile straths, mountains for pasture,
Fiords full of fish.
Boy, you shall have a sweetheart in Alba.'
One day still we followed the raven.
Then the helmsman pointed to a hill.

FIELDMOUSE

'Now,' said the Fieldmouse, 'I think I'll have a
day off. The house is built. The work is finished.
The larder will soon be full.'
 'You can come, Winter,' said Fieldmouse,
'anytime you like, with snow or tempest or flood.
It's a fine tight house, this.'
 'And I won't starve,' he said. 'There's a farm over
there. A few ears of corn in the barn. Cheese and
bread in the farm cupboard. I know my way around.'
 'Soon,' said the master-builder, the provider,
Fieldmouse, 'I'll carry my bride through this door.
The bedroom will be full of little cradles, one for
each mousikin.'
 He sang little songs to himself Fieldmouse was
fulfilled, secure, happy.
 One night he paid a visit to the farm, to see where
exactly the cupboard was, to observe the habits of
farm-cats and dogs (if any).
 'I can deal with that lot,' said Fieldmouse, having
cast an eye on those beasts that dwelt by the fire all
winter. He was a brave resourceful mouse. The cats
washed themselves. The dog flicked a tail, fire-lit.
 Fieldmouse saw a young man at a table in the
lamplight, writing with a pen in a book of blank
pages. Sometimes the man stopped, and laughed,
and then wrote a few more lines. The dark eyes
of the young man smouldered with delight.
 'A poet,' said Fieldmouse. 'I'm not frightened
of him. Poets and animals have always got on well.
He's not one of those mice-hating murderous yokels.
I think the poet would give me a bit of bread off his
plate if I climbed on to his table. I'm sure of it.'
 An old man with a candle appeared at the door.
'Rab,' said he, 'dinna sit up owre late. There's yon
field to be ploo'd in the morning.'
 The poet went on writing.
 And Fieldmouse trotted off home.
A cold November morning. Fieldmouse was doing
a few odd jobs in his new house. He heard outside
in the field some familiar sounds, the steady sturdy
rhythm of horses' hooves, the ploughman's shouts,
plough slicing into wet earth, cries of a hundred
following gulls.
 Then the earthquake struck.

DOVE

'Where are we going,' said the abbot, 'men wear
cruel masks: masks of wolf and boar and hawk.
They still do not know that mildness – in the sign
of grace – is the true heritage of men. Their faces
should shine like the sun. They are only a little lower
than the angels. But we will go among them like
doves.'
 So they sailed north out of Ireland, wearing
gray coats and hoods of doves, and they came to the
island. And they stepped ashore.
 In the straths and mountains and islands around
men went secretly, and stealthily, wearing the beast
masks. Sometimes, like beasts, they fell on each
other, and tore into throat and heart. They looked
across the sound at the abbot and his monks gather-
ing stones to build a church - sailing out in a little
boat to fish – digging a field to sow corn.
 They left them alone. The monks were poor.
When they pulled back their dove-hoods they had
a brightness on their faces. They sang psalms eight
times in the day, of such peace that rage and greed
and fear and envy withered in the hearts of those
who wore the beast-masks.
 The church grew. There was a little bell, it sang
across the waters.
 The abbot stood on the shore of the little island.
'I'm Columba, "the dove". It's time for you to visit
us. You're welcome.'
 They came.
 Columba opened a book with beautiful script
on every page, the initial letter richly dyed like
butterflies' wings. In the incensed chapel he turned
the pages of the book and read to them. They laid
off their beast-masks. Their faces glimmered with
wonderment.
 They watched the solemn slow beautiful dance
of the bread and the wine at the altar. Then the abbot
told them, in a homily, the meaning of the words
and the offering.
 And a dove-coat, a mask, went with homilies to
the straths and loch-sides beyond.
 And the people laid aside their beast-masks and
listened. They learned that their labour in field
and firth had a value beyond the getting of food and
drink – which, though necessary, was beset always
by famine, fire, extortion, and the black worm.
 The dove-coats cut their first harvest with sickles.
They baked the barley. They brewed the barley malt.
 They sang. They performed their solemn beautiful
dance of bread and wine.
 Ah, with a mighty clapping of wings the doves of
the air fell all about the doors of the abbey of Iona.

WOLF

And the wolf roamed here and there through the great forest that covered the land.

The wolf left tracks in the snow.

The wolf lingered beside a river. The throat of the wolf was cold with the water that flowed on and on, singing, from the mountains down to the great water, the sea. That water in the west was bitter. The wolf spat it out. But when he wanted to get to another island, the wolf swam, and he delighted in the cold surge that all but covered his head, but he could see through the washed prisms of his eyes the island. The wolf stood on the shore of the island and shook the sea from his coat in thrilling showers.

Once the wolf came out of the forest, and he saw where the river met the sea that a ship had been drawn up on the beach and a score of men were building huts.

Others cut down the trees with axes. And they dressed the trunks, and carried them to set into the walls of a hut.

Already there was a clearing in the forest.

A spasm of fear went through the wolf, for the first time. Those were creatures he would have to keep an eye on. They were very clever. The thought had hardly passed through his mind when a slim wooden bird flashed past him, thrumming, and lodged in the next tree: biting deep into it, and quivering there, just beside his hesitant paw, an arrow. The wolf turned and fled for the first time. Soon men were everywhere. The ships came crowding out of the east. The little wooden villages were built at the estuaries, or higher up the river. The great trees fell, in hundreds and thousands and tens of thousands. The ground was cleared. Black forests became green tilth, green pasture. Oxen dragged ploughs, sheep grazed on the pleasant hillsides.

The axes of the men flashed and bit deeper and deeper into the forest.

Little market villages were built where once the wolf had roamed in perfect freedom and peace and joy.

Now only the wildest places of the land were left to him. He felt like a creature cornered and doomed.

Occasionally he flashed out of the lessening forest and seized a few sheep (new delicious prey, the flesh tender and the blood warm and sweet).

One evening, when the elders of a tribe were sitting round an open-air fire, the wolf appeared at the edge of the shifting flame-shadows.

The men lifted their spears.

The wolf said, 'I have come to be your servant. I will do what you tell me. I will keep your flocks. I will guard your doors against the night raids of that other tribe across the firth. I will be a good friend to you for ever.'

The chief held out his hand.

And the great smoking tongue of the wolf curled about his fingers: the kiss of peace.

SPIDER

Never again. It was broken. The kingdom lay in ruins about him.

This was the end. This the nadir, coldness and dark of exile, utterly. The grave, this.

He stood on the last stones. Here Scotland ended. Lamentation of sea against rocks.

The swineherd has a hut. The fisherman a bothy. For this king, a cave, without food or fire or couch.

Ah, but some creature was busy building itself a house! The spider hung here and there its delicate scaffolding.

The master mason with his chart and compass, the craftsman dressing a granite block, the labourer going here and there about the site with his barrow-load of cement: what slow clumsy creatures they were compared with this little aerial architect, as he climbed and swung and dropped down on his gossamer thread.

A freshet of sea wind blew into the cave. Down it fell in ruins, the web. The work had been for nothing.

Kirk and castle and palace, ship and chariot: all these, once, not so long ago, lovely artefacts, he had thought to gather into the fair bound of his kingdom. Six times he had tried. Six times it had ended in ruins.

The creature was having another go. Once more the delicate dance of construction got under way. The half-made web shimmered with sea light. A bumble bee rolled heavily out of a clump of seapinks and blundered into the web, and broke it.

The king was sorry for the spider.

The spider knew nothing about rage, or self-pity, or despair.

Once again, out of his own body, he began upon a new edifice of air and light. The work didn't get so far this time. A heavy water drop from the roof of the cave, like a crystal, fell through it.

The king became more and more interested in this creature of endless resource and purpose and energy. A strand of the fourth web would not adhere to the slimy wall of the cave. It ended in tatters.

A water rat, scurrying along a stone ledge, shattered the spider's next house.

Immediately the work began again. The spider swung down and across and up. The delicate structure was all but finished, when the king put out his finger to touch, appreciatively, the work, as (in the old days) he might prove a granite lintel. Silently the spider's castle collapsed, a broken silver thread about the man's finger.

'This grieves me,' cried the king.

Human grief and sympathy were all one to the spider.

Its seventh web spanned an inner coign of the cave: a shimmering perfection.

'Well done,' sang the king.

A month or two later the king returned to his broken kingdom. He began once more to spin the web of policy and statecraft, planning and negotiation, sympathy and summoning and subtleness and sternness, that had its consummation a few years later on a battlefield under Stirling Castle.

SALMON

Knight of the waters, chevalier.

Happy in infancy, among the high cold mountain springs.

Then called away, called to far venturings.

No lingering, no denial. He must go.

Shadow of leaves on the stream, as he slips downstream, shadow of hawkwing, shadow of rowan, shadow of a child's face (broken) in the ever-more urgent waters.

The sea!

The open unchartered salt streams.

The little sweet-watered river lost in the wide bitterness of ocean.

But the young knight has known this. Well he has read the scrolls and scriptures of the salmon. They are a part of him. The map of the journey is notched in his brain. The call has come. He has obeyed.

Who shall list the adventures of this knight in his northern bounds, near the ice, near the whales and the great Arctic wings?

It is hidden, the silver book of seeking, of adventure, of triumph, of winning and wounding. It is known to himself alone, and to all his kind.

All we know is, in the sea pastures he grows into great power and beauty.

The sea hammers about him his bronze and blue and silver armour, ringing!

On he rides, a splendour in the deep currents.

Faint in his brain, a trumpet call. Faint and fleeting and far-off, a summons. *Return! Return!*

He tugs on the rein of a snorting clamorous wave.

The river is calling him home.

South and east he hastens, pausing at no inn or market-place for rest or refreshment.

Worse dangers lie ahead, the wind-drinking four-branched creatures with their nets and their hooks: subtly, cruelly, he's beset.

The old sweet wine of the river. Shadow of grasses, shadows of rosebush and lark.

He seeks the last trophies, increase and death.

With splendour and magnificence this prince of the waters hurls himself against the challenging trumpets of a waterfall.

LION

The ladies sit at the embroidery frames.

They sit in their bowers, in the west, with red and yellow threads.

They sit in the castle bower, above the islands and the ship.

The ladies weave heraldry for the king: LION. Fergus, skipper, comes up from the ship, far-seeker, bearer of corn and fleeces, bearer of gold.

The people in the castle come to hear the story of the voyage of Fergus.

The king is not there. The king is in the forest, hunting the wild boar.

Fergus will not sing the tale of the voyage to scullions, milkmaids, ostlers.

With long white fingers the ladies draw needle and thread through the linen in the frames.

There stands lion, red and raging as the sun!

The people dance. They clap their hands.

He is magnificent, their lion. The king, once home from the boar-hunt, will kiss the sweet-fingered ladies.

Fergus says, with a cold mouth, 'That is foolishness. Never in any land I have sailed to – Iceland, Spain, Latvia, Norway – have I seen such a beast. Nor has any man in the world seen such an animal. Unpick it, before the king comes out of the forest. The king ought to be here. He knew the ship was due. I have a cargo of walrus tusks from far in the north, from the circle of ice.'

Fergus went back to the ship, angry.

A horn sounded. The king had slain the boar in the forest.

The ship of Fergus, trading into Morocco, was blown off course by a northerly storm.

The ship wrecked on a reef.

Men with faces like coal took Fergus from the wreck.

They brought Fergus to their prince who had gold on ankles and arms and forehead. The black prince gave Fergus exquisite greeting.

Fergus gave him a gruff response.

And Fergus gave him a cairngorm from a Scottish mountain.

Cries of wonderment!

The prince clapped his hands. Now Fergus must have a gift.

Into the ivory courtyard, summoned, walked a lion, with great power and dignity and a deep black song in his throat.

The face of Fergus was gray as ashes.

Three moons, and the ship was repaired. Three moons, and the caged lion was set in the hold.

Four moons, and the ship of Fergus returned to Alba.

Ah, the cries of fear and joy when the lion in its cage was set on the strand.

The king commanded the cage to be opened. The king gave the lion a haunch of wild boar to eat.

The lion set his great burning head on the king's shoulder.

'Little wonder,' cried the king when he was old, 'that everywhere we are victorious, when we fight under the sign of such a fierce noble creature.'

Then the sailors set on shore the cargo of African ivory and gold.

NUCKELAVEE

Nuckelavee –' devil of the sea'.

Ah, what terror for a simple countryman to meet Nuckelavee on a dark road, and he coming from the alehouse merry!

The thing Tammas saw was half horse and half man, but all distorted, all wrenched into ugliness and malevolence.

Nuckelavee was skinless, its blood could be seen flowing through its branching veins, also the thumping of its black heart.

All hurt that fell on men from the ocean was the work of Nuckelavee: shipwreck, drowning of fishermen, driving away of the silver shoals.

But Nuckelavee rotted the crops, also, with sea-fogs. If a cow or a sheep fell over a crag, Nuckelavee had lured it to its doom.

The heart of Nuckelavee beat with a black malevolence towards mankind.

Tammas's road lay between a freshwater loch and the sea.

Nuckelavee trotted towards Tammas. Tammas stood his ground. The worst thing a man could do was turn his back on Nuckelavee.

The thing Nuckelavee feared – the only thing – was fresh water.

A single silver raindrop, and Nuckelavee, howling and raging, sought the sanctuary of the sea.

Tammas, emboldened by ale, took a side step into the loch and a splash of loch water fell on Nuckelavee.

The hideous rage of the creature, raked with agony by the sweet water!

Tammas slipped past.

A few steps further on, a burn flowed out of the loch to the sea.

Tammas went splashing across the singing water of the burn.

Once on the far side, he was safe.

Nuckelavee made one last despairing clutch at Tammas the crofter. It almost had him by the hair.

When Tammas got home to his croft, his wife (smelling the ale) cried, 'Your supper's cold! You drunken lazy weed, where's your bonnet?'

That was all that Nuckelavee had managed to snatch from Tammas: his bonnet.

That is the closest encounter that any living man has had with Nuckelavee.

DRAGON

Down the broken west coastline of Scotland streamed the dragon-ships of the Vikings.

Axes flashed in the April light.

Village and monastery burned after sunset.

The people returned to the blackened ruins at dawn. The farms and the chapels had been robbed. Cows and sheep had been slaughtered and taken on board for salting and sustenance.

Would corn ever grow on the burnt fields again? The ships had sailed on south, hungry for silver and gold, pearls and tapestries.

The dragon carved on every prow sought out their sea-path. It was the dragon who lusted for the chalices, the blood, and the fame that such adventures bring. (The story of the voyage, exaggerated and embellished, would be chanted in the ale-halls next winter).

The peoples of the coast had welcomed, for many generations now, the peaceful merchant ships from Ireland and Spain.

But the spirit of the dragon had entered into those seamen from the north.

It happened that Saint Magnus, earl and martyr, endured his martyrdom among those people of the dragon.

A generation later, a fleet of fifteen pilgrim ships lingered in Orkney, waiting for the winter seas to calm.

A winter of gales and blizzards it was.

A company of sailors, riding between Birsay and Scapa, took shelter from a dense snowstorm in a stone age burial chamber called Maeshowe.

To pass the time, they carved runes on the wall:

INGIBIORG IS THE LOVELIEST OF THE GIRLS. …
HERMUND CARVED THESE RUNES
WITH A HARD AXE. …
MANY A PROUD LADY LOW STOOPING
HAS ENTERED HERE. …

One of the sailors carved a dragon on the wall, transfixed with a sword.

The dragon in them had to die before they were worthy to make the voyage.

At the time of daffodils and larksong, the fifteen ships set out for Jerusalem, Byzantium, Rome.

STOOR-WORM

The little world of legend was threatened with total annihilation by a monster of prodigious size and malevolence called 'the Stoor-worm'.

The Stoor-worm girdled the seven seas. Upon whichever country the Stoor-worm laid its sun-eclipsing head, seven maidens had to be fed to it every day.

Otherwise the kingdom would be made a wilderness.

It was as if the Stoor-worm came to mock the knights and warriors of the land: the great heroes.

Ah, the Stoor-worm tired of his diet of girls. Let the king's daughter be fed to it. Then it would go away.

On every road the king sent messengers. Where was the brave knight that would kill the Stoor-worm and save the princess? That hero, when he had proved himself, would have the princess for a wife. He would be king himself, in time.

All the heroes, all the clever devisers who knew ways of killing monsters, shrank into their shells like hermit crabs when it came to doing combat with the world-circling Stoor-worm.

There was one farmer's boy in a distant part of the kingdom. He was such an idle dreamer that they called him Assiepattle, for he spent the time when he ought to have been ploughing and shepherding, beside the hearth. Assiepattle, idler and dreamer and good-for-nothing.

Assiepattle rode to the coast where the head of the Stoor-worm lay. He got a little boat and he lit a torch. When the Stoor-worm opened his jaw to yawn, Assiepattle's boat entered upon the rush of waters. Down the vast throat sailed the boat, and into the belly as red and reeking as a chamber in Inferno. Assiepattle thrust the lighted torch into the liver of the Stoor-worm. The liver was so steeped in rich oils that it caught fire at once.

The Stoor-worm belched flame, and Assiepattle was thrown out on the sea once more.

The Stoor-worm smouldered to death, agonisingly. The thresh of its forked tongue created the channel between Norway and Sweden. A scattering of its teeth formed Orkney, and another Shetland, and another Faroe. Its burning liver still smoulders on in the volcanoes of Iceland. I have no doubt that its hide, weathered into beauty, are the Highlands of Scotland.

The spirit of Stoor-worm is immortal. Today we know it as nuclear war.

Assiepattle is the spirit of poetry, music, art, dance. Now that the scientists and the mathematicians – those modern seers and heroes – stand impotent before the monster they have summoned up, let the imagination begin to work its spells.

EAGLE
(The Child Stolen from the Harvest-field)

An eagle, circling high.
The swaddled child
Lay in the bronze
Shadow of a barley stook.
The mother,
Bronze-throated, bent and gathered and bound.
The eagle
Hovered, stooped, threshed.
The child hung
Hooked in talons, dragged
Up blue steps of sky
To a burning nest
In a crag of Coolag hill.

The harvest mother
Followed. She changed
Burnish for blue wind,
Bleeding hands. She
Lifted the boy like an egg
From the broken
Circles of beak and claw and scream.
She brought him down
To her nest of crib and milk.
She kissed him.
She lit the lamp.
She rocked the cradle. She sang.

Old grand-da muttered
Through the gray
Spittle and smoke of his pipe,
'Better for the boy, maybe
That freedom of rock and cloud,
A guest
In the house of the king of birds –
Not what must come,
Ten thousand brutish days
Yoked with clay and sea-slime.'

SEAL
(Night-song)

You, gray one, will end
Under a blunt club.
The shopkeeper
Must have slippers to his
 sugar-and-snuff fireside feet.

You, joy of the rocks
Will take a hundred trout and haddocks.
A cluster of fine wives
Will wait at the shore for you,
 lord of the gray circles.

You, horizon seeker
Will change with harps
To a corn girl.
Night wind on sea and rock
Will keep you awake in a wooden bed.

I forget all the large young eyes.
A few have voyaged
Far westward.
They have got sanctuary in caves,
 or in beautiful stories.

WHALE

He has broken his boreal bounds, the whale.
Sea seethes about him
Like cauldron on cauldron of ale!

The rinsed eye of the whale
Sees, through spindrift and smother
A watchful wind-drinking sail.

A snow-cloud lours on the whale.
The armoured hide
Rebounds with volleys of sleet and ice and hail.

He pastures deep down, the whale.
The dreaming plankton,
Over his delicate lip they drift and spill.

He must breathe bright air, the whale.
He surges up,
A sudden fountain flowers from his skull.

What bothers him now, the whale?
A boat-ful of men.
He scatters them with a lazy sweep of the tail.

A harpoon has struck the whale.
And the barb quickens.
The iron enters him slowly, cell by cell.

Go to the lee of the berg, wounded whale!
He welters in blood.
The eye dims, and the foundry heart is still.

UNICORN

You will not meet the unicorn
Outside the queen's garden.

He goes among the roses and the fountains
Very delicately treading.

His silver horn shines in the sun.

The queen's ladies
Offer him roseleaves and honey.

Too Coarse!
He devours the scent of the flowers.

He leans his white neck
On the white necks of the ladies.

Peacocks fold their fans and droop
When the unicorn walks in the garden.
The swans Drift dingily to the far side of the lake.
Blackbirds stop singing.

The unicorn comes to the garden at night
Under the full moon.
He feeds on dew, delicately.

He will not go near the sundial.

In winter he moves through the snow
Invisible
But when he breaks the script of the bare branches.

When king and council come
With their talk of war and trade and taxes
The unicorn gallops to the bower
Where the ladies sit at the looms.

'Sweet ladies, give me sanctuary now
In your tapestry'. …

Gravely, there, for centuries, heraldic,
He sports with the lion.
One by one the royal ladies have withered and died.

MOTH

The Moth travels from window to window
Wherever a lamp is set.

There's old Sammy playing his fiddle,
Such a rant
The sweet plea of the moth is lost.

In the next croft
Three children are reading their school books.
He thuds on the pane.
They are lost in labyrinths: seaports and algebra.

Travel on, moth.
The wife is out in the byre, milking.
A fire-drowsed dog
Growls at the birring in the window.

Will nobody help a lost moth?
All he wants
Is a rag to chew, best of all
The golden rag in the lamp.

The moon is too far away.

In the next three crofts:
Ploughmen were drinking ale from a cog
And an old woman was knitting a sock
And a twisted couple
Were counting pieces of silver out of a sock
On to a scrubbed table.
They looked scared when the moth knocked.

Ah, the fisherman is mending a creel in his shed
In a circle of light.
The moth enters on a sea-draught.
Ecstasy of flame
Hurls him to the floor, scorched.
And the fisherman says
'Boy
I wish the skate was as keen to come on my hook.'

The moth woke to ashes, dawn, a cold lamp.

GROUSE

I am a very shy bird. I really don't want to appear on a million whisky labels. I don't deserve a day devoted to me, 'the glorious twelfth of August' I'm not flattered, it ushers in a time of death and maiming.

All I ask is a fine crop of wild heather. And wind and rain and sun. And solitude. And no hill fires.

I have enough human speech to plead with men who flush me out of the heather. *Go back, go back, go back*, I cry, from sills and ledges and eaves of the wind. I erupt from the heather. I make the wind beautiful with the rapid beat of my wings.

One neighbour I can't abide, the crow. That blackness breaks into my nest. Eggs and chicks go into his ugliness. That our caring should add to the hoarseness and harshness of the world ….

I can act, if I have to. Let a wanderer come near the nest, Oh, I'm suddenly a cripple, an outcast, a broken reed, hirpling and dragging from stone to tussock! I draw his eye away from my breaking shells and innocent beaks.

I am the shyest of birds. Do you think I relish the TV announcers saying, or the newspapers snobbishly announcing, that a brace of my tribe was flown from Scotland – limp and lustreless – to be served for dinner at the Ritz on 'the Glorious twelfth'? …

Go back, go back. But they do not go back. The guns thunder and smoke. And many fall, and they hang like rags from the jaw of a hound.

STAG

The great forest is down.
 His eye reads the bare landscape.
 High he moves, against the skyline,
with crown of antlers.
 A stone shifts on the far side of the mountain.
He listens.
 He runs magnificently. He leaps across the burn.
 Keep away! The mountain is mine!
(The intruder may have nothing but binoculars,
or a camera. But those creepers and crawlers, those
spies, are dangerous. A thousand generations alert
him. They carry death; once it was only arrows).
 He obeys the wheel of the sun.
 Turn from the silver scars on the summit. The
year will soon be dead, the mountain a white shroud,
the pool where he drank frozen.
 Sweet and compelling and irresistible, through the
narrowing wheel of the sun, the winterward wheel,
the delicate summons of the hind.
 The cycles of sun and deer must never die.
 His great bell-cry, the challenge, echoes from glen
to glen.
 But it is like death, the winter! A step further,
and his heart would crack with the frost.
 He pastures on seaweed.
 On that other island, the winter grass may be
sweeter. Four miles across the sound, he breaks the
pewter to transient silver, like a huge oak-trunk.
 He is alive still, in the summerward wheel of the
sun, climbing through the new heather and bracken;
up to the new sun.
 Behind a rock, on the far side of sight and smell
and hearing, a rifle is levelled.

WILDCAT

You won't catch me blinking beside coal fires, and
purring when some delicate finger strokes me.
 You'll never see me pleading for pieces of cooked
fish, or liver, or chicken.
 I have no intention of curling into a soft ball on
anybody's knee, or in an armchair.
 Pooh, look at the house cats going in their fine soft
coats, black and marmalade and tortoiseshell!
 All they can do is chase voles and starlings.
 If they saw me coming, they'd go leaping and
screeching into the highest tree in the garden!
 They come, those spineless lickers-of-milk-out-
of-saucers, from Egypt and such places. I expect the
Romans took them here, in ships, to keep their ladies
from being bored.
 Me, I'm a real Scottish cat. I'm as tough as heather
and fierce as a mountain torrent.
 I take hares and grouse in the fall and flash of my
claws.
 I like to go out at night, when my sister the moon
is prowling softly at midnight. My eyes change like
the changing moon. (An Irish poet noticed that).
 Poet and moon and cat are all kin. They go in
lonely circuits.
 I have cousins in Africa: lion and tiger and chee-
tah. They belong to the sun. They blaze, they rage
like fire. 'King of beasts' – pooh, the lion is welcome
to his crown.
 Silent as a lochan in a mountain fold I lie till the
moon rises. The skein of water unwinds to an edge of
granite, a declivity, then I leap pure and fierce and
swift, a snarling cataract.
 Prey? They have drifted, life-long, yearning for
my claws and my teeth, the hare and the grouse and
the vole. With joy and terror they wait for the tryst.

LOBSTER

What are you doing here
Samurai
In the west, in the sunset streams of the west?

How you lord it over those peasants,
The whelks
The mussels and the shrimps and scallops.

There you clank, in dark blue armour
Along the ocean floor,
With the shadows flowing over you,
Haddock, mackerel,
And the sun the shadow of a big yellow whale.

Nothing stands in your way, swashbuckler.

The orchards where you wander
Drop sufficient fruit,
Mercenary in the dark blue coat of mail.

Be content, be content far out
With the tides' bounty,
Going from smithy to smithy, in your season
For an ampler riveting.

Then out, when the whale's a bone in red embers,
Under the silver-blue scales of the moon.

Glossary of Print Terms and Techniques

Acid: Used in etching to bite into the surface of the metal plate and create line or tone. Nitric acid, hydrochloric acid and ferric chloride are commonly used.

Aquatint: Aquatint is a means of producing tone rather than line. The artist covers the plate with grains of rosin (a type of resin). When the plate is immersed in acid the liquid eats into the metal around each grain, leaving a tiny etched ring. The acid can be applied over the whole plate to give an even tone or painted on by hand to create the effect of brushstrokes.

Artist's proof ('A.P.'): The artist normally makes several 'proofs' (see below) of the finished print outwith the numbered edition. Works from the numbered edition are available for general sale while the artist or publisher may retain the artist's proof copies for their own use.

BAT: Stands for *Bon à tirer* (good for printing), a French term which means that the final proofed print has been checked and approved by the artist and that the printers can edition the print, using the BAT as a guide.

Chine collé: Chine is an extremely thin, slightly yellow type of rice paper. It can be stuck ('collé' in French) onto the printing paper, prior to printing the image, in order to give a different ground tone.

Colophon: Printed page in book or portfolio carrying mainly technical information about the contents, for example date, paper type, printer, technique etc.

Crayon etching: A steel etching plate is de-greased and drawn on with lithographic crayon. A diluted mixture of metholated-spirit varnish (called 'straw-hat' varnish) is sprayed onto the plate and left. When washed off with white spirit the crayon lines break up and can be exposed and etched with acid. Some of the prints in John Bellany's portfolio *Images Inspired by Ernest Hemingway's 'Old Man and the Sea'* were made by this method.

Drypoint: A technique similar to etching except that instead of drawing into the waxy ground and then biting into the plate with acid to produce a line, the line is scratched directly into the plate with a sharp needle, which can be used much like a pen. This technique produces fine ridges of metal on either side of the scratched line: when inked the ridges retain a quantity of ink and this gives the printed line a rich, velvety quality.

Edition: Prints can be made in editions of between one and many thousand copies. With most printing techniques the plate or screen will become worn if very many prints are made, so to maintain quality (and exclusivity) editions of original prints are usually kept below one hundred copies and normally average between thirty and fifty copies. Prints made up of several different plates can be extremely complicated and time-consuming to edition, so in these cases editions are kept low for practical reasons.

Engraving: The engraver pushes a lozenge-shaped chisel called a 'burin' through the plate (either metal or wood), leaving a clean-edged incision. This technique requires a great deal of control and is not suited to spontaneous mark-making.

Etching: A metal plate (normally copper, zinc or steel) is covered with an acid-resistant layer of rosin mixed with wax. With a sharp point, the artist draws through this ground (not into the metal plate). The plate is placed in an acid bath and the acid bites into the metal plate where the drawn lines have exposed it. The waxy ground is cleaned off and the plate is covered in ink, then wiped clean, so that ink is retained only in the etched lines. The plate can then be printed through an etching press. The strength of the etched lines depends on the length of time the plate is left in the acid bath.

Hardground etching: This is the normal etching method, but is referred to as hardground to distinguish it from softground etching (see below).

Hors commerce ('H.C.'): French term meaning that this copy of a print or book is intended for display only and is not for sale.

Letterpress: A traditional method of printing text. The text is set in metal or wooden letters: these letters are in reverse and in relief. The surface is inked up and the paper is pressed down onto it.

Linocut: The artist cuts into the surface of a piece of lino with a simple gouge, knife or engraver's tool. The surface of the lino is inked and printed: this can be done by passing it through a press, though it can also be done manually by rubbing the paper onto the lino with a spoon or similar implement. See Ken Currie's *Story from Glasgow*, Terry Frost's *Trewellard Suns*, Peter Howson's *A Hero of the People*, Adrian Wiszniewski's *For Max* and Bill Woodrow's *The Periodic Table*.

Lithography: Lithography means, literally, stone drawing. In addition to fine grain lithographic stones, metal plates can also be used for lithography. The method relies on the fact that grease repels water. An image is drawn in a greasy medium onto the stone or plate, which is then dampened with water. Greasy printing ink rolled onto that surface will adhere to the design but be repelled by the damp area. The inked image is transferred to the paper via a press. For large editions, the grease is chemically fixed to the stone and gum arabic, which repels any further grease marks but does not repel water, is applied to the rest of the surface. For colour lithography the artist uses a separate stone or plate for each colour required.

Monoprint: This is a single, unique print, made by the artist with this intention. A monoprint can be produced by any printing technique – screenprint, etching, lithography – but is only issued as a single print, and is not editioned. The screenprints by John Hilliard, *Seven Monoprints*, are monoprints since they all differ slightly.

Monotype: The artist may draw or paint onto a surface such as glass or metal and then press paper onto the image to take its impression. Because the ink or other medium is transferred to the paper only one good impression can be made.

Off-set Lithography: A technique developed at the end of the nineteenth century, it works on the same principal as lithography (see above), ie. relying on the fact that grease repels water. A large, rubber-covered cylinder rolls over the inked-up lithographic plate so that the ink is transferred onto the rubber. The cylinder then rolls over a sheet of paper, onto which the image is transferred. This double-transfer technique allows the artist's design to be printed the right way around (in straightforward lithography the image is printed in reverse). The off-set lithography process can be highly automated and is widely used in commercial printing to make large numbers of prints very quickly. Books are normally printed by the off-set method.

Open-bite: The artist paints directly onto the metal etching plate with acid.

Photogravure: This technique was common in the late nineteenth century but is rarely used today. Essentially it means transferring a photographic image onto an etching plate. A photograph is taken of a painting or other image, then the photograph is transferred onto a large sheet of bromide film. From these bromides large transparencies can be made, to the scale of the desired print. The transparency is exposed to a sensitised sheet of gelatin and is then transferred onto a copper plate with a squeegee. The image is etched through the gelatin film onto the copper plate in a series of ferric baths. This method was used in the making of Christopher Le Brun's *Wagner* series.

Photo-opaque: A type of paint, normally red, used in the production of screenprints (see below). The artist paints onto acetate sheets with the paint, and these marks are transferred, in reverse, onto the silkscreen via a light-sensitive, photographic process.

PP: Printer's proof copy. As with artist's proof copies, the publisher may make a copy of the print, outwith the full edition, for the printer to retain.

Proof or State: When the artist draws or etches onto the plate or lithographic stone, or uses any other such printing technique, he or she may wish to print the image from time to time to see how it is progressing: this is known as 'proofing' the image. These intermediate prints are known as 'trial proofs' or 'states'. Once proofed the artist can resume work on the image. Often an artist will proof the work several times before being satisfied with the result and can produce as many as thirty or forty trial proofs or states. In some cases the artist may conceive these trial proofs as publishable prints in their own right, and may make editions of the print at various stages in its making (Rembrandt did this). These editioned proofs are called 'states'. When the finished print is editioned, the artist generally makes a small number of proof copies outwith the numbered edition: these are known as 'artist's proofs' (see above).

Rosin: A type of resin used in the production of aquatint and spitbite etchings.

Screenprint: Also known as silkscreen. In its simplest form, this is a technique by which the artist blocks out sections of a fine, woven screen (formerly made of silk) which is stretched over a frame. With a squeegee, ink is pressed evenly through the screen onto a sheet of paper beneath. Only the areas of the screen not blocked out will be printed. Screenprints bearing several colours are made by printing through several different screens, one screen for each colour. Normally an artist will paint onto transparent sheets of film (the same size as the desired print) with a special photo-opaque paint through which light does not penetrate. The artist will use as many of these transparent sheets (separations) as the numbers of colours required in the print, and each sheet must be aligned very carefully with the others. The films are tranferred onto the silkscreens via a light-sensitive process: only the areas which are not painted by the artist will be blocked out and will not allow ink through. The colour screenprints in John Bellany's *Images Inspired by Ernest Hemingway's 'The Old Man and the Sea'* portfolio were made in this way. Images may be transferred photographically onto the screens and printed: this process is now achieved through sophisticated, sometimes computer-regulated machinery. Grenville Davey's prints and a number of the prints in the *London* portfolio were made in this way. Screenprinting only became widely used in Europe from the late 1940s.

Separation: In screenprinting (see above) each colour is originated on a separate, transparent sheet of film, known as a separation. A complex screenprint requiring fifteen different colours will normally require fifteen different separations. A further subtlety is that a single separation may be used to generate two or more silkscreens, each of a slightly different density and each to be printed with the same colour. When such screens are printed on top of each other the colour has a rich, natural appearance.

Softground etching: A variety of etching which uses a soft etching ground, composed of waxy rosin to which vaseline or tallow has been added: this gives a soft, sticky ground which takes impressions easily. It may be used by the artist in two principal ways. Firstly, the artist may draw freely onto a sheet of paper laid on the softground plate: when it is removed it takes with it the sticky softground layer and the exposed plate may be etched in the usual way (see Bill Woodrow's *Greenleaf* prints). Alternatively, the artist may leave impressions in the softground, for example by marking it with his fingers (see the prints by Antony Gormley) or by placing flat objects onto the softground plate and feeding it through an etching press so that the forms are recorded in the ground. In his print series *Night of Islands*, Will Maclean fed material such as seaweed, netting and leaves through the etching press.

Spitbite: An etching technique. The copper plate is first covered with powdered rosin, in exactly the same way that an aquatint plate is prepared. The artist applies acid onto this layer and it slowly bites through to the plate. The artist can literally spit into the acid to create different effects, though this is not an essential part of the spitbite process.

State: See *Proof*.

Stop-out: An etching term. The etching plate can be placed in an acid bath for a short time, taken out, and parts of the plate 'stopped out' with varnish. When the plate is put back in the acid, the stopped out areas will not be bitten any further though the rest of the plate will continue to be etched. With this technique the artist can make a print with a variety of fine and heavily etched lines of varying tones.

Sugar-lift etching: The etching plate is first coated with the powdered rosin used in the aquatint process. The artist then paints an image onto this with a special, water-based ink to which sugar has been added, and then coats the plate in varnish. The plate is immersed in warm water. The sugar dissolves and lifts off the coat of varnish to expose the metal. This ground is then etched with acid following the normal etching method. The technique gives an unusual, painterly effect.

Title-page: The page or sheet at the front of the book or portfolio, bearing the title of the project and the artist's name.

Transfer Lithography: The artist draws or paints onto a sheet of transparent paper resembling grease-proof paper. The image on the paper is transferred, in reverse, onto a photo-sensitised lithographic stone or plate by shining light through it. Because the lithograph prints in reverse, the final printed image is the same way around as the original image drawn or painted by the artist. Alan Davie's *Magic Reader* prints were made in this way, allowing the script to be read correctly.

Acknowledgements

For their help in preparing this catalogue we should like to thank Charles Booth-Clibborn, founder of The Paragon Press, who has assisted at every stage; Jeremy Lewison, Deputy Keeper (Modern Collection), Tate Gallery, London, and Professor Duncan Macmillan of Edinburgh University, for their perceptive essays; and Patrick Elliott, Assistant Keeper at the Scottish National Gallery of Modern Art, who has edited the catalogue and written detailed entries on each of the publications. The catalogue entries are the product of lengthy interviews with the artists, and we should, above all, like to thank them for participating in this way and for approving the finished texts.

We should also like to thank the following: Patricia Allerston; Léonie Booth-Clibborn; Edward Booth-Clibborn; George Mackay Brown, for allowing us to reproduce his texts for *The Scottish Bestiary*; Thomas A. Clark, Crispin Jackson and Kenneth White for allowing their texts to be reproduced; Brad Faine and Clare Burton of Coriander Studios Ltd., London; Beth Fisher; Laure Genillard Gallery, London; Charles Gledhill; Jay Jopling, White Cube, London; Peter Kosowicz and Simon Marsh of Hope Sufferance Press, London; Lisson Gallery, London; Marlborough Fine Art, London; Antonia Reeve, who undertook much of the photography; Karsten Schubert Ltd., London; Hugh Stoneman; Arthur Watson and Jonathan Jones of Peacock Print-makers, Aberdeen; Peter B. Willberg, who designed the catalogue.

Within the National Galleries of Scotland we should like to thank John Watson, Graeme Gollan and James Berry who mounted all the prints for the exhibition and Keith Morrison, Ian Craigie and Tom Livingstone who undertook all the framing; and Janis Adams, Michael Cassin, Margaret Kelly, Siobhan Dougherty and Philip Long. Lastly, we express our warm thanks to Faulds Advertising, Edinburgh, for their sponsorship of the exhibition.

Richard Calvocoressi

Publisher's Acknowledgements

I believe contemporary British art constitutes an extraordinarily rich and vital visual culture in the world today. I owe my existence as a publisher to the artists included in this volume. I recognise that without their vision, commitment and generosity The Paragon Press would have floundered. I am also indebted to the authors and poets I have published, most notably George Mackay Brown and Thomas A. Clark for their remarkable texts.

I am especially grateful to Richard Calvocoressi, Keeper of the Scottish National Gallery of Modern Art, for instigating the exhibition which this catalogue accompanies, and to Duncan Robinson for agreeing to show the exhibition at the Yale Center for British Art in New Haven. My thanks also to Patrick Elliott, Assistant Keeper at the Scottish National Gallery of Modern Art, who has edited the catalogue and organised the accompanying exhibition; Patrick Noon for curating the exhibition at Yale; Peter B. Willberg for designing this publication and for working under less than ideal circumstances; Jeremy Lewison, Deputy Keeper (Modern Collection), Tate Gallery, London, for his encouragement and for his introductory essay; and Professor Duncan Macmillan of Edinburgh University for his essay on the Scottish projects.

I would like to thank all those individuals, whether they be printers, museum curators, collectors, designers, typographers, bookbinders, librarians, colleagues and friends, who have contributed to, encouraged, and made possible my publishing to date: Phil Able; Phil Baines; Richard Brown Baker; Moisha and Bob Blechman; Patrick and James Booth-Clibborn; Hiram Butler; Alfons Bytautas; David Case and Marlborough Graphics; Richard E. Caves; Gordon Cooke; Alan Cristea; Marcus Dean; Brad Faine and Coriander Studios Ltd., London; Vladimiro di Folco; Charles Gledhill; Nigel Greenwood; Anthony Griffiths and Francis Carey of the British Museum; Douglas Hall; Keith Hartley, Janis Adams, Margaret Mackay and Philip Long of the Scottish National Gallery of Modern Art, Edinburgh; Crispin Jackson; Jay Jopling; David Kichl; Simon and Angela King; Peter Kosowicz and Simon Marsh; David Landau; Christopher London; Liz Macrae and the Lisson Gallery; Karen McCready; Dr Ann Matheson of the National Library of Scotland, Edinburgh; Rosy Miles of the Victoria and Albert Museum; Ian Mortimer; John Odgers; John Purcell Paper Ltd.; Robert Rainwater and Roberta Waddell of the New York Public Library; Andrea Rose of The British Council; G. Ryder Ltd.; Romilly Saumarez-Smith; Sarah Snoxall; Hugh Stevenson of Glasgow Museums and Art Galleries; Simon Theobald; Claus Thierbach; Ian Tyson; Arthur Watson and Beth Fisher at Peacock Printmakers, Aberdeen; Kenneth White; Greville Worthington; Deborah Wye, Wendy Whitman and Andrea Feldman of The Museum of Modern Art, New York; and, above all, my parents.

I dedicate this publication to my wife Léonie in love and gratitude for our daughter Edwina, and in anticipation of all she will endure being married to a print publisher.

Charles Booth-Clibborn